PERFORMANCE PROJECTIONS

PERFORMANCE PROJECTIONS

FILM AND THE BODY IN ACTION

Stephen Barber

REAKTION BOOKS

Published by Reaktion Books Ltd
33 Great Sutton Street
London EC1V 0DX, UK

First published 2014
Copyright © Stephen Barber 2014

Printed and bound in Great Britain
by Bell and Bain, Glasgow

A catalogue record for this book is available from the British Library

ISBN 978 1 78023 369 7

CONTENTS

In Transit: Between and Across Performance and Film

An art form intersects with another in a vital shattering and re-configuration of both. Afterwards, each may initially look the same, identical to the instant before that collision, but they have now been transformed. What emerges from that intersection can form an amalgam, an infiltration, a convergence, an accumulation or a stripping bare. It can engender a new entity of irrepressible experi-mentation, but it may also form a locus of final disintegration and power, in which one element of that intersection of art forms is overruled and consigned to oblivion, or else splits itself apart. As the entity which pre-eminently spans conjoined art forms, corporeality projects volatile dualities of its own, perceptible most immediately in a condition of extreme tension or an emergent but unknown spatial zone. This book is concerned with the intersection of performance and film. Between and across performance and film, across and between film and performance, in intimacy and riotous contestation, through darkness and illumination: that unknown zone is where future histories of the human body will be generated and witnessed.

In its explorations of performance, this book's particular, dual focus is on acts of performance art, in their widest sense, and on gestural, performed acts undertaken – often momentarily, and subject to summary vanishing – in *exterior* spaces, primarily those of cities (it is less concerned with performances spatially enacted in the interior spaces of art galleries and museums, or of theatres and

choreographic venues). Its focus on film is dual, too: on the film image as the pre-eminent, formative medium across a century or more for the perception of the human body and its movements, and on the digital image as exerting both a renewal and obliteration of film, in its rapport with the human eye. Performance primarily constitutes a corporeal act – manifested against spatial surfaces, backdrops and screens – whose enduring residue is instilled into a moving-image form.

This book is concerned with the multiple, determining ways in which vision intercedes between performance and film. Performance entails an act undertaken by figures inhabiting spatial surfaces, interzones and subterranes, whether conceived intentionally as a performance-art action or else carried through momentarily and compulsively, even accidentally; it is always made present in space by the corporeality that also allows it to be recorded in images. But, both in the gestures of performance and in the sequences of films or digital media, corporeality as a medium of duration can be instantly annulled. It exists only in its envisioning. The body's flesh-imbued sensory presence in performance may abruptly blur, misfire and deliquesce into space, and the celluloid or digital pixels holding its detritus may malfunction and vanish into thin air, too. In that sense, performances form the casting of shadows and spectral presences across spatial surfaces and into the gaps between them. Those acts constitute pivotal life-or-death markings, pitched between darkness and invisibility, conceived for the eye but subject also to their own loss, through the arbitrary priorities of the eye and its recording instruments of vision, which always possess lives of their own.

This book also explores what exactly takes place in the 'mystery' of that liminal, interzonal movement between performance and film. Performers may instigate the filming of their acts; many such acts have historically been conceived and executed solely for their realization as filmic sequences, thereby reinforcing film's

recording-medium status as an integral ally of performance, with the cryogenic capacity indefinitely to sustain performance's existence after its momentary enacting. Conversely, film-makers may themselves solely determine the rendering of performance into the medium of film; film can form a direct contravention of performance's assigned intentions, to the extent that it actively obstructs performance, and utterly scrambles its time and space, with the aim of reconfiguring corporeal traces as filmic traces. Film may also be activated neutrally, without any intention to record or appropriate performance, through accidental or automatic moving-image sequences, shot by surveillance cameras or oblivious human documenters of performance. But in each instance of performance's intersection with film across widely disparate forms – through collaboration, against the grain or automatic – a vital residue of performance's corporeal acts is always generated, momentarily or indefinitely, for archival preservation or near-instantaneous disposal. Every manifestation of filmed performance is one in which the human body's presence is materialized, but simultaneously transformed. Film uniquely impacts upon performance to reassemble corporeality.

In its mapping of seminal infiltrations and conjunctions – generated across and between performance and film – this book is predominantly focused upon the *spaces* in which those dynamic encounters take place. As such, it is concerned with performance as an event and phenomenon that is invariably undertaken in an intimate rapport with space, whether one of complicity or antipathy. That rapport is one in which a division of time is also at stake. The performance theorist Erika Fischer-Lichte has probed the delicate but formative shift that takes place between a performance's temporally limited occurrence within its space, which she defines as a charged manifestation of 'spatiality', and that encompassing space's existence before and after the performance act:

Spatiality . . . is transitory and fleeting. It does not exist before, beyond, or after the performance but emerges in and through it, as do corporeality and tonality. As such, spatiality needs to be distinguished from the space in which it occurs . . . First, the space in which a performance takes place represents an architectural-geometric space that pre-dates the performance and endures after it has ended . . . The performance's spatiality is brought forth by the performative space and must be examined within the parameters set by it.[1]

Those parameters are accentuated, and also cast into a new dimension, whenever a performance act takes place in exterior space, and notably when it is conjoined with moving-image media.

A very wide range of films and of forms of film appear in this book, encompassing documents and documentaries, feature films and fiction films from film cultures ranging from German cinema's Weimar era to that of 1960s Japan, as well as contemporary digital loops and corporate animations. But in most cases, the films which are at stake here are experimental ones (as with the very first 1890s filmings of performance), in which a film-maker or film artist has approached an act of performance with a set of preoccupations, and a conception of time and space, existing at some degree of variance from the preoccupations and orientations of the performer. Film-making is always an act in counterposition to an act of performance; it is never simultaneous or identical, even when its aim is purely to replicate a performance in film. The intersection of performance and film is often conjoined as much by mismatches as by suturings. Every attempt in film to seize performance's temporal slippages forms one further variant of an ongoing, open-ended filmic experimentation into time and space. Film possesses its unique and accumulated histories of experimentation just as performance does, while film's experimentations are notably exacerbated in the

contemporary moment as a result of the unprecedented trans-mutations which digital technologies have exacted on that medium.

The conjunction of performance and film is integral to the perceptions and histories of both forms; at the same time, traversing those two entities constitutes a precarious tightrope walk.[2] As misfired attempts to film the acrobat Philippe Petit's spectacular transit over the void between the New York World Trade Center's twin towers in 1974 indicates, tightrope walking itself can form an outlandish and illicit corporeal performance extending between already vanishing endpoints, and resistant to moving-image capture. The conjunction of performance and film is not dependably a rational or linear terrain: it is often also one of riotous insurgency, of fallings into darkness and of disorientating sensory loss and excess that can leave the eye of the spectator multiply displaced. Whenever performance enters film's arena, it may be delicately accented and sensorially enhanced by that manoeuvre, its corporeal gestures revivified, but at the same time it is always irreversibly overhauled by film and relocated elsewhere. Film, in turn, may be deployed into performance's arena and hold its own there for a time, juxtaposing itself against performance acts, and even visualizing and projecting those same acts on screens located within the performance space; but if it endures too long, imposing its own spectatorial rituals and compulsions, film's presence will eventually unsettle the dynamics of performance and require extinguishment. The spectator of enmeshed performance and film has to negotiate the demands of two contrary entities and to envision dual, intersecting histories.

Performance art forms a vast global phenomenon. Many young artists, from China and Japan through Europe and the Middle East to the USA and South America, now position their work explicitly as performance art, as though no other form of art could satisfactorily deploy the kinds of corporeal, political, protest-based or aesthetic

processes that performance can. But in order for performance art and all associated gestural actions to be manifested after their execution, they must be filmed and that film disseminated, whether on artists' or galleries' websites, YouTube, arts e-journals, social media, exhibition spaces or other locations in which the traces of performance art are instantaneously accessible. Many contemporary performance artists are also simultaneously the filmic documenters of their own work, since digital media erase almost all of the delay, attention and required aptitude formerly attached to the filming of performance art. As such, the conception of contemporary performance art is often inseparable from the envisioning of how it will appear and be projected, in the next moment, in its moving-image form. Performance art possesses its distinctive filmed lineage, emerging 60 or so years on from film's mid-1890s origins, in the form of the deteriorated celluloid documents of performance works by Gutai and Fluxus artists, and that lineage extends directly to the present moment, since contemporary artists can always rapidly access that filmed performance history. In a sense, contemporary performance artists have no option but to absorb and recapitulate that filmed history of performance art, since it is now so predominantly present and pervasively locatable through digital resources such as ubu.com; any performance artist with the impossible desire to begin again in an unprecedented way, in filmed performance, would first need to exact an all-consuming ocular and sensory self-deprivation, and an archival annulling of performance's memory.

Since film is often now perceived identically *as* performance art, in part as a result of that excessive and accumulating plenitude of performance's digital moving-image archiving, a comprehensive disentangling and re-envisioning of those two entities – performance and film – is necessary in order for their distinctive interconnections to be perceived, and for their vital, defining disparities to be delineated. Performance's transaction into the moving image constitutes a

multiple one that encompasses filmed performance, the rendering of performance into digital media and the future transformation of performance bodies into emergent sensory media. When performance takes place in exterior space, its past, present and future are simultaneously at stake. Performance threads itself through time above all via the medium of film, but that time is rarely linear or homogeneous in the perception of contemporary performance artists, and filmed performance's revelations are often unforeseen and awry, abruptly insurging across and through time. An image from filmed performance art's origins, in the 1950s or '60s, can often be more tellingly juxtaposed and conjoined with a contemporary act of performance than an image from a moment ago.

Performance's multiplicitous intersections with film can be approached historically, through the examination of amassed traces, locations or documents in archives or other resources, but they may also be interrogatively seized in the contemporary moment, through spatial and ocular transits of the locations at which performance can readily be anticipated to occur and to be filmed, or else by more exploratory trajectories that involve a permanently open eye, attuned to performance's sudden manifestations and vanishings. Performance art, like film, is never a fixed or closed art form. It may mutate in an instant into an outlandish, rapidly elapsed spatial act that appears to possess no conceivable alliance with the exhibition or identification of art; but that same act, viewed retrospectively in its filmed form, may take on the status, together with the time and space, of performance art. The mutable interstice between performance art and less clearly identifiable gestural acts executed in space (notably peripheral or interzonal space), especially those propelled by repetition and obsession, forms the point at which film's capacity to generate and cohere performance as art, or as spatial act, is most tangibly at stake.

Performance's conjunction with film is not only a matter for visual art, performance cultures and moving-image media. Its

projections form unique manifestations that also have pivotal relevance for the study of the human body in its gestural, sensory and spatial dynamics, and for the human eye in its capacity to capture and process split-second, aberrant manoeuvres. The future of corporeal and ocular power can be envisaged at the intersection of performance and film. But more widely, the projections of bound-together performance and film also hold and transmit philosophical, social, political and especially ecological dimensions, notably in their exposed, space-located manifestations. The potential survivals and extinctions of social and public spaces are dependent upon the capacity both of human figures to perform and protest within them, and of independent, autonomous moving images to be made of those figures' performative presence and acts.

The space at which performance and film interact most product-ively is often subject to terminal instability: the spatial interzone, gap, wasteland, subterrane, threshold or transit site. That space may be a city space, but it may equally be one in which all trace of the city has been excluded or subtracted by the performer and film-maker: film possesses the capacity both to construct revealing transits from corporeal to city space and back again, especially when that space is in riotous uproar, and to focus entirely on corporeal space, so that city space appears definitively occluded, and would have to be re-imagined from zero to exist again. City space is never what it appears to be, and film's interaction with performance is crucial in overturning apparent spatial constraints to expose the essential cruelty of space. When film is said to 'render' space, in its occupation by performance, that rendering has the resonance of a slaughterhouse process of rendition that violently reduces and condenses vital animal corporeality into a state of disintegration within which it can be con-sumed; that process also possesses the association of rendering with a liminal moment at which performance and film spectrally break through walls and surfaces, thereby engendering outlandish

conjurations and mutations of flesh and city space; finally, the term 'rendering' also evokes the digital domain in which a multi-dimensional virtual space is created through the transposition and transferral of corporeal elements, pulled from their originating space. Bodies lose control of themselves, and are potentially exposed to torture, in a political process of in-transit, cross-global 'rendition'. But rendering may also entail a sensitized process in which the space of performance is seen to oscillate from one extreme form to another, and from one location to its exactly opposite site, through the act of its filming. Only through that multiplicitous, fractious process of oscillation can the contemporary global form of digitized city space, with its contrary dimensions and pressures, be clearly sited, along with the corporeal presence of its inhabitants, occupants and protestors, engaged either in performative acts and gestures, or else subject to stasis. Contemporary space in cities possesses at least three such forms.

In its first manifestation, city space, in recent years, has become a maximally dense site of emergency contestation and protest. Such protest may have an economic origin that opens out into infinite forms of contestation, as in the turmoil of European cities subject to economic freefall and resulting youth unemployment, Athens and Madrid above all. That origin may also be a response to corrupt power or the desire for religious power, as in the uprisings of North African or Middle Eastern cities such as Tripoli or Damascus. It may equally have its origins in deep unease with the engulfing global supremacy of digital information, and be countered both with digital information itself and through infiltrations or occupations of city space, as with the acts of the Occupy movement around 2010. Urgent city-space protests may also be ecological ones. But in all of these manifestations of protest, city space is inhabited by absolute urgency: the sense that only an accumulating, intensive contestation – constellated by acts of performance in that space, and itself a form of

corporeal performance – can resolve the impasse. Space becomes emergency. And, in all such manifestations of urgency-instilled space, film is invariably present as a primary, exacerbating medium of documentation and viral unleashing. Equally, all such apparently unique spaces of maximally urgent contestation possess their precedents, as at the end of the 1910s, or in the 1960s, or at the end of the 1980s: all of them (that is, those situated post-1895) moments in which film intervened to transform city space's emergency protests into performative acts.

Alongside that manifestation of city space as possessed by an optimal and expansive emergency, and marked by protest, contemporary space is also, contrarily, disintegrating. The central plazas and squares of cities, especially those occupied by corrosive confrontations between protestors and their subjugators, are denuded, such as those of Athens and Istanbul. Space is rendered exhausted, dilapidated, through such processes as the expulsion and dispersal, for reasons of property speculation and other economic aims, of central city populations, or as the residue of flat-out confrontations between protestors and police, or by the intentional excoriation and voiding of central space by city authorities for non-publicized, opaque motives; the outcome is that what once appeared to be the central plaza of a city now presents itself inversely as that city's most negligible edge. The locations of performance and film historically sited in such central plazas – large-scale theatres or choreographic venues and similarly vast, ornate cinemas – constitute pivotal indicators of that process of coruscating oblivion in the form of abandoned cinemas and razed performance venues; often, the most intensive and experimental manifestations of protest take place in and around those reconfigured spaces of film and performance, momentarily reoccupied by performance artists or film-makers.

City space is simultaneously contested and abandoned; but it is also overridden by the unprecedented rise of digital culture, and

that culture's engulfing expansion through space. Protest and denuda-
tion may be diminishing and imminently vanishing subcategories
of that third, final variant of city space. The genealogies of graffiti
inscriptions left behind on spatial surfaces by protests, together
with the accumulated, almost worn-away textures of obsolete space,
form allied and intersecting presences that are immediately trans-
figured in the digital world. Film possesses an extensive history of
recording performances in spatial situations of protest, such as the
exclamatory work of Pussy Riot, and of conversely documenting
performances silently enacted in abandoned or atmospheric space,
as with the work of Ana Mendieta; but digital culture is one that
instantly subsumes and regulates both performance and space, and
immediately co-opted film, from the 2000s, replacing and upgrading
its technologies but appropriating its visual compulsions and auras.
The concentration of digital culture in contemporary space manifests
itself in image screens, corporate hoardings and the endlessness of
smartphone images; at the same time, it is invisible to eyes now fully
habituated to digital culture. Performance may not be a future human
option in pervasively regulated digital space, unless it takes place
with the abrupt, aberrant suddenness that often characterized per-
formance art's insurgencies into exterior city space.

If contemporary space holds all three of those variants simul-
taneously – and, undoubtedly, many more, in its fluid dimensions
and durations – it is already at bursting point, even when apparently
empty. Space, as the conjoined location of emergency protest,
scoured denudation and an ongoing engulfing by digital culture,
needs to be perceived as a shifting, seismic entity, instilled with
the past, present and future in a co-existent compacting that demands,
for its occupants, either a constant refocusing of perception or
else an instant habituation. Space is almost beyond language, but
not beyond performance: such impacted conditions principally
expel performance into space, and also compel the devising, by

contemporary performance artists and their moving-image col-
laborators, of new forms for the seizure and securing of performance
by the moving image – potentially, amalgams of film, digital data
and the visionary but soon obsolete media that captivated 1890s
moving-image instigators in Europe and the u.s. as they attempted
to find ways to transmit performance into sequences and projections.
Contemporary city space, together with its multiple and contrary
layers, is itself now an entity to be experimentally tested, expanded
or contracted, both to delineate its future as a site for performance,
and to investigate its receptivities and resistances to moving-image
visualization.

Performance, in its conjunction with film, forms an open site of
spatial exploration and conjuration in which overlapping spaces
between performance and film may be conceived in a parallel way
to that in which film's innovators in the 1890s compacted delusional
intuitions, stolen ideas and prior experiments in order to envision
a conceptual space in which to site the moving image. Alongside
such conjured sites, performance also possesses its lineage of exact
and once-tangible spaces in which encounters with film constituted
vital performative acts with repercussions for the perception and
imagery of the human body in the contemporary world. Formative
events of filmed performance art, for example, took place in precise
locations, such as the cellar of an apartment building in Vienna, for
the work of that city's Actionist artists of the 1960s, or an experimental
art venue, the F Space in Santa Ana, California, for Chris Burden's
Shoot performance of 1971. Once such performances had elapsed,
those spaces no longer held any apparent residual trace of them;
the cellar space reverted to its emptiness, the art venue was prepared
for its next performance or exhibition, and only film still pinpointed
the contours of those spaces momentarily inhabited by performance.
Concurrently, particular cities comprised pivotal sites in the historical

development of performance art, among them New York, Los Angeles, West Berlin, Vienna, London, Tokyo and Osaka; performance artists often undertook their work between those cities, or in involuntary exile from them, as in the movements in the 1960s of performance artists such as Günter Brus, from Vienna to West Berlin, or Yoko Ono, from Tokyo to New York, accompanied, directly or indirectly, by the film-makers already associated with the moving-image rendering of their work: Kurt Kren, for Brus, and Takahiko Iimura, for Ono. Alongside performance venues and cities, institutional spatial locations, documented by film, also 'grounded' performance art's history in the 1960s and '70s, notably in the architectural forms of venues for students to study performance art with its key figures, such as the California Institute of the Arts, in proximity to Los Angeles, or the Biggako art school in Tokyo.

The evidence of performance art's conjunction with film possesses a lineage that is closely linked to the historical perception of performance in the domain of visual art, and its frequent intersections with the area of film, especially experimental cinema and its histories. Traces and evidence of that conjunction have been assembled and manifested particularly by large-scale global overviews of performance-art history and the formative role of film within that history, such as the exhibition *Out of Actions: Between Performance and the Object, 1949–1979*, shown at museums of contemporary art in Los Angeles, Vienna, Barcelona and Tokyo in 1998–9, along with numerous other retrospectives that survey and delineate performance art from the temporal perspective and imperatives of its traces' moment of exhibition. Such survey exhibitions invariably locate or dispute historical and temporal origins for performance art in forms such as provocative public performance events, or manifestations of action painting and civic activism, of the 1910s, '20s, '40s or later; they oscillate in their points of focus from centre to centre of performance-art activity, and establish canons in which particular

movements (Gutai, Fluxus) and individual artists (Abramović, Beuys) may be highlighted as especially significant presences, particularly when a strong documentation of their work subsists or is still ongoing. Within such exhibitions, a special annex designed in the form of a darkened cinema space may be given over to programmes of films of performance-art events, or smaller-scale monitors and screens may be interspersed in galleries in proximity to the exhibited and tangible remnants of performance (such as manifestos or notebook scores, residual artefacts and pieces of torn or bloodied clothing); material artefacts may also be overlayered by moving-image projections. The traces of performance art, in its alliances with film, also extend beyond the gallery or museum space; along with the digital resources and archival collections that hold the evidence of performance conjoined with film, performance art can also infiltrate other domains, such as those of music and theatre performance, as in such productions as Robert Wilson's Lulu (2011), in which Expressionist film history also interposes itself. The dynamics of the display and institutional exhibition of filmed performance occasionally allow film to take the upper hand, as for example in programmes or retrospectives of the work of film-makers who consistently filmed performance-art events across extended spans of time, such as Stan Brakhage, Jonas Mekas and Kurt Kren. Alongside such museum-sanctioned canonical lineages of performance art and film, of parallel significance are one-off, ephemeral acts of performance undertaken and filmed in exterior or subterranean space, often in anonymized form, that share and accentuate concerns with such matters as corporeality, duration, sensorial or sexual disjuncture and oppressive power, among others, which historically preoccupied performance art.

Once performance is allied to the moving image, it is invariably exposed also to film's regimes of transformation, memory, reinvention and re-imagining. Performances may be sieved non-narratively from

such moving-image sources as fiction films and documentary films, from digital animations and corporate loops, or from other sequences such as those shot on iPhones. In all instances, performance's conjoining with film distinctively forms a sequence whose visual and sensory resonances accumulate from gesture to gesture, from performance to performance, and from projection to projection, even when that sequential form misfires or malfunctions. In that sense, a fundamental divergence exists between a performance rendered in filmic (including all video media) and photographic forms. Photography, in many ways, has been a more pervasive, representationally oriented means of documentation for performance than has film; the bodies of work of many performance artists, such as Gina Pane, are known predominantly or entirely through still photographic images rather than via film. Performance artists associated primarily with selfphotography may, through posthumous retrospectives or amended art-historical knowledge and priorities, come to be seen also as film-makers, as with the moving-image work from 1975 to 1978 of Francesca Woodman. Performance artists have often distrusted the sequential form of film, while the manual development of photographic images historically provided immense scope for the duplicitous or playful manipulation of performance documentation well before the digital era. The work of many performers is also documented through combinations of photography and film determined either by technological and aesthetic choices or else through an element of chance in the available media for documentation: a performance work may have been recorded in still rather than moving images only because, at that moment, its documenter lacked film cameras or cartridges, or else actively sought to experiment with the interstice between the photographic and the filmic. For example, Eikoh Hosoe, who photographed performance in Japan from the 1950s through to the 2010s – most notably, his extended collaboration with the performer Tatsumi Hijikata,

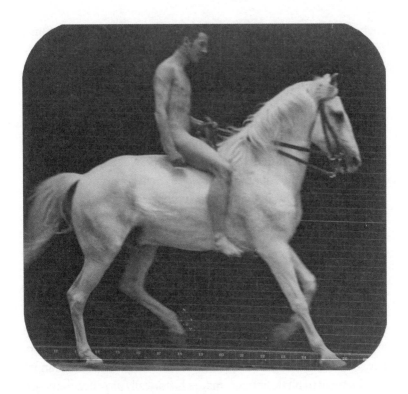

Eadweard Muybridge, *Canter*, 1880s: glass disc.

Kamaitachi (1965–9) – intended the photographic image (in its pub-lished and exhibited forms) to take on specifically filmic dimensions and concerns, such as panoramic projection, gestural exploration and ocular reconfiguration.³ Notably, any sequence of filmic or digital images of performance may be arrested and reduced to its constituent still images. Film and photography in their intricate conjunction with performance are always tightly bound to the pre-occupations of the moving-image innovator Eadweard Muybridge, whose work from the 1880s to the 1890s, with its performative pre-occupations, extended from still to sequential photography of figures

in motion through to moving-image projections of those sequences in proto-cinematic spaces.

Film is often perceived as the medium that pre-eminently secures the future existence of performance. In that scenario, film would possess a firmer hold upon durational time than performance. Although a performance has the capacity to be repeated, no repetition will ever be exactly identical (even if mismatched only by a hair's-breadth gesture), so a performance series could be seen as a set of foreclosed variants around the same preoccupation rather than identical representations able to prolong themselves indefinitely. For that reason, performance may be perceived by its spectators as progressively dissolving into the space in which it is enacted, across its duration, apparently leaving behind nothing tangible beyond disintegrating memories and sensations – except for its residue in the moving image, if it is filmed. The perception of performance as evanescent and fragile crucially pivots around the presence in space of corporeality, whose immediate vanishing, at a performance's lapsing, appears to assign that performance to a voided future. By contrast, film is often seen as a miraculous preservative of performance to the extent that its flawed cryogenic processes become entirely invisible in the act of projection, and the film of a performance then supplants the performance itself; in that perception, any filmed performance could thereby be perpetually reanimated at will, as though performance and film, in their conjunction, had seamlessly meshed. But the bodies held in performance and in film form profoundly different entities. Performance's corporeality is comprehensively reconfigured by film, potentially to the extent of effacing performance's original intentions and its distinctive, defining gestures.

It is not necessarily performance that forms the fragile medium which, in its corporeally instilled occupation of space, lacks any tenacious hold on duration and therefore needs to rely upon

moving-image documentation to secure its endangered future. In many ways, it is instead film itself which is integrally short-lived, with all of its technologies pre-consigned to oblivion. All moving-image media are (and always have been) imminently or already obsolete, and subject to oscillations and arbitrary reversals in their capacity to seize images of the human body; performance art's widespread attachment from the end of the 1960s to newly available video Portapak and instant-playback technologies, in their successive formats, intimates the disparity between a vital or immediate performance act and the inbuilt obsolescence of the moving-image medium chosen to document it, with the result that video-rendered performance art of the early 1970s often appears uniformly blurred and monochrome (the characteristic Acconci 'look'), while earlier celluloid-rendered performance art of the mid-1960s (as in Kren's films) may snap into glaring focus in vivid colour, as though it were by far the more contemporary documentational medium. The unruly and often antithetical components grouped under the term 'film' form an unstable, diverse concoction of technologies and formats whose sole point of alliance is their provisional status and their certainty impendingly of being discarded. In that way, film does not necessarily hold the bodies of performance; bodies slip from film, as they do from space. Film incorporates, instead, a succession of its own performative bodies, always subject to the moving image's volatile dynamics: bodies which could, in a sense, be 'returned' to performance, if performance's essential corporeality is determined to be one entirely generated through the unique spatial act of performance before its recasting into moving-image forms; film's bodies may be transacted back into the domain of performance through an awareness of exactly how film transforms performance, and what elements of corporeality always remain ineradicably bound to performance and its space, and resist being subsumed into film.

As well as forming a fragile, obsolescent entity, film, from its origins, also constituted a distinctively spectral presence and the pre-eminent medium for the conjuring of ghosts. The first audiences for moving images were rarely terrified or driven to flee the auditorium by what they witnessed (such as Muybridge's first projections from glass discs of figures in motion, and the celluloid projections of the Lumière brothers and Skladanowsky brothers); instead, they experienced a dual sense of awed captivation and diabolical out-landishness. From its first manifestations, film formed a spectacular audience-focused performance in its own right that acted upon the eyes and propelled the human body into unprecedented manoeuvres. In that sense, film possesses its own transient and contingent figures; corporeality projects itself no more dependably or enduringly through film than in performance. Even in the digital world that assimilates film or conjures it away, the infinite pervasiveness of pixelated corporeality renders the body in performance as ultimately in-accessible as in earlier forms of moving-image media that attempted to seize it.

Film's own defining transience instils it with the capacity to embody the absences, across time and space, that are essential to the intersections between performance and moving-image media, and to those intersections' inhabitations by corporeality. As films of performance and city-space such as those by Warhol demonstrate, film is able to contain significant intervals of emptiness and silence, and of physical absence; such absences invariably pivot upon the percep-tion of the spectator, for whom a void in time can form either an origin for absorbed reflection and interrogation, or else an attention-fissured inrush of multiple 'real' times. Across performance and film, the moment when there is evidently nothing there, before the eye, is also that at which everything is for the spectator to determine and re-envision. But as soon as corporeality enters the respective time zones of performance and of film, time itself oscillates and

shifts. Corporeality delineates and also exacerbates the essential non-synchronicity and maladjustment interposed between the times of performance and film, and the ways in which such fractures work to intimate and project traces of the body in performance, in their flickering absence and presence.

The moving image's rapport with performance, at least up until the digital era, was characteristically one in which the particular dynamics of corporeal projection issued directly from those disparate, non-aligned durations of performance and film. As a temporal entity, filmed performance, together with its bodies, is always subject to plummets into syncopes, misrecognitions and vanishings. Only in the instances when a performance act was undertaken with exemplary brevity (as, for example, with Burden's split-second Shoot) could the duration of film appear reliably to coincide with that act, albeit with the performance's preparations and residues excised. The capacity of video formats of the 1970s and '80s to assimilate relatively lengthy performance durations proved always subject to their imperative to foreground their own distinct time as recording media, over and beyond the time of performance. Whenever moving-image media edit, overhaul or overrule performance's duration, performance will be altered in ways that highlight the constitution of moving-image media as assemblings and sequencings of individual 'shots'. Performance, in its moving-image rendering, is itself transformed into 'shot'-sequences of temporal fragments, each composed of abbreviated or elongated bodies. In the contemporary moment, the documenting of performances' total, unbroken spans with digital devices appears to signal a historical break from film's overruling of performance's time, but also intimates an aberrant return to the stasis of celluloid film's first fixed-camera recordings of performances in the 1890s and 1900s. Whenever contemporary performance acts are multiply captured with mobile hand-held devices such as iPhones, and instantaneously streamed online, the

unique time of performance passes into a new immediacy of projection in which corporeality may be as absent and lost in time, as in the instances when filmed voids, emptinesses and silences comprised performance's seminal forms.

A distinctive and revelatory manifestation of the human body is invariably projected whenever it simultaneously traverses the domains of performance and film. The following parts of this book explore the intersection of performance and film across city space and its subterranes, via corporeal markings or scarrings, through riotous cultures of protest as performance, and in digital media's engulfing of space and of space's animating or obliterated bodies, whose residues often form the lost films of performance. In all of those manifestations, the conjunction of performance and film is also a privileged and sensitized site that vitally discloses ecological, political and social preoccupations, visions and contestations.

Performance's Elsewheres: Rooftops, Courtyards, Subterranean Spaces

Performance is predominantly a city-located medium in its intersection with film and moving-image media, whose images propel the gestures and acts of performance against and across the space of cities, as well as amassing those gestural acts into moving-image sequences that form amalgams with multiple, shifting city-traces, including graffiti, hoardings and screens. Whenever performance takes place in an external city space – in such forms as performance art enacted in plazas and pivotal sites of extreme visibility, or else through aberrant corporeal acts ephemerally performed in those same exposed sites – it is open to infinite filmic capture from all directions and at all moments, and is integrally bound with that city space. But performance is also always 'elsewhere' in relation to that space and in its relation to moving-image forms: it is never seizably locatable, and can take place also in peripheral and interstitial city spaces in which seminal experimentation in flux between performance and film has often been maximally at stake across moving-image history: hidden courtyards, infiltratable subterranes, wastelands. Even enclosed within an auditorium, performance is always inflected in some way by the city surrounding it, through the barest sonic trace from outside, or the city-imprinted bodies of entering spectators. This part of the book is mainly concerned with filmed performance in city space in its many manifestations. Whenever a film camera registers even a fragment of its duration and environment, or a flickering residue of its bodies within semi-darkness, performance in city

space is immediately inhabited by the domain of film, and an intricate and unfixed rapport emerges in which performance is not an isolated entity, but one rendered open to the transmutating revelations and potential confrontations of corporeal acts in contact both with film and city space.

In order to explore the contemporary forms of performance in its rapport with film and moving-image media, a journey back to the origins of film-making and film projection is required – and what becomes evident, on that journey, is that performance acts always formed a primary focus and preoccupation of film from the very first filmic sequences, and that performance was primarily conceived by film-makers in the form of ocular spectacles that needed to be documented within city spaces: often locations with expansive, panoramic dimensions, and sites in upheaval, with the corporeal capacity to induce momentary mass-convergences, including those of spectators. From film's first instants, city space forms the presence that instils a dynamic tension into the rapport between performance and moving-image forms. But that journey of reversal through time, in order to view performance's intersections with film from within those originating instants, is never linear, perpetually sent askew by the image-marked detritus of past time. The rapport between performance and film, enacted across city space, eludes the form of a cogent corporeal act or a flawless image sequence. In many ways, it instead takes the form of the many thousands of moving-image sequences assembled for vast-scale book publication and eventual public projection in glass-disc media by Eadweard Muybridge, through his extended pre-filmic experiments with multiple cameras at the University of Pennsylvania, always inflected to some degree by the surrounding city space of Philadelphia; Muybridge – for reasons of veracity, or perversity – often incorporated into his resulting sequences flawed or displaced bodies, void or blurred elements (recorded by misfiring cameras) in which only a spectral corporeal

omission could be discerned, and ruined or jarred images that negated linear perception, as though those off-kilter, malfunctioned bodies and images formed his work's essential focus. The historical rapport between performance and film – in its capacity to illuminate the future status and entity of the human body, in its performative dimensions – resists linear narration, and its determining images often demand to be irrecuperably torn from the films that once appeared to hold them.

In addition to that malfunctioned linear or horizontal axis, backwards through time, the tracing of performance's intersections with film also entails explorations of vertically oriented transits – upwardly oriented gazing, and falls from buildings in vertiginous plummetings through city space – that also evoke the precarious tightrope-walking manoeuvres, and the potential dangers for representation, that have been integral to performance's relationship with film. Performance no longer forms a stable medium (if it ever originally was) once it is connected with film, and is meshed too, through that process, with the city space that surrounds it: performance's bodies may then become subject to repeated and accelerated falls through vertical space. And those filmed bodies also attain a spatial flexibility and spectral penetrability in performance that casts them outside cities' recognizable central zones: they enter the time-drained and occluded back courtyards of buildings, ascend to rooftops for optimum solar irradiation and descend to subterranes that may entail light-starved experiences of disintegration and madness. As with the malfunction-instilled, non-linear relationship of time to performance's rapport with film, space, too, is in wayward juxtaposition to filmed performance, and may take the eye on vertigo-propelled, deranged journeys. The human figure forms a mutable, transiting presence in such temporal and spatial disorientations; it may vanish altogether, split or proliferate in acts of transformation or duplicity, as it has from film's first renderings of performance.

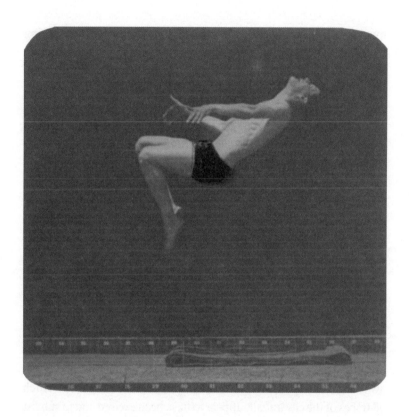

Eadweard Muybridge, *Somersault*, 1880s: glass disc.

Many of those spatio-temporal and corporeal journeys located in this book take place within the distinctive environment and history of Berlin, which provides the ideal conditions for spatial interrogations – including those with a subterranean axis – of performance's intricate intersections with film, from the early 1890s origination of celluloid film as a medium conceived by its experimenters (at least in part) to document performance, to the contemporary moment. In that sense, Berlin forms a sustaining city presence that balances the high-wire disequilibriums endemic to performance and film. But each

moving-image sequence that traces with intimate tactility the shifting contours of performance's bodies could equally well be located in the space of any other city, as long as that space possessed the fragmented and disjunctive zones in which performance's intersection with film thrives. In that sense, those potential, interchangeable spaces are the globally located 'elsewhere' spaces that Siegfried Kracauer invokes in the title for his book of performative, on-foot traversals of Berlin from the late 1920s and early '30s, *Streets of Berlin and Elsewhere* (which veer, in that context of their 'outlandish' dimensions, to the space of Paris). Spaces can be torn from any city environment, just as moving-image sequences may be non-narratively wrenched out of any film in order to probe the performative city movements of human bodies.

Filmed acts of performance inhabit the distinctive spatial dynamics of city space, and are subject to the ocular and corporeal movements of performers, spectators and film-makers that orient themselves across that space: within and against and above and below it. But, as a formative aberration for the intersection between performance and film, such acts may also be expelled, to the maximum degree, away from city space, and relocated in an exterior zone from which all traces of the city initially appear to have been excised and to subsist only in their barest residues, if at all, or seem never to have existed in the first place. Performance in such environments may abruptly emerge from the domain of another art form, such as earth art or land art, or it may be generated, almost against its will, from seismic historical layers which convulse a space. Film acquires a privileged status in relation to such performances, situated far outside city space, since their isolation means they will rarely be attended either by intentional or accidental spectators (audiences would need to make an exceptional journey, or be subject to exceptional chance, to be present) and such performances' trace, for future time, will primarily take on a moving-image form. The surrounding 'natural'

landscapes – rivers, lakes, mountains, forests – or environmental backdrops of such performances form shifting, mutating surfaces in their rendering by film: in effect, projection screens, whose content is determined in part by the eye of the film viewer, so attuned to assimilating the pervasive traces of city space that their apparent absence or expulsion compels the eye to search for and conjure those traces around the performer's body.

The backdrop for performance and the projection screen for film are both at stake in a sequence of the film Spiral Jetty, shot by Robert Smithson following the installation of his immense spiral construction, in the form of basalt-rock fragments, extending out into the water at an isolated point on the shore of the Great Salt Lake in Utah in April 1970. In one sequence of the 32-minute film, whose voiceover reflects on the status of spirals as a focus for obsessional preoccupations with time and knowledge, Smithson performed an act of running along the entire spiral's course, from the lake's shore to the spiral's internal vanishing point. Smithson's performance was shot from above by a cinematographer located in a helicopter; from time to time, Smithson, his figure clearly visible in a white shirt, glances vertically upwards towards the helicopter as it intimately follows his circuitous transit of the spiral, until he reaches its end and stands exhausted, buffeted from above by pulses of air from the still-hovering helicopter. Smithson's corporeal performance – undertaken apparently without spectators (apart from the cinematographer) and solely to be filmed – explores the time and space of the just-created artwork; in the Spiral Jetty film, that performance forms an amalgam with his spoken reflections on the status of spirals. At first sight, it is a performance beyond city space in an isolated landscape of Smithson's own reconception. Even the traces of the jetty's construction and filming – the cars at the lakeside and the track leading to it, the cacophony and shadows of the helicopter itself – do not amount to a direct invocation of the city. But at the film's end,

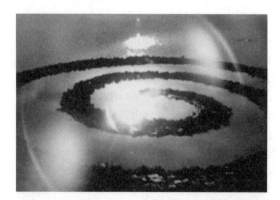

Robert Smithson,
Spiral Jetty, 1970:
film-images.

Smithson reveals the material through which his film was created
in a sequence showing the studio in New York in which celluloid
film cans, spools and an editing bench are arranged as a detrital
presence that mirrors the lake and the spiral construction itself; in
a text accompanying his film, Smithson writes of his return from
the spiral to the 'desert' of New York in which the film finally comes
into being, ready for projection on a screen.[4] And, in its contemporary
art-museum projection, that film possesses a tangible city-space
framework for its exhibition, for example in Berlin's Hamburger
Bahnhof art museum, where it is endlessly projected in a digital

Joseph Nadj, *Last Landscape*, 2006: film-images.

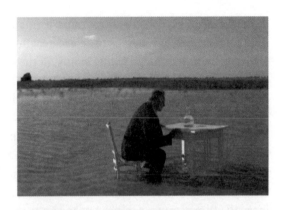

loop on a large screen in a darkened and otherwise empty gallery, so that Smithson's corporeal performance – spiral-running his construction – is finally exposed to immediate city space as well as to the conditions of light, noise, smell and touch in which it was enacted in 1970.

In *Last Landscape* (2006), a film by the prominent performance artist and choreographer Josef Nadj, the bed of the river Tisa in northern Serbia forms the city-voided exterior focus for moving-image sequences in which Nadj, over an extended period of time, first inhabits the shallow river by installing a table and chair within

it, then executes a convulsive act of performance art on the river's drained mud-bed as it begins to desiccate, and finally explores that site again in its ice-frozen winter status. At the film's opening, Nadj draws a map of the river (a Danube tributary) in its location at the heart of Europe's historical uproar and of the destructions and depopulations of its cities before making his journey to the river itself. Although the film is Nadj's, assigned to him as performer/filmmaker just as the Spiral Jetty film is assigned to Smithson, his body in performance, excavating the mud-plain around the Tisa, is always shot from a distance or in panoramic transits, often frontally as he faces the film camera, against a near-empty backdrop. No trace of human construction appears in the river sequences, apart from a small stone pumping station on the river's shore, and all evidence of cities appears to have vanished. But in the film's concentration on Nadj's convulsive movements on the Tisa riverbed, inspired by his choreographic work in Japan with ankoku butoh choreographers, and his corporeal immersal in that river's mud, his figure may perversely embody the dissolution and fall of all cities, across Europe and worldwide.

Whenever city space appears absent and voided in film's rendering of performance and its environment or backdrop, the viewer is compelled to imagine and investigate that absence, and reconfigure the traces and evidence of cities, around human figures in the act of performance. The intersection of performance and film is irresistibly conjoined with city space, even in that space's apparent maximal erasure or separation; as a location for filmed performance, landscape – whether despoiled or pristine – is invariably sited at the last moment before its reversion to the domain-in-flux of city space. Above all, the perceptions and sensations that acts of performance serve to materialize in space are always subject to whatever film, or the viewer's eye, accentuate, relocate and sift out, even and especially against the grain of performance's original intentions. And once

the corporeality of performance becomes transacted into a moving-image medium for projection – from the first film projections of 1895, on their journey towards the contemporary moment – it forms another, 'elsewhere' entity, always in intimacy with, or engulfed by, city space.

Performance and film both pivot around the human body; the binding ligature between the two forms is corporeally made of gestures, enactments, movements, falls, assaults, transformations, vanishings. But the material of film – revealed by Robert Smithson at the end of his *Spiral Jetty* film in the form of celluloid spools and editing devices in a studio workshop – is distinct from the material of performance, in its form of props, scenery or other objects that may be assembled in warehouses adjacent to the auditoria of performance, or else improvised in the performance-space itself. Those objects surrounding or (more vitally) held by performers have not encountered any fundamental change for millennia; only the presence, across the twentieth century and expansively so in the contemporary moment, of moving-image projections as determining scenographic elements within an ongoing performance space, accompanying and intersecting with the corporeal, have created upheaval in that spatial arena. But film began to take on its distinctive identity as a medium for the documentation and exploration of performance at a particular moment, in 1893, with the widescale availability of celluloid film capable of holding and eventually projecting moving-image sequences, and the resultant severing of film from still photography. In that same year, with the moving-image projection experiments at the Chicago World's Columbian Exposition by Eadweard Muybridge and Ottomar Anschütz, the parameters for film spectatorship also started to coalesce; although Muybridge still used 'archaic' moving-image materials (he was still projecting from glass discs) rather than celluloid, he created a dedicated moving-image projection-

space, his Zoopraxographical Hall, which audiences entered – paying a fee along the way – in the same way that they would enter a performance space, focusing their attention collectively and frontally onto a projection screen, positioned in the same location within the space at which a human figure would habitually appear in order to initiate a performance. For every act of projection, Muybridge himself appeared directly alongside his Chicago Exposition screen to perform a lecture exposition that inhabited the same time and space as his moving-image sequences' projection.

The contemporary rapport between performance and film is as enmeshed and duplicitous as its originating instant and space; but from that first instant, film directly seized performance. The Berlin-based moving-image innovators Max and Emil Skladanowsky retrospectively assigned the date 1892 to their first celluloid film of performance made with a view to public projection, but that film could equally have been made a year or two later, and fraudulently backdated; habituated to working in external city space, the brothers ascended to the rooftop of a multi-storeyed apartment building on the Schönhauser Allee in northern Berlin, and for several seconds one brother filmed the other, exposed in direct sunlight and casting the first haunted shadow of cinema, in the act of performing a maladroit dance – part outlandish, improvised choreography, part gymnastic exercise – against a backdrop of steeples and factory chimneys. Until that moment, the Skladanowsky brothers had been magicians, entrepreneurs, tricksters, restless tourers of Europe or magic-lantern projectionists, but that multiple status abruptly cohered, on the Berlin rooftop, into a new and unique entity: they became film-makers, of performance. That spectacular corporeal performance was not dependent on the presence of any spectators in order to be filmed; the brothers were well aware of the capacity for their innovation to be surreptitiously stolen from them (just as they stole elements for the ongoing concoction of film from other

Max Skladanowsky and Emil Skladanowsky, *Apotheosis*, 1895: film-image.

innovators), so it formed a covert act, subject to the maximum suppression of visibility until it could be publicly demonstrated. But that experiment oriented towards public projection then endured a deferral for an extended period while the brothers designed a celluloid film projector – the Bioskop – and attempted to locate a projection space; that initial film of performance remained permanently unprojected, barely surviving only in the form of a few fire-edged celluloid frames conserved in an archive.

In contrast with the occluded visibility of their first experiment with filmed performance, the films shot by the Skladanowsky brothers in the summer of 1895 for public projection later that year held an optimal, extreme openness. During that summer, they filmed sequences of many of the prominent performers then active in Berlin: magicians, dancers, jugglers, acrobats. To render those figures with the greatest contrast and depth of shadow, the sequences were shot in the sunlit open air in the gardens of performance venues; to maximize publicity for their new experiments, the brothers made no secret of their film-making, instead actively soliciting the attention of the owners of prominent performance venues, since they intended

to project their films in pre-existing auditoria rather than in the form of a specially designed space such as the one Muybridge had conceived for his Chicago moving-image projections two years earlier. On 1 November 1895, and then throughout that month, the Skladanowsky brothers used their own Bioskop projector to show a 15-minute programme of celluloid films – all of them films of performances, including a final film in which the brothers appeared from beyond either side of the projection screen to receive their audience's adulation – in the Wintergarten ballroom of the Central Hotel, on the Friedrichstrasse, the avenue along which all of that era's innovative visual spectacles took place; the projection was positioned as the last element of a 3-hour programme of live performances in the same idiom as the films' content, and its spectators, who sat around tables in the auditorium – their attention focused on the projection screen which occupied a space habitually devoted to performance – switched near-instantaneously from watching performances to watching films of performances (according to newspaper reviews of the time, that experience possessed spectral, outlandish, even diabolical dimensions).[5] The Skladanowsky brothers enacted the first public projection of celluloid films in a form directly prefiguring the spatial and temporal cinematic experience that would become pre-eminent for the next century or so by showing non-narrative, fragmentary films of performance; in the following month, December 1895, their projection technologies and films were immediately surpassed and rendered obsolete by the first public projections of the Lumière brothers in Paris, and by March 1897, after touring their films across several European countries, the Skladanowsky brothers abandoned the medium of film with a final projection of new films – principally cityscapes of Berlin, notably of the Alexanderplatz – at the Zentralhallen performance venue in the German port of Stettin.

As the first film-makers of performance, the Skladanowsky brothers' tightrope transit through the tumultuous mid-1890s period

Thomas Edison and
W.K.L. Dickson,
Sandow, 1894:
film-image.

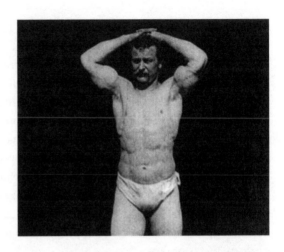

of film-making and film projection emanates accelerating catastrophe,
as though it were a performance whose initiatory moment of glory
necessarily induces disintegration and oblivion; the Skladanowsky
brothers became peripheral, forgotten figures until the mid-1930s,
when the National Socialists briefly returned them to public promin-
ence, and Hitler attended a projection of their Wintergarten-era
performance films. Their work also notably intimates the duplicity
and doubling which is essential to film's amalgam with performance.
Within their programme of films shown at the Wintergarten ballroom,
the Skladanowsky brothers included a film entitled *Wrestlers: Greiner
and Sandow*, intimating that one of the two combatants shown in
that film was the then-celebrated German bodybuilder and wrestler
Eugen Sandow, who had already been filmed in the USA, performing
spectacular muscular demonstrations with an insouciant air, on 6
March 1894, by the inventor assigned by Thomas Edison to experiment
with moving images, William Dickson, together with Dickson's cine-
matographer, William Heisse; that Edison moving-image sequence
had then been widely seen in European as well as American cities,
including Berlin, as one of the films displayed in the single-viewer

Kinetoscope arcade-devices patented by Edison. The far less muscular body of the counterfeit 'Sandow', seen performing a wrestling bout in the Skladanowsky brothers' own film, is entirely mismatched from the real Sandow who had been filmed in the USA. Through that seminal figure of the bogus, fraudulently invoked 'Sandow' in the Skladanowsky brothers' film, a formative duplicity and corporeal disjuncture are set to work, dating from the origins of film's distillation of performance, and extending to the contemporary moment and the digital moving-image rendering of acts of performance. Alongside film's salutary documentation and memorialization of ephemeral performance, it integrally enacts – at the same instant – an underhand subterfuge and conjuration in appropriating and transmutating performance's bodies.

In its approach to performance, film may be disconnected from linear narrative, as in the Skladanowsky brothers' performance fragments, thereby revealing the essential dynamics of processes that intersect performance, film and space, notably in the central areas of cities, but also in their more peripheral zones; new manifestations and amalgams of narration are generated from such concentrated disconnections of linear narrative in the form of abrupt illuminations of corporeal and vocal gesture, sudden amassings and dispersals of audiences, and city space torn open, exposing its subterranes as if to an autopsy. Film was never intended by its 1890s innovators to encapsulate or to synchronize itself with the linear duration of performance; as Muybridge's formative work demonstrates, it was concerned with sequencing, animation and discontinuity in its rendering of performance acts, as well as with the perception of repetition in the loop-projection for spectators of the resulting films (each performance film of the Skladanowsky brothers was repeated numerous times, at their Wintergarten projection event). In that sense, performance and film are notably engaged in one of their maximal, often disjunctive interfacings in the period from the mid-1890s to

the early 1930s, when industrial cinema's synchronized sound began to bring about invisible conjoinings of performance and film that are prescient, in some ways, of the widespread contemporary perception of moving-image performance documentation as performance itself. By extracting sequences from fiction films of the early 1930s – when sound synchronization often remained jarring – and stripping them of their narrative congruency, the abrasive immediacy of the rapport between performance and film can be revivified, together with the pivotal role of city space in accentuating that rapport; such performance sequences may be located both in the panoramically eye-oriented central plazas of cities, and in hidden back courtyards where the habitual ocular dynamics of city space are missing or were never installed.

Thirty-five years after the Skladanowsky brothers' filming of Berlin's central Alexanderplatz in 1896 for their final projection events, that plaza became the locus for Phil Jutzi's film Berlin Alexanderplatz, drawn from Döblin's novel of the perceptual disintegration of city space, and co-scripted by Döblin himself; the film was shot very rapidly, on location, across the months of May and June 1931. In two sequences of the film, the criminal street hawker Franz Biberkopf performs vocal monologues against a hoarding-saturated wall of wooden boards that partly hides from view the ongoing reconstruction of the plaza, into which deep subterranean shafts and vast excavations are being dug for new city-transit systems and buildings. Biberkopf's performance space is entirely generated by the upheaval of the city itself; at the same time that he locates his performance at the city's heart, it is also taking place in an interstitial wasteland that has come into existence and visibility through the plaza's ongoing transmutation, and will soon disappear again. Biberkopf's rawly recorded monologues are purely sonic and directive; although those monologues insistently invoke the consumer frenzy of the surrounding city space, what he himself has to sell – tie clips

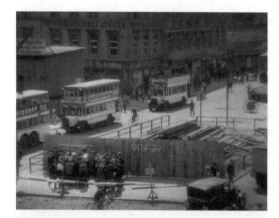

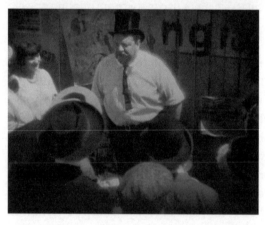

Phil Jutzi, *Berlin Alexanderplatz*, 1931: film-images.

in the first sequence, model toys in the second – are void artefacts, and he makes no sales. That voiding of his monologue's ostensible mercenary remit propels his spectators' attention instead onto Biberkopf's body and voice; that attention is absorbed into his gestural presence and vocal expulsions, which oscillate between drawing his spectators' focus further into performative corporeality, with its sonic manifestations, and directing that focus outwards again, as Biberkopf orients his commentary towards elements of

Phil Jutzi, *Berlin Alexanderplatz*, 1931: film-images.

the cityscape around him and the grotesque or authoritarian figures inhabiting it. The film camera duly follows Biberkopf's directions, either locating those figures as they transit the adjacent city space, or else exploring the subterranean excavations which surround him and his audience.

Biberkopf's figure is the exact inverse to that of the Skladanowsky brother who was filmed in isolation, without an audience beyond a lone cinematographer, performing choreographic gestures on a

building's sunlit rooftop: Biberkopf's shadowed performance is intended solely to generate and then preoccupy an audience, which will only stand before him until their attention is shattered by a competing spectacle. A key function of the Alexanderplatz sequences is to demonstrate the ways in which film adeptly captures the accumulation of an audience before a spectacle which is already ongoing, having been initiated by Biberkopf's body and voice in announcing his presence in that particular site. His performance – simultaneously invoking his own body, and the space of the city around him – is already beginning, but because Biberkopf appears set to stand all day in the plaza, giving innumerably repeated performances with the same content, each performance must be perpetually abandoned and a new one announced to generate a renewed audience. Individual film shots in each of the two sequences serve to accentuate the way in which an audience amasses in external city space: an initial scattering of spectators is drawn by the performer's body or voice, then a crowd abruptly proliferates, gathering before Biberkopf in a state of excitement. In its relation to that performance, film focuses on the spectatorial dynamics of collection, of contact between audience members, and of concentration. In order to intensify that audience's attention, Biberkopf stands directly before a backdrop that simultaneously functions as a projection screen, merging with and mediating his own body, and comprised of hoardings with a dynamically inassimilable content; as well as advertising performance venues designed for spectacle and pleasure, these hoardings announce political meetings and officially forbid Biberkopf's performance even as it takes place. From that hoarding screen, Biberkopf propels his voice into the physical presence of his audience.

In the first plaza-located sequence of Berlin Alexanderplatz, Biberkopf pre-empts the imminent and inescapable lapsing of his audience's attention, abruptly abandoning his performance as soon as he catches sight of the figure of the prostitute Cilly, who has suddenly appeared

at the back of the audience, in a state of disruptive laughter, to form the element which will annul that audience. Biberkopf immediately detaches himself from his hoarding screen and traverses his own audience to its far side in order to make an assignation with Cilly. The audience is now stranded in external city space, with nothing to see or hear, expelled from Biberkopf's performance and dispossessed of their status as an audience, in a parallel way to that in which, in Romeo Castellucci's theatre production *Hyperion: Letters of a Terrorist* (2013), the entire audience is abruptly expelled from the auditorium, physically and vocally, by riot police who announce: 'There is nothing to see'; those spectators end up, their entity as an audience overturned, dispersed into an alley outside the auditorium, unsure what will happen next, if anything. In the sequence of Biberkopf's amassing and conjuring away of the audience for his performance, the in-flux corporeal and ocular movements of that audience are anatomized by film with an intimate attention to spectatorial vision and its closure that only film can impart to the manifestations of performance. In the second of the two sequences filmed in the space of the Alexanderplatz, Biberkopf concentrates his amassed audience's attention by pointing to the absence of one of his arms (lost during a botched robbery between the two sequences). In that second sequence, the enduring remains of Biberkopf's body are displayed in vocal performance as he stands before his hoarding-screen backdrop; only his arm has vanished, but Biberkopf's focus on that defining corporeal absence sharpens his audience's attention.

Performance forms the medium that, propelled by film's aberrant manoeuvres, traverses city space in *Berlin Alexanderplatz* from one locational extreme to another. The filmic narration of the journeys, of performers and audiences, between those sites, is cast into ellipsis; their spatial orientation and status scrambled, those figures find themselves abruptly relocated from the central plaza of the city to

its most occluded, straitened zones, and back again. While Biberkopf's chosen site for performance in the upheaval-generated wasteland at the city's Alexanderplatz heart endures across two sequences within that film, the displaced site of the back courtyard – inhabited by the most poverty-stricken populations of Berlin's tenements, along with the mentally ill, beggars, activists and refugees – sustains itself from film to film in the early 1930s, and through to the '70s and '80s. The back courtyard forms the site furthest removed from public vision and its open performative arenas; to enter the back courtyard already requires an act of reluctant infiltration from the street, and a passage through however many courtyards the tenement possesses (up to six or seven, in the worker districts of northern Berlin constructed in the late nineteenth century, with tenements frequently amalgamated with improvised factories or workshops), until the terminal space is reached, often near-excluded from daylight and screened by a vast brick firewall from adjacent tenements. That screen, as with the hoarding screen sited by Biberkopf to corporeally project his Alexanderplatz performances, forms the backdrop for itinerant musicians, magicians or acrobats, but unlike the Alexanderplatz screen, it holds no image or text other than an official declaration forbidding all performance, thereby rendering it the optimum venue for last-ditch, desperate manifestations of performance. Instead of hoardings, that screen is marked with traces of ruination and the absence of time.

In *Berlin Alexanderplatz*, Biberkopf inhabits the back courtyard, but initially as a spectator rather than a performer. He stands directly within the courtyard, viewing a performance – enacted alongside a wall-affixed notice outlawing all performance (and begging) – by the prostitute Sonja and her accompanist (an accordionist with dark glasses, and a handwritten sign across his chest announcing that he is 'fully blinded'); but apart from Biberkopf's sensorially engaged spectatorial role, and several limbo figures who accidentally traverse

the courtyard during the performance, most of the remainder of the involuntary audience for that performance are hidden inside their apartments, glimpsed only when they appear at their windows to gaze down or throw small coins that plummet to the performer's feet. The sheer, visionless parameters of that performance space are delineated by shots that track vertically up and down the cracked, damp-peeling walls of the courtyard, occasionally catching fragments of acts (an undressing, for example) undertaken in the near-dark interiors. The Alexanderplatz sequences' filmic mapping of open spectatorial dynamics, in following the abrupt amassing and dispersal of external-space audiences, is precluded by the tight captivity enforced by those walls; the audience for Sonja's performance is fixed and static, and will endure, resident in that space, long after the performance has evanesced. That audience must remain sonically intimate with the performance, unless it closes its windows, and – whatever the level of disinterest or oblivion the performance incites – appears still driven intermittently to gaze down from those windows, in a form of compulsive spectatorship of performance, poised between internal and external space, that was analysed by Kurt Kren in his film *Window-Gazers, Rubbish, etc.* (1962). Such habituated spectators *live with* performance and therefore do not need actively to collect together as an audience, remaining in a tangential condition in relation to each instance of performance; as such, they cannot be collectively abandoned in the way that Biberkopf adroitly renders his intently focused Alexanderplatz audience obsolete, and nor can they be coherently filmed, since they make themselves near invisible, as though endangered by a potential fall into the performance space.

Biberkopf rapidly disrupts the already ongoing performance of Sonja; instead of dropping coins around the feet of the performer and allowing the habitual monetary regime of the spectacle to continue, he incites Sonja to approach him, just as, in the space of the Alexanderplatz, he lures his audience into momentary existence

with corporeal and vocal exclamations. Corporeality itself forms the medium of oscillation that allows the spectator's status to be abruptly transmutated into that of the performer; Sonja is forced to approach Biberkopf and undertake a sequence of gestures to extract coins from his pocket (which Biberkopf himself claims not to be able to access, performatively gesturing absence with his missing arm), return them to the pocket, then extract them a second time, thereby dissolving the momentum of her own performance across that intricate gestural sequence. Through his sabotage transaction, Biberkopf seizes control of the performance; observing the danger that the remit of performance is moving beyond his supervision, Sonja's ostensibly blind accordionist sullenly crosses the courtyard to approach Biberkopf in an attempt to arrest that sabotage, thereby revealing the duplicity of his blindness. Through the resulting exchange, in which Biberkopf sexually appropriates the performer by making an imminent assignation with Sonja in another location, that particular performance is annulled, and all of Sonja's future performances will also no longer take place (to concertina narrative: Sonja, renamed Mieze, will soon be murdered by one of Biberkopf's criminal associates); but that act of overturning an instance of back-courtyard performance will not end it as a distinctive filmed-performance entity, which is dependent solely on the endurance and infiltratability of its impossible spatial location, rather than on performer or audience.

In the early 1930s moment of performance's external-space filming – during which film-sound often remained still deficient in firmly coalescing with the moving image, or proved enduringly resistant to that process – the location of the tenement back courtyard forms a significant space for signalling the presence of performative corporeality, subjected to a regime of intense pressure that manifests itself along vertical as well as horizontal axes. Film sound, as the

spatially oriented marking of performance, leaks from the exterior to the interior and back again: for example, from the roofless courtyard into the vertical tiers of surrounding apartments, inhabited by spectators who are always sonically implicated in the itinerant performance taking place below, as much as they repudiate it. Once such representations of spatial volatility became more rare, over the following years, as performance and film meshed in industrial cinema, the dynamic of an abrasive rapport between performance and film diminished until it was reignited through performance art and experimental film intersections of the 1960s and '70s. Only a year after *Berlin Alexanderplatz*, the collaborative film of Brecht with Slatan Dudow, *Kuhle Wampe* (Empty-Belly Camp, 1932), again located its pivotal performative sequence in that Berlin back-courtyard space, but now repositioned it within the framework of activist cinema, in the era of acute political transmutation that led, in the following year, to the forbidding of the film by the newly elected National Socialist government and the dispersal beyond Germany of its makers.

An unemployed, anonymous youth ceaselessly transits the avenues of the city at speed, by bicycle, in search of temporary manual work; gradually, that interrogatory tension, mediated by headlong movements across space, shifts into voided, stilled exhaustion, with the incapacity of those transits to generate work, and the youth returns to the desolate tenement where he lives with his parents and sister. Already, as he slowly enters the building from the street, a cacophony seeps from the back courtyard; one musician gratingly plays an old saw, as though generating last-breath noise from the city's detritus, alongside a figure seated at a harmonium. As with *Berlin Alexanderplatz*, the film camera vertically studies the cracked surfaces and windows of the courtyard, but only two downturned faces can be located, and the musicians face a blank wall rather than an audience. As he crosses the courtyard, the youth stops, and stands with his bicycle in the otherwise empty space, gazing at the threadbare

Slatan Dudow and
Bertolt Brecht,
Kuhle Wampe
(Empty-Belly
Camp), 1932:
film-images.

performance for 15 seconds and thereby constituting its sole spectator; but he is unable to confirm or disrupt its status as a performance through the kind of financial transaction that Biberkopf initiates. He then ascends to his family's apartment; his parents and sister conduct an argument about his unemployed status in which he silently takes no part, and once the room has emptied, he removes his watch, climbs to the window ledge and plummets to his death in the courtyard, where the cacophonic performance has recently lapsed, or may still be sawn-out even as he falls, rendered silent only within his own perception. That split-second, vertiginous fall generates its own form of performance in which redundant corporeality is transacted via death into spectacular corporeality, its momentary efficacy in generating an audience confirmed by the crowd of excited spectators, three deep, which immediately gathers around his fallen body in the confines of the courtyard to comment on the act as one creating absence (one workless man less) and speculating on the exact location of the window from which that fall was launched.

Film's tracking of falls into death, from its early decades, comprises a seminal preoccupation extending through to contemporary moving-image forms, manifested, for example, in Eric Steel's film *The Bridge* (2006), in which the film-maker and his multiple cinematographers spent an entire year waiting beside the Golden Gate bridge in San Francisco for suicidal figures to fall – occasionally taking performative leaps, as though for potential filmic documentation or for the benefit of their audience of passers-by – in order to contain those falls within 4-second moving-image sequences, but in which the erratically falling body often eludes the capacity of film to hold it for most of its transit; digital moving-image formats enabled those cinematographers, awaiting death, to shoot around 10,000 hours of dead-time moving images, surrounding 23 sudden plummets. In many ways, film as a medium also carries the momentum of

vertical plummeting that it frequently aimed to seize, in corporeal contexts, in films such as that of Brecht and Dudow; film's history, as its rapport with performance intimates, is never linear, but obstinately enacts its own downfalls (its ossification into studio-system formations and generic styles; its barely opposed supplanting by digital-media forms) as a sequence of plummetings, enacted across a duration which, in contrast with that of performance, is violently abbreviated. And film, from its origins and via its attuning to losses of time and memory, formed a medium uniquely sensitized to the corporeal manifestation and performance of death.

Following the back-courtyard fall into death of the silent, anonymous figure, his family's survivors must leave their tenement apartment; their poverty is such that even the sectors of the city assigned to its most denuded, excluded or displaced inhabitants expel them, and in an ultimate 'descent', that family travels to the 'empty belly' camp for the homeless in the terrain of forests and lakes at the city's peripheries. That terrain, as well as being strangely Edenic, forms the exposed location of open-air activist performance in which mass spectacles of socialist workers' theatre, surrounded by packed, entranced crowds, are performed as annexes to sports events; but those spectacles of 1932, together with the lakeside camp itself, are at their precipice moment, and will imminently be razed, together with many other performance and city-located cultures, in the following years' National Socialist suppressions. Beyond its intentional trackings of corporeal falls in such ocularly focused spectatorial arenas as the tenement back courtyard, film involuntarily scans historical falls into calamity, together with the performances that mark the acute elation and extremity of such moments, before performance's vanishing.

Performances undertaken in constricted, occluded city-space zones such as the back courtyards of tenement buildings enduringly formed

focal points for film's explorations both of audiences' amassings and dispersals, and also of the dynamics of performance that allied it, as though inescapably in such spaces, with film. Following a dead-time syncope of 45 years, the Berlin back courtyard manifested itself again in a sequence from Werner Herzog's film *Stroszek* (1977), with Herzog's preferred performer Bruno Schleinstein ('Bruno S.'), in which Stroszek walks down the centre of an empty, frozen street in West Berlin, pulling a cart holding his accordion and xylophone, to access the particular back courtyard which he has chosen for his performance. That performance, in distinction to the back-courtyard spectacles filmed in the early 1930s, emanates the sense of a last-ditch act, in the process of being seized by film, just before it deliquesces into obsolescence; soon, no such performance will be tenable any longer. Stroszek enters the space of the building simply by pushing on its door, which is unlocked; he is able to carry through a spatial infiltration that signals the open interconnecting of performance, film and city space whose enacting, across infinite variants and permutations, always transforms each of those three entities. Shut-down space momentarily mutates into open space, through performance's insurgence into and across it. In the next shot, Stroszek has re-entered external space, in the form of the open-air back courtyard, and is surrounded by identical precipice walls to those of the sequences of Jutzi and Brecht/Dudow. But rather than panning vertically up and down the walls, as in those earlier films, Herzog's film camera horizontally circles them in a spiral manoeuvre, inducing the vertigo that invariably precedes a city-located plummeting; in the course of that spiral transit, Herzog accumulates the spare traces of the performance's spectators. Still more so than the captive audience for the earlier back-courtyard performance films, Stroszek's audience appears oriented to oblivion and disinterest, but remains still compelled to gaze down in anticipation of the imminent spectacle; the film camera isolates pairs of spectators at two separate balconies, half-hidden by

Werner Herzog,
Stroszek, 1977:
film-images.

cigarette smoke and in the process of disappearance (withdrawing from exterior to interior) even as they are filmed. In the courtyard space itself, two children are present, poised against a doorway at the space's edge, to watch the spectacle at a tangent, with acute concentration.

As soon as Stroszek's performance begins – firstly with a xylophonic improvisation, then in the form of a shouted-out song which entails added vocal improvisation for each of its narrative-fragment elements – the film camera's position shifts to one directly in front of the performing figure, who orients his performance simultaneously to that documenting presence (as with the rooftop Skladanowsky brother, performing directly in front of, and for, the film camera), as well as to the audience of ground-level children and elevated, window-gazing spectators; the corporeal intimacy between film camera and performer is splintered by that disjuncture between the performance's intended spectators. Stroszek's body is screened and projected forwards by a rear wall, as with that which propels Biberkopf's figure towards his audience in *Berlin Alexanderplatz*, but Stroszek's wall surface has disintegrated to the point that it can barely hold decades-old posters forbidding courtyard performances and other subversions of that space. Any possibility of the audience for the performance sanctioning it financially, for example through the throwing from windows of small coins at Stroszek's feet, appears foreclosed, but that performance is abbreviated and abandoned by Herzog's filmic rendering of it (cut in mid-performance, leaving behind only its xylophonic element) rather than through any decision of Stroszek, or of Bruno S., to curtail it. In the next shot, following that elision of performance, Stroszek has already packed his instruments back onto his cart and now abruptly exits the courtyard door; two children accompany his transit, while a third remains in the courtyard and resolutely turns his face against the film camera, as though negating all spectatorship.

Film works to seize and archive performance forms and the city spaces they distinctively inhabit at the instant before such forms and locations cease to exist. That 'just-pre-obsolescent' status of performance is acutely sensitized to its momentary capture in moving-image sequences, torn from transmutating city space and extracted, too, from all filmic narratives surrounding the performance's documentation. Such sequences possess a filmic and performative life of their own, which is focused spatially on the encounters and confrontations between film and performance, and is located beyond all concern with linear narration; in their incipient vanishing, performance forms and their spaces may become memorially instilled in film, or else lapse. Although those Berlin back-courtyard spaces endured across subsequent decades, the presence of performance in them became voided by the locking or coding of such spaces' exterior doors in the years following Berlin's reunification. Twenty years further on in time, and as though recollecting an Eden (distinct from his infernal incarcerations, firstly as a 'psychotic' child during the National Socialist era), Bruno Schleinstein evoked that barring of open infiltrations between street space and courtyard performance space, as well as the expulsion of non-sanctioned performance from newly corporatized street space itself: 'Once upon a time, there was a beautiful town . . . You could go everywhere, in all the courtyards and on all the streets . . . After the Wall fell, everything changed.'[6] Before his death in 2010, Bruno Schleinstein's final external-space performances – their vital obsolescence exposed to moving-image capture in the form of spectators' veering smartphone-shot sequences – often took place in wastelands and exterior interzones, such as the terrain of the derelict East Berlin slaughterhouse sub-city as it awaited its reusage.

Stroszek is expelled from his performance spaces, harassed by street gangsters who also erase his medium of performance by violently separating his accordion into two parts. Once the capacity for

Bruno S. in the slaughterhouse grounds, 2010: iPhone image.

performance has been foreclosed, space opens up to madness or is subject to unstoppable transits, gestures and movements. Stroszek's expulsion – beyond the space of the back courtyard, and even beyond West Berlin itself – extends still further than that of *Kuhle Wampe*'s evicted family, who travel only to the ephemeral campground at the city's edge; Stroszek, together with his companions, the prostitute Eva and the dementia-inflicted Scheitz, is displaced instead to an infernal manifestation of the American Midwest, in which his status abruptly reverses from that of performer to spectator as he expends small coins to activate animal arcade 'performers' – caged rabbits and chickens that must frenetically dance, in their enclosed spaces, to the point of exhaustion or death – before his own terminal performance, ascending vertically beyond the film camera's range on an out-of-control mountainside chairlift while clutching a shotgun and a frozen chicken, as mystified police spectators collect below.

Peripheral city spaces for film's rendering of performance, such as the open-air auditoria of tenement back courtyards, habitually contain a lone figure, such as that of Stroszek, filmed face-on in stasis while spectators observe his performance at ground level or via the apertures of tiered apartment windows, or else two figures,

as with Sonja and her 'fully blinded' accompanist in Biberkopf's courtyard, tracked by the film camera in movement across that space as Biberkopf entices Sonja out of her performative status. But the courtyard space can also be filmed as one saturated across its perimeters with multiply amassed corporeal figures, in which the distinction between performer and spectator is often impossible to determine. From the same moment in which Stroszek's performance was filmed, in 1977, then most intensively across the years 1979 to 1983, and more intermittently until 1989, the near-abandoned, decrepit tenement courtyards of East Berlin's Prenzlauerberg district formed the pre-eminent location for riotous punk-rock concerts that comprised one manifestation from the many idioms of dissident refusal against the GDR regime that thrived in those courtyard environments, alongside, for example, ecological forums, experimental performance art and activist film-making. No sanctioned venues existed for concerts of the GDR punk scene, and every act, gesture and sound associated with that performance culture was proscribed by the state-security agency, whose aged leader, Erich Mielke, railed in his speeches to associates of the necessity to extirpate all 'punks, skinheads, heavy metallers' who had been inducted into neo-fascistic criminality by 'electronic mass-media'.[7] In turn, the East Berlin punk-rock performance culture negated the forms and prohibitive structure of the GDR state. Its back-courtyard performance spaces, especially in streets such as the Schliemannstrasse and Dunckerstrasse, still damaged from the Soviet Army's 1945 transit through that district and now part-emptied in preparation for demolition, formed environments that were intended to elude, to the maximum possible degree, the pervasive ocular scrutiny of security-agency observers that characterized 'public' space in the GDR. Almost always, such performances were filmed in Super-8mm film within frenetic crowds, with jolted hand-held cameras oscillating between recording spectators and performers, and thereby instilling

acute, flux-driven intimacy into those performance films; but more professional films were also shot, by the security-agency's cinematographers, from covert vantage points such as high-storey windows, for identification and eventual punitive action against participants in those back-courtyard performances.

Although the back-courtyard environment formed an optimal location for cacophonic punk-rock concerts – screened from exposure to state-security surveyed street-space, and also providing an enclosed sonic and corporeal environment for chaotic gestural interaction between its tightly packed occupants – such performances also extended beyond that environment, their participants traversing city space, on public transport or by foot, in defiance both of police harassment and of moving-image surveillance. In wide-open plaza environments such as the Alexanderplatz, spatially transformed since the filming of Biberkopf's performance there in 1931, elevated surveillance film cameras tracked and zoomed into the gestures and performative transactions of punk-rock groupings as they transited those spaces. The dilapidated courtyards and grounds of an extensive complex of clinic buildings, the Ulmenhof – constructed in 1894 on Berlin's far eastern edge, in the Wilhelmshagen district, as a place to shelter crisis-afflicted or maladjusted city inhabitants – formed a preferential illicit site for large-scale punk-rock assemblings, which took the filmed form both of concerts and of more mutable, eruptive performances comprising aggressive dancing and ritual confrontations. Wastelands and interzonal spaces, as with those of Bruno Schleinstein's final, courtyard-expelled performances, also formed optimal sites for East Berlin's punk-rock performance cultures, such as the vast internal space of a gasometer cylinder awaiting demolition on the northeastern edge of Prenzlauerberg district in what would later become the site of the Ernst-Thälmann park; once that obsolete gasometer had been detonated, in July 1984 (a spectacular event that engulfed the entire surrounding district in

an expansive cloud of dust and debris, and was filmed, in colour footage), the resulting ruined terrain formed an additional exterior locus for punk-rock concerts and amassings. The dispersed grounds of a funfair located within the Plänterwald woodland, beside the river Spree, also provided East Berlin's punk-rock performance culture with an exterior gathering site.

East Berlin's punk-rock culture, always subject to police action, became especially threatened in 1983 when the GDR state-security agency decided to eradicate it, in part by infiltrating punk-rock groupings with security agents, thereby gathering data for the mapping of gatherings across the city, as well as through the comprehensive outlawing of that performance culture; the filmed surveillance footage of punk-rock performers and spectators formed one punitive evidential medium through which they were arrested en masse and incarcerated, often for periods of one to two years, or else conscripted into the GDR's army and thereby removed from city space (as well as from all future possibility of assimilation into the social structure of the GDR). That state-security plan was systematically accomplished, with the result that the GDR's punk-rock performance culture, with its many hundreds of performers and spectators, became spatially dispersed and decimated, to the extent that, in most cases, its participants never saw each other again until after the dissolution of the GDR.

East Berlin's back-courtyard punk-rock culture of the late 1970s and early '80s was enacted in a deeply contrary spatial form, mani - fested through its dual filming, both by its participants and its opponents in the state security services. The spaces chosen for that performance culture needed to form arenas that its participants could enter, but at the same time had to be protected against that culture's enemies. Such spaces eventually underwent an intricate process of infiltration and contamination by security agents and their informants, who necessarily had to fully assume the active

roles of punk-rock performers or spectators themselves in order to carry through their aim of erasing the same performance culture into which they had been fraudulently integrated. Alongside the corporeal voiding of the East Berlin back courtyards that were ephemerally occupied by that performance culture, these spaces themselves became earmarked for architectural voiding in the final decade of the GDR's existence. To increase housing capacity and avoid the cost of rehabilitating the decrepit tenements of Prenzlauerberg, the GDR authorities planned to demolish the interior spaces of that district's buildings while keeping the 1890s-era outer facades decoratively intact; the internal spaces would then be adapted for the construction of prefabricated concrete towers of the kind already pervasive in many other districts of East Berlin. That plan would also serve to excoriate the wider culture of dissidence that had spatially anchored itself in those semi-hidden back-courtyard zones. In that sense, films of the East Berlin punk-rock culture's locations carry the same aura of a just-pre-obsolescent space, boundaried by bullet-holed, dirt-encrusted walls, as that exuded by the courtyard-space within which Bruno Schleinstein performs in *Stroszek*. In the event, the 1989–90 collapse of the GDR annulled all plans for the partial demolition of Prenzlauerberg's buildings, which were instead renovated by property-speculation companies; their back courtyards remained intact, but emptied of performance, as were those of Bruno Schleinstein's Edenically remembered West Berlin.

Performances, especially when conceived and enacted as neg-ations and subversions of the state or corporate power that surrounds their momentary outburst, may optimally situate themselves in the heart of the city, in maximal exposure to their own erasure as well as to their effective spectatorial witnessing, or else in peripheral zones, such as twentieth-century Berlin's back courtyards with their resident audiences, in which processes of infiltration and

Carsten Fiebeler, *Ostpunk!*, 2006: Super-8/ surveillance film-images.

concentration configure performance locations that appear corporeally anchored, in gestural movement and sonic intensity, but may forcibly be annulled and vanish as rapidly as performance's central city spaces. Across both of those locations of performance, film forms the medium that probes and memorializes the spatial dynamic underpinning the eruptions and disappearances of performance, in their oscillations from central to semi-hidden city space and back again. Film also holds traces of the insignia (clothing, accessories, instruments, weapons) and gestures that bodies engaged in performative

Carsten Fiebeler,
Ostpunk!, 2006:
Super-8/
surveillance
film-images.

negations wield as integral elements of their subversions and their defining insouciance; retrospectively, such filmed traces may appear vitally anachronistic, in the same way that fashions erode but – across time, or from unforeseen perspectives and tangents – resurge aberrantly as seminal city markers. For spatially conjoined performance forms, such as those sequentially (and non-narratively) enacted in back-courtyard space, from the saw musician and plummeting suicide figure of Brecht/Dudow to the punk-rock performance-culture frenzies that provoked the GDR state-security elites, film

possesses the adroit capacity to show performative transmutations with their axis in a distinctive spatial interlinking.

Performance infallibly embeds the occluded 'elsewhere' locations of its enacting into city space, even in the contemporary moment in which such manifestations of external-space performance appear immediately subject to multiple digital moving-image rendering. Performance's gestures may become fully merged into city space's surfaces, often with the intention of instilling performance *within* those surfaces (once performance's corporeal acts infiltrate city space, they ineradicably form essential parts of that fabric). Such embeddings of performance may be lost in plain sight: positioned in wastelands and interzones, or virtually screened away within cracks in city surfaces such as those created by extreme disjunctures between abandoned and overused buildings, which disorient the viewing eye as it attempts uneasily to shift focus between such sites. Even at the heart of the city, ongoing performance acts may be undetected if their perpetrators actively camouflage their gestures with sleight-of-hand manoeuvres, or through the acute minimality or repetition of those gestures; in their contact with such perform-ance forms, an accidental spectator may realize only after a deferred interval, of minutes or even years, that they have witnessed a per-formance, and then seek to reassemble it through their filmed traces of it, through a restaging via memory, or by a combination of film and memory. Performance – whether conceived as an indi-vidual act of obsession that takes the form of an insurgent movement into city space, or else as a performance-art entity more clearly identifiable within art-institutional parameters – may slip im-perceptibly through the ocular apertures of contemporary city space, through or against the intentions of its perpetrators, but it will almost never elude the scope of pervasive moving-image media in their perpetual scanning of city space. It may be performed *unseen*, but still filmed.

At first view, it may appear that the excessive, pervasive rendering of external city-space performance, through smartphone-generated moving-image sequences or other digital forms, from multiple and overlayered perspectives, represents a full or complete representation of that performance. But the volatile entity of excess, whenever it is introduced into a representational framework, destabilizes and disintegrates its subject so that a multiply filmed performance assumes the form of archivally resistant fragment sequences that cannot cohere or gel into a cogent overview of that performance. Excessive filming generates a breakdown in the representation of performance, so that, rather than prefiguring a future form of performance filming in which every performance, without exception, will be exhaustively and comprehensively filmed, such moving-image processes instead propel the viewing eye, in freefall, back to the 1890s perceptual regime of the very first filmic sequences, of figures momentarily conjured on rooftops, or, still further back, to Muybridge's excessive animation sequences of human, performative movement. Film's early era, with its already insistent compulsion to seize acts of performance, forms an almost-lost history of corporeal fragments, often presenting sequences of mysterious, stranded bodies to which no reliable data can be assigned; in that sense, it intimately allies itself with contemporary moving-image sequences, of performance acts in city space, in which the multiplicity of performance's rendering ensures that nothing conclusively can be known, and that any perspective or perception of bodies in performance remains invariably vulnerable to its own contradiction and annulling. Even a tiny disparity between two sequences' filming of a human body in performance, across a pixellated blur of flesh, opens up a chasm in representation.

Alongside the representational abysses incurred for the performing body, in its multiple filming, the city environment surrounding performance acts, undertaken in central plazas or in 'elsewhere' spaces, exacts its own fissuration of that body. The

spectator's eye, oscillating between the performing body and city space, necessarily sifts a heterogeneous mix of that space's contemporary image-cultures and historical debris into the body it views. And with each subsequent moment of spectatorial attention, that detrital sifting of the city across the body is newly enacted. In that sense, the performing body is always, again and again, seamed and constellated by the city around it, even before it is multiplied into film's image sequences and projections. The city cannot ever be comprehensively contained by the perception of the spectator inhabiting it, so it irrepressibly but irregularly bursts out of normative perception, that process doubling the spectator's perception of the eruptive dimensions of performance, in external city space; performance, too, overrules the city and sets it into upheaval. Film, in its capacity exploratively to trace the manifestations of performance's overspilling dynamics, carries confrontational doublings: performance against city, and city against performance. Only in secreted-away locations, beyond even peripheral back-courtyard arenas, performance may be enacted, and filmed, without that interposition of an affrontment with its defining space.

From its first ever sequences, film predominantly rendered performance and adjacent city space simultaneously, in concentrated forms, within the same celluloid expanse, and for projection onto the same screen; whenever, in those first decades of its existence as a recording entity, it focused primarily on city space and its surfaces – as in the European-city documents of the Lumière brothers and Skladanowsky brothers, or the documents of Albert Kahn's worldwide-dispatched cinematographers – multiple performance acts and elements intractably entered its frame, engendering a curtailing fragmentation of all narrative. After the detour of industrial, studio-genre cinema (across seven decades or so), film returned, in its contemporary moving-image idioms, to its initial project for the conjoined, intensive rendering of city space and performance, in

isolated fragments, but now in a form proliferating to infinite excess. In that sense, film works – as a sensitized and attuned medium, across city surfaces and ground-level sites – with phantasmatic apparitions of performance bodies that are always pre-annulled and imminently exposed to their dispersal or subjugation, and ready to be propelled out of existence, other than in their survival in the medium of film itself. But film has also possessed the capacity to infiltrate itself *under* the over-exposed surfaces of the city, into other domains of performance's representation and liminal visibility, in subterranean zones.

No sustained history of performance in subterranean and underground locations exists; instead, sub-city performance and its filming takes place intermittently across performance history, in formative and contrary instances, and also as vital *potential* future performance, in a contemporary era in which city surfaces – both central plazas and peripheral sites such as semi-occluded courtyards – are increasingly subject to excoriating power structures of state and corporate surveillance that aim to erase performance, and its insurgent corporeal manifestations, from city space. Subterranean performance forms an aberration within both spectatorial and filmic frameworks: it demands an audience that is willing to infiltrate itself, often through dangerous terrains or obstacles, into spaces from which the means of exit may never be clear, and in which the performance itself may be difficult to perceive, through darkness or semi-obscurity; film's technologies, though half-founded on darkness, respond negatively to the sieving out of forms of corporeal performativity from within light-denuded environments, and historically require additional sources of light in order to register performance acts in such spaces. At the same time, in liminally lit subterranean spaces, performance acquires new capacities for transformational gestures, activist or power-negating manifestations and experimental inventiveness, as

well as an intimate, darkness-coalesced alliance with film, in extreme conditions in which both the performing body and its moving-image media are situated as exposed entities.

Subterranean performance infallibly entails or incites a deranging of the body, both through corporeal dislocation and also via the positioning of the body in a sub-city zone in which visibility has become volatile. In that sense, performance bodies in such zones (which may be the subterranes of such buildings as city asylums) are subject, notably in their filming, to gestures of psychotic uproar, compulsive repetition, disturbance and mutation, which generate their acts' status as vital, prescient performance forms in the digital world. The loss or semi-loss of light itself skews the founding visibility of performance and initiates an ocular spectatorial regime in which light conditions may shift from moment to moment, thereby rendering the spectatorial act itself into one which is liminal, poised on a tightrope walk a hair's breadth from a fall into pitch darkness, and open to arbitrary and unforeseen illumination. Those reversals make subterranean performance sites uniquely valuable for works – performance artworks, alongside obsessional gestural acts – whose axis is the transmission of liminal experience, focused on sensations or gestures which may or may not be represented or perceived, and may or may not even exist, within an encompassing environment of simulation and engulfing multiplicity. Subterranean performance entails a separation from ground-level external visibility (it has plummeted through a gap in the city surface to become virtual), along with a representational fissuration by which its capacity for viewing and dissemination – notably through film and screen-focused film projection – is always at risk. As such, performance underground, as an elusive medium, can never elude the malfunctions and seisms that inhabit such fragile acts; all habitual perception and intentionality is subject to reversal (for example, from activist engagement to ambivalent insouciance, or from a frenzy of gesture

to utter stillness), and all support structures, including those of technological facility, are undermined or erased. In that sense, sub-terranean performance is locatable not within Plato's cave with its representational regime of ocular corruption, and its spectatorial oscillations between subterranean and external space, but rather within the parameters of inescapable desperate elation mapped by Fyodor Dostoyevsky's Notes from the Underground: 'The long and the short of it is, gentlemen, that it is better to do nothing! Better conscious inertia! And so hurrah for underground!'[8]

The conception of performance spaces located in subterranes, beyond the adulterating dynamics of city space in its central and peripheral forms, also resonates with histories of 'underground' performance and film cultures that sought to carapace their experi-ments by subtracting them from agencies or power regimes that were prone to censor, outlaw, distort or obliterate performances, alongside acts of filming and film-projection events, as with the history of The Film-Makers' Cooperative, founded in New York by Jonas Mekas along with other film-makers in 1962 (thereby precipi-tating the founding of film-makers' cooperatives in many other cities, often sharing spaces with performance groups or collectives, as in London), and with the histories of the underground, sub-city-level performance and film cultures of all Eastern European countries in their eras of authoritarian and totalitarian regimes. In many cases, such underground-culture venues were literally situated in subterranean or mobile, transmutating spaces (hotel rooms, derelict halls, private apartments) to avoid intervention by the police or state security services; the term 'underground cinema' gained prominence in the 1950s, through the work of Kenneth Anger and others, but the idea of an 'underground' performance culture extends back to the end of the nineteenth century, to work such as Jarry's Ubu Roi (1896), then far further, across reversed time, to all instances of subversive and resistant performative gestures enacted in conditions

of acute historical upheaval or sensory disorder. The idea of 'under-
ground' film and performance cultures remains conjoined with
those covert cultures' perception as reprehensible and punitively
subject to arrest at any moment (as with Mekas's projections, of
works such as Genet's film Un Chant d'amour, raided by the police
and prosecuted, or the first production of Ubu Roi, exposed to
responses of riotous turmoil that led to its curtailing). But the
conception of underground cultures' spaces of film or performance
also encompasses spatial forms resulting from imaginative expan-
siveness, desired beyond apparent practical realization and so
'impossible' (and therefore always provocatively realizable). Robert
Smithson wrote of his idealized cinema space:

> What I would like to do is to build a cinema in a cave or an aban-
> doned mine, and film the process of its construction. That film
> would be the only film shown in the cave. The projection booth
> would be made out of crude timbers, the screen carved out of a
> rock wall and painted white, the seats could be boulders. It would
> be a truly 'underground' cinema.[9]

The space and light conditions of subterranes form direct or
incidental impediments to film's capacity effectively to seize corporeal
gestures in performance; bodies may spectrally disappear into dark-
ness, resonating with the subterranean direction of funeral-witnessed
entombing, from ground level vertically downwards. Such bodies
can also oscillate unpredictably between visibility and invisibility,
thereby setting irresoluble challenges for performance's film-makers,
across its histories; equally, such challenges incited film-makers to
experiment in unprecedented ways with subterranean performance-
film-making and its editing strategies, as with Kurt Kren's mid-1960s
filming of the performance-art actions of Otto Muehl, and other
Vienna Actionists, in the cellar space below Muehl's apartment

building, in which Kren (while drunk, according to his own accounts) not only filmed the performances, but edited them in-camera into hundreds of liminally separated segments in order to disintegrate all documentational intent of the film-making process, with the contrary aim that such performances became transacted into the proprietorial domain of film. Kren's projections of films of the Actionists' work, denied public visibility in that era, also took place in the same cellar space, often during (and film-overlayering) the performance of new actions.

The spatial domain of the subterranean, for performance and its filming, extends across multiple manifestations: cellars, sub-city transit systems, conduits, vents, passageways, bomb shelters, derelict factory basements and innumerable other sublevel sites. Such spaces may also encompass optimally desired or imagined locations, as with Smithson's cave-cinema plan, so that they shift between material and envisioned (or hallucinated) forms, together with spaces that duplicitously simulate the subterranean, as an instance of the many duplicities integral to space's relationship to performance and film. Subterranes may present few obstacles to spectatorial access, as with the underground bar, in Tokyo's Shinjuku district, in which most of the transvestite-sex performances of Toshio Matsumoto's film *Funeral Parade of Roses* (1969) take place, requiring only a commitment to blind-drunk debauchery on the part of their audience; but more usually, across performance histories and performance futures, subterranes strategically screen themselves away from exposure to external ground-level vision, as occluded apertures in city space, still infiltratable, but only after an assault-course semi-blind descent, by ladders or lift shafts or stairways, or on hands and knees, into darkness.

Subterranean performance space operates in a 'seeing blind' ocular regime; darkness is the predominant entity occupying and determining

that space, and the capacity to view, catch sight of, glance at or glimpse performance forms the exception within that regime, along with the ability of film to seize the perversion or miracle of light-lit gesture. Such darkness-imbued performance evokes the figure of Sonja's 'fully blinded' but actually fully seeing accordion-playing accompanist in *Berlin Alexanderplatz*, who is habitually consigned to a feigning of blindness but, for the exceptional incidence of his confrontation with Biberkopf (in which the accordionist no longer performs, but is transformed into an intervening spectator of Biberkopf's intricate gestural exchange with Sonja), returns to a state of vision, albeit a duplicitous one. The defining darkness of subterranean performance space intimates its relationship to wider processes of the erasing of performance, in which a performance may be censored out of existence by an exterior authoritarian force, or else through the caprice or artistic imperatives of its instigator, who cannot continue and so curtails the performance. The censorship of performance possesses a long and fraught global history, exacerbated since the nineteenth century's end by the filming of performances and the attendant use of that performance film documentation to substantiate or confound censorship processes. The darkness of performance is also intimately associated with the oblivion accorded to unrecorded performances, including those for which the performance's instigator declines (or lacks the means) to engage a film-maker to document it, and those for which the memory of the performance's audience comprehensively malfunctions and fails. The forgetting of performance forms a distinctive manifestation of memorial disintegration in which the spectator may wish to conserve a performance in memory, but cannot, through memory's inbuilt self-combustion, or else wills its casting into oblivion, if the performance has riled or wounded the spectator; equally, the visual elements of a performance may be forgotten, and the text remembered, or vice versa, just as a malfunctioning film camera

may visually record but aurally fail to seize the performance, or vice versa. Oblivion, forgetting, loss and suppression all form essential presences attending subterranean performance and interconnecting it with wider dynamics of performance and its filming, in which the capacity of the eye even to envision performance at all constitutes performance's originating prerequisite.

Subterranean performance presents a rigorous testing of the ostensible capacity of film to be 'sensitized' to performance (light-sensitive, above all), and thereby in alliance with it, despite the often-fractious historical status of that conjoining of performance and film. Unless film-lighting technologies illuminate – and thereby despoil – fully darkened performance acts, such acts cannot ever be filmed, except via thermographic or night-vision recording devices; subterranean performance is allied more closely to the intentional unrepresentability and impossibility of the filming of performance, rather than to performance's self-exposure to being rendered into moving-image sequences. A cinematographer attempting to record corporeal forms in near-lightless subterranean conditions incessantly monitors and attempts to overcome the 'problem' of darkness. In its extreme instance, the filming of light-denuded performance would have to be abandoned, just as a film-maker lacking adequate cartridges would need to abandon the film-making act (as often happened during the 1960s era of performance-art film-making). Innumerable further variants of the incapacity of performance to be filmed would encompass, for example, the impasse of a film-maker unable to infiltrate dense crowds surrounding a performance act in external space, the impasse of a film-maker physically prevented from filming by a reluctant performer, or the impasse of a film-maker encountering performance space voided by interdiction. In all such variants, performance is not filmed at all, or if a film is made, it fails to show the distinctive space or bodies of performance. Subterranean performance subsumes and intensifies all such

challenges to performance's filming, thereby forming the contrary entity to acts of performance executed in external central city space, effortlessly filmed to excess by countless iPhones and other digital devices.

Performance forms may intentionally induce darkness to pervade their space, in order to avert their incorporation into film, or else to instigate a reconfigured relationship between performance and film; most notably, the ankoku butoh ('dance of utter darkness') performance form, instigated in Japan by the performer and theorist Tatsumi Hijikata at the end of the 1950s, and oscillating between performance art and choreography, placed its primary emphasis on the body's relationship to darkness, both as a metaphor for corporeality in its contemporary existence and to materialize the engulfing proximity of darkness to the body. Since ankoku butoh performances, in their first decade, were enacted only rarely, for audiences which misremembered them (as spectators' accounts of those performances demonstrate), their persistence into future time depended on their transmission into moving-image and photographic forms. The photographer and film-maker Eikoh Hosoe deployed both forms, first filming Hijikata's ankoku butoh performance, in *Navel and A-Bomb* (1960), shot on a black-sand beach solely for the film camera, and then – as though aberrantly reversing in time, from moving-image to still-image media – documenting it through photography. In the first filming of ankoku butoh, by the Tokyo-based American writer and film-maker Donald Richie, *Sacrifice* (1959), the darkness-oriented gestures of Hijikata and his collaborators were accentuated by a technical mistake in the film-processing laboratory, which accidentally printed Richie's 8mm performance film too darkly, so that the spectacle (again, filmed solely for the camera) could barely be seen, thereby instigating an exploratory act of viewing on the part of the spectator.[10] And in the final film of Hijikata's ankoku butoh work, *A Summer Storm* (1973), shot by student cinematographers and

documenting a performance at an auditorium of Kyoto University, darkness still nearly engulfs the performers, so that their gestures emerge tenuously, for fragments of time, from void filmic space.

In its rendering of performance, in light-drained environments such as subterranes, film draws on its constitution as a medium for which darkness always formed an integral element. From its origins, film required the interposition of darkness between its still celluloid frames in order to generate the eye's perception of movement. And in its spaces of projection – identical, in its early years, to those of performance – film pivoted on the abrupt plummeting of its expectant audience's vision into darkness, with the extinguishing of the venue's lights; David Lynch's films, *Mulholland Dr.* (2001) above all, emphasize the spatial darkening and subterranean aura of auditoria to announce the onset of a transmutating mystery, through the deploying, in that film, of a cinema auditorium – that of the Tower cinema, in Los Angeles – not for film, but for performance, in the form of Rebekah del Río's sepulchral rendition of the song 'Llorando', whose abandonment, with the singer's sudden blackout fall backwards, to the ground, into unconsciousness, also plunges the audience into a new, deeper darkness.

Since subterranean performance spaces often possess no tangible or visually coherent spatial arrangement – no marked entrances or exits, only improvised apertures in semi-darkness – they form sites in which spectators and performers need to generate renewed alliances and points of contact, to hold on to one another, even intimately, so that they do not fall. The boundary between a plunge into darkness-induced unconsciousness and the sustaining of sub - terranean performance – filmed, if at all, in fragments and ephemeral illuminations – is narrow and prone to disappearance. As such, subterranean performance spaces constitute privileged sites of infiltration and intersection. The spectatorial act of locating the performance

space may itself form a process of corporeal infiltration, in which far more than the pushing open of a street door (as in a back-courtyard performance regime) is required; the spectator may optimally infiltrate the space via heating tunnels, vertiginous stairways or obscure passageways, and therefore require the active collaboration of other spectators, as well as knowledge gained from consultations of architectural plans or the previous filmings of that space, in order to excavate a way into it. In such a tenuously navigable domain, intersections between media and across physical forms are negotiated from zero, by trial and error; as such, they require a comprehensive reconception of the manifestations of corporeal gestures, for example in a film-maker's attempts, in near-darkness, to conjure such gestures into visibility-sanctioned existence by allying them with other physical acts or with elements of the surrounding subterranean zone. New means to interconnect and weld disparate fragments of performative bodies, as well as inanimate presences, are exacted in such zones; the passageways between subterranes, into which performance without set limits may overspill, form as vital elements of such spaces as the site nominally assigned for the performance itself. Subterranes constitute sub-city spaces for performance that invariably implicate and encompass corporeal forms and their transmutations, notably in terms of the sensorial and ocular spectatorial capacities that are constantly fissured and reformulated by their inhabitation of subterranes; such stratas' collective naming as the city's 'underbelly' intimates the all-consuming process, traversing and interconnecting physical and architectural entities, entailed in darkness's engulfing of subterranean performance spaces and their momentary occupants.

Film's own infiltration into the darkness of subterranean performance space itself forms a fissuration of the ostensible capacity of moving-image media to seize both the representation of spaces and the duration of acts unfolding there; as with the underground spectator's perception, the filmic rendering of subterranean strata

and their contents may also be set into a scrambled spatial disjuncture in which duration itself becomes volatile. In that sense, the filming of subterranean performance adds new and potentially aberrant intersections of time and space to the connectings of performers' and spectators' bodies exacted by the inhabitation of subterranes. The act of filming performance in near-darkness positions itself in close proximity to the experiments of film's origins in the 1890s, in which the moving-image rendering of performance remained in flux, capable of extending in any spatial or temporal direction and of instigating unforeseen amalgams and conjoinings of film and performance; similarly, 1890s experiments in originating public film projection, such as those of the Skladanowsky brothers and Lumière brothers, involved exploratory engagements with the mutable zones of darkness and visibility in order to devise the technological manoeuvres required to oscillate between them, and thereby project illuminated films of performance to audiences seated in darkness. Even the Lumières' name (the brothers of 'light'), together with the location of their Salon Indien public projection space of December 1895 in the subterranean basement of Paris's Grand Café, intimate the contrary poles at stake in film's pivotal affiliations with darkness.

Especially when film is able to establish sequences of actions from the intermittent visibility of subterranean performance, such actions may be accentuated into the form of confrontations, enslavements and manifestations of psychosis through their casting into darkness; subterranean performativity is established through a configuring of alliances and via conjoined visions, but its manifestations may rapidly go haywire. In Chris Marker's La Jetée (1962), a seminal film for all performative representations of subterranes, the survivors of a surface-razing global calamity are enslaved underground, in a 'network of galleries' under Paris's Palais de Chaillot, and are induced to perform vision experiments, inducing madness, in which they must attempt to make contact with figures from the past and future;

darkness intensifies their eye-screened capacity to infiltrate those time-barriered domains and revivify memory itself. But even a successful envisioning of the future and its occupants will bring death for the maximally skilled navigator, via darkness, of the intersected past, present and future, who is assassinated, back on the exposed surface of the city, while crossing a viewing pier at Orly airport. Further accentuating the temporal exposure to transformation of actions performed subterraneously, La Jetée is a film composed almost entirely of sequences of photographic stills (a moving-image form which Muybridge's work of the 1880s crucially prefigures), so that each performance action must be concentrated into a split-second image, to be propelled forwards or backwards in time.

Subterranes, and the passageways leading into or out from them, form receptive locations for the corporeal eruptions of performance that may be adeptly torn by film from sub-city space. Such performances can be intended for on-site audiences, and already ongoing when film intersects with them, or else entirely conceived as performance acts to be filmed. Those acts may also be removed from the domain of multiple subterranean figures, negotiating a rapport in near-darkness, to be performed instead in apparent solitude. Above all, such subterranean performances' axis is in psychosis, upheaval, transformation and negation. In Andrzej Żuławski's film Possession (1981), Isabelle Adjani's character Anna, disintegrating into an expansive madness that reveals itself in monstrous corporeal forms, experiences a memory flashback in which, at the end of one of her incessant journeys via West Berlin's underground transit system, she traversed a dimly lit subterranean passageway while carrying a bag of shopping. As Anna, wearing a dress which resembles a prison or asylum costume, starts to move through the empty passageway (no other figures can be seen, other than a ticket seller who will neither intervene nor watch her performance), she breaks into delirious laughter, which rapidly mutates into cries and screams

Chris Marker, *La Jetée*, 1962: film-image.

as she begins to collide against and along the walls of the passageway
as it bends into a form that would partially shield her from any obser-
vation from either end. She then performs an extended choreography
of insurgent gestural madness directly for the film camera, smashing
the shopping bag against the wall so that its liquid contents immerse
her, then, her screams echoing in the subterrane, executing an out-
landish dance – incorporating trance-possession gestures and a
sudden fall to the ground – of violently out-of-control movement.
The filming of this is contrarily meticulous, following her contortions
intimately, and shifting from close-up tracking of the performer's
body – so close, that at several moments, the performance's film
image blurs – to a more detached shot, as the sequence ends with
a release of corporeal fluids, amid screams. The narrow passageway
location for that spectacular dance of intensive madness is detached
from the visual regime and surfaces of city space, poised ephemerally
in an isolated subterranean site; the performance which that elongated

Andrzej Żuławski,
Possession, 1981:
film-images.

site's walls work to project is conceived solely for its filming as a performance, rather than for an on-site audience observing it as it takes place. That unique space for subterrane performance then vanishes, as the film in which it is held (an impossible seizure) jars onwards, to its next sequence.

In the passageway sequence of Possession, the trance performance of madness is filmically configured as one which must hold the self-choreographing female body in isolation from all other bodies, and instil that body within a subterrane that is a world away from the surface of the city; film-location work has the capacity to void spaces (such as that of the Platz der Luftbrücke underground station and its exit passageway, in the Possession sequence), to accentuate that isolating of the body, in preparation for performance's insurgence. Corporeal voiding and isolating, in that sense, form prerequisites for the filmic registration of sub-city trance performance, just as the ingestion of narcotic substances comprises a prerequisite for many other filmed trance performances. That tripartite focus in Adjani's dance, on body, performance and film – screening away all else, other than the passageway walls which project the gestures of dance – allows sub-city psychosis to materialize itself. Torn out from the fiction film Possession, that sequence holds an aura of uniqueness; in the raw violence of its enacting (an irreplicable act, since Adjani never performed that dance for a public audience, nor again, in other films), it cannot be intimately sequenced, across or against time, with the spatial topographies of other sub-city psychosis spectacles, in the way that back-courtyard performances, such as that of Bruno S. in Stroszek, intersect with those of other courtyard-sited films. At the same time, Adjani's performance, torn from film entirely, may be located within histories of performance culture, especially that of ankoku butoh, which, above all other performance-art forms, incorporates gestures from corporeal subterranes of madness and

self-implosion, often performed underground in the context both of its venues' locations and its experimental-art framework; that performance form attained its sudden international prominence (having already been known in Japan, at least peripherally, since the late 1950s, when Richie began to film it), at precisely the era of *Possession*'s filming, originally through the performances in Paris and West Berlin of choreographers such as Ko Murobushi. In that sense, as a performance without a precise topographic or filmic lineage, Adjani's disorienting dance sequence of trance-induced madness may fluidly traverse histories of performance and moving-image media to find allied, hidden spaces.

The enacting of trance performances, inducing or instigated by a madness which is habitually ephemeral, generates its own regimes of spectatorship, which may encompass the negating of spectatorship itself; film can contrarily seize and memorialize an act otherwise denied an open viewing by audiences. Adjani's *Possession* sequence interconnects with filmed trance-ritual choreographies sited beyond the exposed visibility regimes of city space, and undertaken primarily for spectators who are co-participants in the trance performance itself. Film induces its own ocular and sensorial trance regime for its audiences, as in the film works of Maya Deren. In 1955, in Ghana, Jean Rouch filmed the pre-eminent trance-performance film of transient psychosis, *Les Maîtres fous*, in an external performance space hidden from public view at the peripheries of the city of Accra, for an on-site audience composed of participants in the ritual, alongside Rouch's film crew. Rouch's possessed male figures – ostensibly induced by maleficent gods to perform repetitive acts of maddened violence, and finally to kill and eat a dog, with mouth-frothing frenzy – are presented by his film's voiceover as conjuring for themselves an ephemeral madness, enacted in defiance or ridicule towards British colonial power (then subsisting at its last moment, before Ghana's independence), so that those figures would then be able

to re-emerge, in the corporeal guise of renewed sanity, to perform their habitual duties and occupations on Accra's streets. Rouch's film insistently tracks the performative onset and carrying through of trance psychosis, as though it is film's power itself, rather than the possessed figures, that generates and sets the spatial parameters for that act, as with Adjani's *Possession* performance sequence, conceived solely for its rendering by the film camera. Film itself performs a corporeal possession.

In contemporary films of trance performance, those dynamics of origination and accentuation, across performance and film, remain intact. The Tangier-based performance artist Natasha Pradhan both films and participates in enactings of the music-driven 'lila' trance performance form, undertaken in apartments located in the

Jean Rouch, *Les Maîtres fous*, 1955: film-image.

Andrzej Żuławski,
Possession, 1981:
film-image.

centre of that city but secluded from public view; that form of performance space is perceived by Pradhan as one in which all acts forbidden in external city space (and most interior spaces) are uniquely permitted, so that the lila spectacle may extend across all terrains of madness, sexuality and cacophony. Performance is enacted below the level of public vision, except through its seizing by film and the resulting film documents' dissemination; but, for Pradhan, film itself never initiates the lila performance.[11] Pradhan's oscillation between the dual roles of performance film-maker (habitually filming the lila-performances at a tangent, from a liminal position, neither from the audience, nor from the performance space itself) and performance participant possesses its own lineage, notably in the work of Kurt Kren from 1969–70, which often involved Kren's own film-space participation in sexually explicit performance art actions, conjoined with his filming of them.

In Adjani's psychotic trance performance, her body is located in an isolated subterranean space that, in its rendering by film, forms an infinitely mutable transit zone which could propel that body

anywhere across and under the city, provided that those performance spaces of new psychoses are devoid of spectators; in another, external-space sequence of *Possession*, Adjani's character Anna, having abruptly stepped into a deserted street and thereby precipitated the spectacular overturning of an oncoming car-transporting vehicle, walks – arms outstretched behind her – directly along the dead centre of the street, adopting exactly the same idiom of West Berlin city transit as *Stroszek*'s Bruno S., four years earlier, as he pulled his cart of instruments, along the street's centre, towards the back courtyard where he would perform. Those filmically doubled figures of performative disequilibrium, 'Isabelle A.' and 'Bruno S.' – simultaneously excluded from the city, but resistantly able to inhabit it and perform in it by infiltrating its subterranes and hidden spaces – form exemplary performative figures for the untold multiplicity of deranged bodies, of that filmic era and also of the contemporary era, encompassing refugees, exiles and the former inhabitants of asylums, who constitute the unseen inhabitants of the city's (all cities') peripheral and underground zones, undertaking incessant transits of sub-visibility and subterranean spaces, and infiltrating their way – often by performative acts – into the spatial core of displacement. Films of deranged and displaced performance are seminally located at the boundary between darkness and light, traversing visibility and occlusion.

Subterranean and virtual spaces of performance principally constitute threshold sites, tightrope-walk passages, infernal abyss edges and vision-instilled precipices for the three-way relationship in dynamic flux between corporeality, film and performance, in and across city space. Along with the pivotal site of intersection between still images and moving images at which Marker's film *La Jetée* is located, such subterranean spaces evoke the work of Muybridge, who, in California in 1872, in a meticulous act of self-choreography, had himself photographed, in a pre-filmic sequence of images, poised in tense stillness and at a position of extreme elevation, at a

Yosemite Valley precipice, gazing into the 3,400-foot-deep subterrane below, which appears far vaster than the ground-level terrain, as though subterranean space always possesses the potential to expand still further and engulf ground-level surface, effortlessly to annul it. Muybridge's Yosemite images were commercially distributed to their audiences in doubled form, two identical images positioned alongside one another, to facilitate their viewing in stereoscopic media. Muybridge's performative act, like those of Kren and Pradhan, is one in which a physical participant of performance is also simultaneously overseeing that performance's visual rendering; a moment after each image's capture (by one of Muybridge's assistants) of his performance of corporeal, void-facing stillness, he would have needed to rush at speed to the camera in order to supervise the instantaneous development process then demanded by wet-collodion photographic technology. That liminal oscillation, between performance and image-making, is also the means by which a performance executed without spectators, or with its audience limited to participants, can be transmitted (albeit after delays, such as that of Muybridge's photographic development process or of Pradhan's filmic website downloading), in the form of its visual residue, to unrestricted and open-ended future audiences. In its rendering by film, performance undertaken in contact with subterranean space – often touched by psychosis or displacement – is optimally located at the corporeal thresholds or exits of that space, at which an act of plummeting or insurgence appears imminent.

Since ground-level, once-public city space – now proprietorially controlled and monitored via digital media by corporations and state agencies – will become increasingly subject to ocular scrutiny, and to the potential extirpation of all manifestations of performance from it, subterranean space emerges as an ever more vital area for performance experiments and their filming in the contemporary

Eadweard Muybridge, *Glacier Point*, 1872: stereoscopic image.

era. The city's surface, as a scoured and excoriated environment for performance, precludes and voids the eruption of performance acts and the volatile amassings of their audiences, to the maximum extent, forming an exposed medium that is already maximally occupied with such visual spectacles as digital image-screens transmitting corporate animations, along with saturated icons, insignia and hoardings. In that sense, surface has no space for the corporeal infiltration of performance, unless that performance is commissioned, in delineated time as well as space, to fully serve corporate agendas. Subterranean performance space is also full, but with contrary presences – darkness, psychosis, boundary zones – as well as with the impossibilities and dilemmas for corporeal filming which it presents, together with the intermittent performance-culture history (necessarily as unseizable as film's capacity to record near-darkened performance) of enacting spectacles below city space. Subterranean space also constitutes a future-oriented entity – part-metaphor, part tangible space of vision – in its relevance for all performances intended to take place in resistance to the stultification of space, to corporeal

subjugation and to ecological despoliation. In that sense, a subterrane also forms a city-space aperture able adeptly to traverse all divisions between underground and surface, in order to instil its disruptive content into the relentless regulation of surface space; to envision performance subterraneously accentuates the conception of new performance forms in city space and via their moving-image rendering.

Above all, the extensive subterranes of abandoned buildings, pre-eminently asylums and sanatoria, at the peripheries of cities, form optimal, exemplary sites for future performance experiments and their filmed traces. International histories of the deployment of such subterranes for performance are invariably fragile or non-existent, since such usages are characteristically ephemeral, covert and often depend on the surrounding city space being subject to ongoing, acute transformation and contestation, as with the period immediately following the collapse of Eastern Europe's authoritarian regimes in 1989–91, or the contemporary moment of spatial eruption and protest, extending across city space in South America, North Africa and Europe. On the northeastern periphery of Berlin, the vast subterranean space (extending almost as expansively as the ground-level constructions) beneath the Buch asylum constitutes a prefiguring future-performance location in which subterranes and surface-level oscillate and interconnect. The Buch asylum, designed as a vast sub-city of the anticipated mad at the time of its construction in the 1900s and early 1910s, remained largely unpopulated since the many thousands of young males expected to occupy it, having been driven insane by the neural excess of city life, were pre-emptively slaughtered in the First World War. Instead it formed the site of Biberkopf's incarceration, in his transient psychosis following Mieze's murder, in Döblin's Berlin Alexanderplatz; then, its pavilions adapted for medical use by the occupying Soviet army, it 'hosted' Hitler's autopsy in May 1945. On the eastern periphery of Paris, the subterranes of the Ville-Evrard asylum – displaced, as with Buch, across numerous

Buch asylum, 2013: author photograph.

pavilions – form a correspondingly attuned site for potential per-
formance experimentation in the future, through which all gestures,
and their moving-image rendering, may be subject to possession
and reactivation by the compulsions and ghost-residues of city
psychosis. In 1939–43, the performance theorist and film scenarist
Antonin Artaud (the only certifiably non-mad occupant of the asylum
across its history, extending from the 1860s) was incarcerated at
Ville-Evrard, persistently subjected to beatings and maintained in
a state of starvation; undiagnosable, he remained constantly in
transit between the asylum's pavilions, from the epileptics' pavilion
to the maniacs' pavilion to the undesirables' pavilion, back and
forth. Such psychosis terrains as Ville-Evrard incite performances:
in 2007, the company Vertical Détour, including asylum occupants,
performed extracts from Artaud's Ville-Evrard letters and magic

spells in the asylum's derelict kitchens. Just as the interstice between subterranes and city surface constitutes a sensitized aperture for ocular infiltrations into, and across, both spaces, Artaud's Ville-Evrard incarceration forms an enforced interval space between two contrary bodies of performance theory – the 1930s Theatre of Cruelty theory he had formulated prior to his internment, and the 1940s body-without-organs theory he devised after his release from the asylum – through which the elements of that performance theory can be viewed transversally, in their integral form.

Along with the subterranes of abandoned asylums, those of sanatoria also constitute key future-oriented sites for sub-strata performance which may insurge onto ground-level city space to erase its regimes of corporeal constraint. The subterranes of the Beelitz-Heilstätten sub-city for tuberculosis treatments, built from 1898 on the southwestern periphery of Berlin, forms an immense underground network of proliferating, disintegrating spaces: passageways, tunnels and heating vents and fresh-air conduits (the tuberculosis patients needed to be maintained in an overheated environment, engendering a delirium conducive to their participation in the sanatorium's amateur performance culture). During the First World War, the sanatorium was adapted for the treatment and convalescence of wounded soldiers, including Hitler, whose corporeal transit through the peripheral space and time of Berlin, southwest to northeast, extended from the cauterization of his war wound at Beelitz-Heilstätten in 1916 to his autopsy at Buch in 1945; in the subsequent decades of the Soviet occupation of East Germany, the sanatorium also served as a specialist hospital for elite military and civilian patients. Since the mid-1990s' abandonment of the sanatorium, with the withdrawal of Russian military forces from Germany, its subterranean conduits have formed the precarious media of corporeal infiltration for many performers and film-makers intent on undertaking films (often pornographic films), performance-art acts, graffiti interventions,

Beelitz-Heilstätten sanatorium, 2013: author photograph.

destructions and thefts in the ornate operating theatres, salons, ballrooms and wards. Over the years, those incessant transits from subterranes to surface gradually eroded and exhausted that aboveground level, exacerbating its unmaintained deterioration across time, so that by 2014, the sanatorium formed a denuded, spectral sub-city of ruination, still emanating the untold residues of fever and psychosis. Now, for future performance, all that remains is for the near-dark subterranes of the sanatorium – previously perceived as transit channels – to assume their pivotal spatial status as a multiple location for liminal performance and its filming.

Cities – especially those contemporary cities that are subject to transmutation and coursed by corporeal seisms of protest and unrest – are always boundaried by spaces of psychosis and disintegration, and by enclosures of displacement and expulsion: courtyards,

subterranes, abandoned buildings and factories. Those spaces form imminent locations for performance, and for performance's filming, in a digitized era in which performance cultures may be emptied from external city space, via surveillance technologies and the riot-police manoeuvres prefigured by works such as Romeo Castellucci's *Hyperion: Letters of a Terrorist*, with its mid-performance expulsion of the audience, intimating the just-pre-obsolescence of the status of performance space itself. Theories and wide-scale reformulations of performance also emerge from such spaces, and from the voids between them, as in Artaud's enforced theoretical 'voiding' during his incarceration at the Ville-Evrard asylum, which he countered by his construction, through rage and protest, in rigorous performative acts, of his magic spells, lacerated and burnt prior to their intended transmission, and intended literally to dismember or raze the bodies of his enemies: the sinister agents and assassins whom he perceived as having dispatched him to that space of madness, to silence and surreptitiously 'disappear' him there.[12] In their broadest sense – as tangible spaces, as well as theoretical metaphors for experimentation with city space and corporeality under pressure – subterranes form seminal sites of survival and exploration for the future of performance in the city and for all moving-image renderings of performance that will ensure its endurance in filmed fragments of corporeality.

Performance, enacted and filmed on the external surfaces of cities or within their subterranes, vitally concerns the status and future entity of the human body; in many ways, all performances and their filmings constitute multiple archivings of the body's disintegration, always accentuated by its intersections with city space. Subterranean performance, in particular, emphasizes exploratory manoeuvres, by spectators' vision and the lenses of moving-image media, intended to seize gestures and emanations of a performative body that may vanish at any moment, thereby subtracting from space all trace of

performance itself. The distinctive sub-strata obstacles to perform-ance's visibility, beneath the city, serve also to evoke all closed or closing apertures to vision in contemporary space, notably those restrictions on the eye enforced by the corporatizing of previously public arenas, their parameters delineated by riot-police violence. But the multiple spatial infiltrations that enable subterranean per-formance also form a counterpart to the ways in which performance and film together possess the capacity to enter the infinite interiors and sub-skin subterranes of the human body itself; if city-surface performance becomes a finally prohibited and voided entity for the body, its own 'subterranean' eruptions and reconfigurations con-currently present ever-more pressing preoccupations for performance and its moving-image media. Incising the subterranes of the body itself, as a site or metaphor for performance, also constitutes a means to envision the conjoined relationship between body and city in tur-moil.

Notably, the visualizing of corporeal subterranes as potential sites of performance generates a parallel sense of the mysterious and virtual elements of the relationship between performance and film, in which performance may always resist and counter, to some degree, its own assimilation and projection by moving-image media. In the irreplicability and immediacy of its gestures, the body in per-formance remains infallibly unseizable by moving-image media; it cannot ever ultimately be represented. Moving-image media of the body in the act of performance, extending from the most accidental smartphone sequence shot tangentially by a disinterested passer-by to the most intentional sequence of surveillance film (shot, for example, for corporeal identification for purposes of criminal pros-ecution), cannot ever comprehensively render the body's mysterious interior, and remain glancing surface encounters which the body may itself seek further to deflect, as in a performer's self-masking during a protest performance. Film possesses an extensive history

of infiltrating the body's subterranes, often in a medical or warfare context. Endoscopic micro-camera and pill-camera sequences explore the passageways of the body, searching for sites of disruption, just as *Possession*'s sequence of Adjani's passageway mad dance locates pivotal malfunction in the city's subterranes. Similarly, contemporary thermographic moving-image media seize the presence of the body's internal heat for digital analysis, mutating it into colour-coded representations, in order, among other aims, to activate the decimation via weaponry of that heat-emitting body. Pornographic film-making's camera lenses, too, may enter and illuminate the body's darkened parameters, scanning passageways and assessing the presence of fluids, in an infiltration that oscillates between sensorial excavation and the impulse for corporeal negation. Among film's experimentations with the subterranes of the human body, Stan Brakhage's film *The Act of Seeing with One's Own Eyes* (1971) forms the leading attempt to discover whether death itself is locatable within the remit of performance. In that film, documenting the procedures of an autopsy room in the city of Pittsburgh, Brakhage's sequences of scalpel-incised or disassembled corporeal subterranes occasionally disclose moments of extreme transmutation, in which, for example, the intricate gestures performed by disengaged mortuary assistants, around and into the autopsied bodies, appear abruptly to mesh with those bodies' forms and to momentarily reanimate them, through such movements as that of a moribund arm propulsively reaching outwards, as though in a performance of protest. But in such uncanny movements as those enacted via Brakhage's film, the body still locates itself, even in death, in its own autonomous zone, always potentially re-vivifiable into performance, but intractably opposed to its final rendering into film.

The manifestation of insurgent corporeality itself – as an internally originating anger or allied emotion that spectacularly erupts, vocally, gesturally and in the form of bodily fluids – may also be viewed as

Stan Brakhage, *The Act of Seeing with One's Own Eyes*, 1971: film-image.

one which transits from the corporeal subterranes to external city space; it can take on an explicitly performative form for spectators, as in Günter Brus's many performance-art actions of expelled urine, excrement and blood, undertaken across the second half of the 1960s, or that of innumerable contemporary performance artists whose work involves the making-visible of whatever appears most subterraneously dark and outlandish in the matter of the human body, often through the form of obsessional inscriptions of that expelled matter onto city space. That abrupt emergence of corporeal matter (into an auditorium or art gallery, or into exterior city spaces not habitually assigned as performance locations) forms a seminal performance preoccupation, extending far beyond such reductive categories as 'body art'. Once the body's contents are transacted into external city space and onto its surfaces, they become more

intimately exposed to their seizure by film, as corporeal traces and detritus, but still evoke the 'impossible' transit of the body's subterranes, via performance, to exterior city space. Artaud, as the pre-eminent theorist of such performance acts, evoked them in two disparate ways, on either side of his Ville-Evrard incarceration. In his 1930s performance theory, such city-located expulsive movements could be precipitated by external agents, such as the bubonic plague that decimated Marseille's population in 1720–22 and involved a salutary mutation of the body's interior fluids into the virulent new media of plague fluids as they broke the body's carapace, emerging in a contagious proliferation; but in his final, post-asylum performance theory of 1946–8, Artaud envisages an intentional, self-generated autopsy process that condenses the body to its essential components and vitally meshes subterranes with surface, so that what it transmits (explicitly beyond the capacity for representation, including that of film, for Artaud) is an act of performance – a choreography of the body in a condition of furious insurgency and eruption: a one-body riot – whose spatial presence on Paris's streets is uniquely viewable, at the moment it takes place, by the spectator's eye, but will also imminently erase that space and all of its agents of control and suppression. That act's aim for its spectators, in transforming corporeal subterranes into unprecedented external-space performance, is: 'to emerge/go outside/to shake/to attack/the mind of the public'.[13]

Performance in contemporary city space may counter the potential expulsion of its presence from surveillance-subjugated, digitized external environments through still more corrosive and intensive manoeuvres enacted against that process of subjugation and control, drawing upon the eruptive potential of subterranean space (often historically conceived as a spatial site of resistance) and the aberrant capacities for insurgence of the human body itself. Performance, across its history, has instigated events and upheavals of perception through which an apparently unassailable entity of supreme power

is exposed as fragile and instantaneously subjected to disintegration and ruination. Through the overturning of spatial homogenization and of the corporate pre-eminence of contemporary city space, reactivated performance zones may emerge in which the relationship of the body in performance to that of the moving-image media that render it becomes one in which each works to sharpen the other's exploratory capacities. New spaces for performance and film may be created that incorporate liminal transits from subterranes to surface, from the body's mysterious strata to its spectator's vision, and from performative preoccupations with the city to those of the body.

CORPOREAL PROJECTIONS:
MARKS OF THE BODY

The space and presence of the human body form the pre-eminent elements that generate the entity of performance in its volatile meshings and interconnections with other entities, especially the spectator's eye and the film camera's lens. The human body is itself a projection in performance, which marks itself into that eye and lens, determining its own residues and memories, in the forms of ocular after-images and filmic sequences, but such projections – across memory and representation – also leave traces in the subterranean strata of the body in performance. That projective status of the body remains invariable across all of the manifold but conjoined forms of performance: performance art, dance, digital media art focused on the human body, theatre, activist or riot-directed acts, and obsessional, one-off actions conducted in external city space. Performance is always expansive in its corporeal ramifications, so that the body's presence becomes intensified as it enters and pervades space, and the filmic sequences that seize it, even in fragmentary or disintegrated forms, bear the traces of that intensification of the body in space. Any act of writing which attempts to explore performative forms, such as that of dance, is also transacted into an expansive and open-ended corporeal act, as the Japanese performance theorist Kuniichi Uno emphasizes:

> Gradually dance came to infiltrate the writing and very flesh of my thought . . . For me this questioning of the body has opened

up a vast field over which everything is connected to everything else, a vast spider's web of problems where I wonder if there could be a special status of life that corresponds to this body, and what kind of time and assemblage of different forces this life opens up in revealing a political or social field, still to be discovered.[14]

The unique dimension that filming brings to performance is that of creating a further, autonomous entity, extending beyond those of performance and film. That entity – generated from performance and film, but distinctly separate from both, in their amalgamation – is always precariously poised, through its status of autonomy, on a tightrope transit between the domains of performance and film, which invariably attempt to 'claim' it (through the way, for example, a film of a performance is often perceived, and even acclaimed, as being identical with the original performance itself); such an impeded transit, however, exponentially strengthens that entity's hold on the human body which it reveals and projects. In such projections, of filmed performance as constitutive of corporeality, the body's fractures and self-inflicted woundings, along with its capacity for imminent vanishing, are infinitely magnified, along with the exactitude and transformatory capacities of its gestural movements. In a dual strategy, film propels the body's gestures more deeply into itself, but also seductively extracts those gestures from the body's surfaces and allows them to inhabit the surrounding space, which film is attuned to render in intimacy with the body itself. In that sense, the human body forms a more powerful presence than either performance or film (it can, if it so desires, discard and annul both media), but once it intersects with them, it is caught in an intricate process of conflictual oscillation, pitched across the mutable zones between the presences of the body in its spaces of performance, and the memorially spectral but also dynamically

spectatorial presences of moving-image media. In all of those inter-
sections, the body *gains* from its contacts with performance and
film: it accumulates in strata and acquires new dimensions. It can
project its vital aberrations. Even in its disappearance, it is sustained
into the future through its performative transmutation into film's
sequences. The amalgam of performance and film forms the human
body itself, together with its vital residues.

The body always leaves marks, both upon performance's spaces
and the celluloid surfaces or digital data of moving-image media.
Even across the evanescing duration of performance, the body in-
fallibly imprints its trace, however infinitesimal: the scuffing of a
heel into a ground-level surface during that body's acts of abrupt
turning, the acidic residue of sweat or tears jettisoned from that
body onto an adjacent wall by a propulsive movement, or the expulsion
of saliva propelled through vocal exclamation onto the clothes or
facial contours of nearby spectators. Bacteria, acids, collateral damage
and minuscule corporeal traces from performance are marked into
its spaces, so that the trajectories of movements and the sonic dimen-
sions of a spectacle may always potentially be reconstituted, at least
in part, via the forensic examination of its location, as though at the
scene of a crime or of an act of autopsying, from those fragmentary
residues. The memorial capacity of a performance's spectators also
constitutes a physical marking, in the retina and brain cells, which
memory reactivates and transmits back to the spectator's tongue or
fingers, as they attempt to remember or visually represent a lost per-
formance. Similarly, a body filmed in performance cannot finally
endure the dissolution of its presence once it has been registered.
Even the most decayed performance films still carry the body's
ineradicable trace, as with the films amassed in India by the archivist
Mohan Khokar, of celluloid mid-twentieth-century documents such
as those of the celebrated dance performer Ram Gopal, discovered
discarded in a dustbin after decades subjected to dilapidation by the

Kurt Kren, *Self-Mutilation*, 1965: film-image.

monsoon climate, the celluloid so contaminated by fungal growth and its own material's dissolution that only the barest discernible presence of the performer's body survives. Similarly, digital manipulation of a damaged or obscured performance film in which the body is near-impossible to see or has submerged into darkness, as with Richie's first ankoku butoh filming, reactivates that body's visibility. Corporeal markings may appear to subsist only a hair's breadth from disappearance, but such traces, across performance and film, form perversely resilient presences, as in the innumerable instances in which a document or film of performance believed irretrievably lost will duly reappear.

Alongside the body's marking, in the act of performance, on its surrounding spaces and surfaces, and on the moving-image media recording it, performance is always inscribed on and into the body itself. It may be rendered in the immediately visible forms of scars,

bullet-holes, burns or other long-term abrasures and apertures, as in the body-directed performance-art lineage of such figures as Marina Abramović, Chris Burden, Ron Athey and Gina Pane, in which a mid-performance self-assault (occasionally an assault by the audience) left a trace persisting far beyond the performance's duration itself, embedded in flesh. But even the most mundane performance cannot ever vanish entirely from the body; the habitual gestures of sheer repetition itself, as in a performance near-identically restaged many hundreds or thousands of times, create physical evidence of internal impairment in a parallel way to those generating repetitive strain injuries. Physically demanding gestures of dance performance, over decades, inflict damage upon those pivotal parts of the body from which such gestures originate. Even performances of total stillness, or of relentless gazing in immobility, such as that of the Turkish performance artist and choreographer Erdem Gündüz (named 'the standing man' by global media outlets), enacted within the turmoil of Istanbul's Taksim Square in June 2013, leave their corporeal markings. Those amassed markings, in their untold variants, as corporeal traces of performance, may operate at skin-level, as with 1960s performance-art traumas; as sub-strata injuries of the musculature or skeletal structure; as neural or cerebral fissures; or as a collecting of all such imposed and self-wielded marks, thereby embodying performance. In that sense, films of performance, as well as documenting particular acts of performance in auditoria or public space, may equally constitute filmings of naked post-performative bodies in which such marks can be seized, as film cameras transit across and between them, in order to render performance through its temporally and spatially layered damage, accumulated within and upon the body itself.

Archives intended to hold the memory of the body in performance also possess that filmic capacity to incorporate performance via the scanning of skin surfaces and through intimations of corporeal

Erdem Gündüz, *The Standing Man*, 2013: film-image.

subterranes. Performance archives may take many forms, from insti-
tutional collections of segregated documents and films located in
climate-controlled edifices to arbitrary and capricious amassings
of jumbled materials in chaos. A visitor's journey down to a subterrane
or cellar may be required, as with the archive of Genet's work. But
in every case, a performance archive attempts to materialize the
evidence, with its disjunctive strata, of performers' bodies, or that
of writers and film-makers of performance, or of the entity of per-
formance itself, as though it held a uniquely corporeal form. Such
archives constitute physical residues, just as a film of performance
skins the act it records, or the spectatorial memory of performance
distils key moments and discards others, from a performance's
entire duration. All archives of performance form sites in which –
through the kinds of adept conjurations and materializations

endemic to film's originating era of the 1890s – performance's bodies are tangibly resuscitated from disappearance.

The body is at the origin of film's intersections with performance; without an act of spatial occupation by the body, however momentary its duration, film has nothing to seize other than darkness or emptiness. Even in films of performance art in which no trace of the body is caught for extended periods, a corporeal insurgence into space remains anticipated, except in the instance that the performance pivots on the body's exclusion, eradication or voiding from space, by maleficent agents or through a wider corporeal vanishing; future films of performance may take the form of infinite digital sequences in which the body never makes its appearance in space (as the equivalents of surveillance-camera filmings of 'secured' space, which should never be crossed and whose corporeal traversal would constitute an aberrant emergency). A performance film without the body's presence, in that sense, forms an anti-film of performance's voiding. An act of intention is always at the starting point of the body's own entry into the space of performance, but performance may be filmed with no intention at all, by accident or robotically. A film-maker may seek purely to document performance with an intended representational veracity, or conversely (as with film-makers such as Kren and Iimura) to conflictually transform the time and space of that performance via the interposition of film's own dynamics. Once the body in performance enters the arena of film, it becomes subject to film's shifting zones of intention, which allow the body to be adhered into film, but also enable film to engulf and occupy the body. When film engulfs the body in performance, it assumes the status of a presence now layered ineradicably within that filmically regenerated body, and a new origin for performance is thereby created in film itself.

For both performance and film, the body constitutes the seminal preoccupation that activates each medium and vivifies it with

contestations, evocations, conflicts, spectacles, without which only emptied-out space and moribund celluloid or digital data subsist. The transmutations of the body, across performance and film, result from the all-consuming obsession that corporeality presents. In the same way that abstract art concentrates perception of an ostensible absence of the body into that body's residual traces (such as the minuscule awry gestures or irregularities that disclose the artist's corporeal intervention into a monochrome painting), the body's near-absence in performance or film accentuates the necessity that, when corporeality finally manifests itself, it will undergo an upheaval. Conversely, when performance's filming renders a corporeal excess – as in films of intensely active performance groups such as Zero Jigen in Japan in the 1960s, in which the film frame becomes saturated with expansive gesture and inrushes of cacophony – that proliferating presence of corporeality is subject to an enforced reduction by the spectator's eye, and distilled into those spare gestures that solely project, with optimal focus, the performative contestations at stake.

In all films of performance, at some juncture, the body must vanish from sight, either because the performance is over, the film-cartridge recording it has lapsed or the film-maker has been impeded from continuing to document the performance. In many performances, the loss or expiry of the body from performance space does not exactly coincide with the performance's own end: in an auditorium, the performance's spectatorial focus may switch, for minutes or hours, to the residues left behind by the performance's corporeal confrontations; or in an external performance space, no conclusion to the performance may be signalled at all, once the performer's body has disappeared from view, so that it is left to the spectators to determine the performance's conclusion, located at the instant their ocular attention abandons it. In films of performance, such moments of the expiring of corporeal presence are almost always mismatched from the duration of performance itself; film requires

far longer than performance to register a corporeal voiding, and that 'interval' in itself has often been a preoccupation of film, as in extended sequences – such as those of Michelangelo Antonioni and Béla Tarr, in The Passenger (1975) and Werckmeister Harmonies (2000) – of deserted city space, or liminal space, from which a body has departed or into which an anticipated body may never arrive. Film, separated from the body, may durationally sustain that perceptual transformation of fissured space – from corporeal into abandoned space – to the point at which film finally assumes for itself the presence and substance of the body with its performative capacities.

Performance art, in particular, allows the body to fully occupy space, exposed to an audience's gaze for extended, if intermittent, durations, most notoriously in Beuys's film-documented action I Like America and America Likes Me (1974), in his gallery-space ritual interaction with a coyote, or else in a state of ostensible unconsciousness, as in Tilda Swinton's performance of sleeping in a glass box, The Maybe, enacted at numerous art museum venues from 1995 to 2013 and multiply filmable at will by its spectators. The pervasiveness of the body, in such performances, may exceed the capacities of film, so that, in its documentation, performance becomes rendered only in the form of extracts, as in Helmut Wietz's film of Beuys's action. But, whenever the body is near-absent from performance – voided in space, or arriving only at the last moment – performance and film are at their most intensively conjoined, in the search for the sensorial contours and representational capacities of a body without which they will lapse as media. Film documents of the body's performative scarcity resonate with archival films (such as those amassed by Mohan Khokar) in which material disintegration has sieved out almost all residual filmic trace of the performing body, so that the eye needs actively to interrogate each sequence in order momentarily to relocate the body. When the near-voided body finally

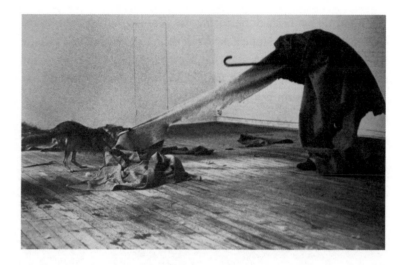

Helmut Wietz, *I Like America and America Likes Me*, Joseph Beuys, 1974: film-image.

makes its abrupt, deferred appearance, performance and film con-
spire to invest their maximal co-presence within it, so that the
body is often extravagantly propelled – as in those films of Antonioni
and Tarr – into sequences in which, from absence, it expansively
transmutates into a catalyst of murder or apocalypse.

Performance and film embed their own presences and traces
into and around the body, through the enforced historical framework
of events, technologies, lineages and theories into which the body
is positioned at the exact instant in which its public act of performance
becomes exposed to its spectator's eye or to moving-image media;
especially since the prevalence, from the 1990s, of international
museological contexts for performance art and experimental film,
presented in the form of vast overviews and retrospective exhibitions,
the body in performance is ligatured and carapaced by such defining
contexts, and its acts instantaneously overlayered and infiltrated by
parallels, intentional or accidental, with innumerable other acts in

the multiple histories of performance. The body in contemporary performance art may appear as the derivative, recapitulated variant of 'key' performance-art acts that took place long ago but remain prominently visible through their rendering into film documents that are now spatially accessible in museum exhibitions, or else collected in digital performance archives such as ubu.com. But, at the same time, with the immediacy of every new performance enacted in contemporary external city space, and its seizure of its spectators' vision, the body always possesses the capacity to annul all constrictive context, to expel performance histories (and all ossified histories) as detritus from its own domain, to reconstitute performance from zero, and to imprint its own corporeal origin upon the time and space of its filming.

As well as being infiltrated by performance and film, and their histories, the body itself may inflict its own self-markings, so that the performer's body is rendered into a surface and interior corporeal projection of performance, and thereby especially attuned to its encounters with film. Particularly in the domain of performance preoccupied with exploring the parameters and fragilities of the body, the performer's skin may become a surface either for punitive self-stigmata or for ecstatic self-display. Skin itself forms a neutral medium, punctuated by a lifetime of imprintations and accidents – operation scars, healed cuts, birthmarks, wrinkles – but remains always open to performative interventions that will transform it either momentarily (for example, through acts of repeated slapping which blood-redden it, as in the characteristic work of Japan's Kaitaisha performance group, or burnings which ephemerally scorch it) or permanently, so that the markings of performance will be carried through into death. Imprinted skin can be spatially offered to visibility or subterraneously obscured. Corporeal self-markings may also be divided between those which the performer secretly

carries, as internalized doubts or traumas that only emanate to the surface from their habitual invisibility in extreme situations of emotion or loss of control, and those which are always visible, as rips, incisions and scars, or corporeal accessories, that manifest themselves in such a way that the orientation (sexual, political, ecological) of the performer is always in a state of ongoing projection, as with a perpetually on-display loop of film.

Bodies in performance, especially activist or sexually inflected performance, will accumulate arrays of corporeal markings with an explicitly performative intention in the form of a self-archiving of textual and visual forms: tattooings, piercings and skin incisions, among others. Imprintations into the body are executed with the tips of tattoo needles, or razored, as instruments of performance in the same way that the voice, or the hands, may be perceived as performance's instruments. Such markings into the body accumulate as internally directed (needles and razors are always wielded inwards, or transversally) preparations of the body for performance, but at some point the marked body will undertake an inverse manoeuvre to face outwards, towards its spectator's eyes and external spatial locations, so that corporeally focused performance shifts to ocular- and city-focused performance. Markings of the face, in the form of maskings or tattooings and lacerations, generate optimal performative projections of the body, since the eye, to 'read' performance, habitually first scans facial representations or obscurings; film, too, adheres to the face, unless an act of zooming or blurring redirects ocular focus. In the spatial projections of the body's archived contents, through the act of performance, corporeality forms its own screen; the city space surrounding it, for open-air performance, in plazas or wastelands, constitutes a second, 'environmental' screen that can also incorporate the digital screens often pervasively transmitting moving-image sequences in external city space. Whenever a performance in which corporeality explicitly manifests its markings is

filmed, the spectator's eye assesses multiple screens simultaneously – corporeal screens against, and in intersection with, environmental screens – as conjoined elements of performance in space. Such body screens form intimate counterparts, generated by performance, to all manifestations of projection screens, from those of moving-image media's first projections of the 1880s and '90s, to the city-located digital screens that accompany and accentuate contemporary external-space performance.

Any emphatic marking of the body in performance will unsettle the eye, since it annuls the transparency through which corporeality with its gestures is optimally projected. The foregrounding in the body's performance of what has emerged from its interior or sub-skin zones will constitute a fissuration of that stultified transparency upon which all institutionally sanctioned performance depends. Self-scarrings, such as those often executed in body-testing performance art, or facial maskings and total envelopings of the head, as in the work of the activist performers of Pussy Riot, impair the habitual time and space of performance in a parallel way to that in which a cinema screen, striated by razor cuts or audience damage – for example, in the Lettrist art movement's cinema-space experimentation of the early 1950s in Paris, or in all-night cult-movie projection frenzies worldwide – forms a concurrently fissured medium of projection. Cinema spaces in states of malfunction, whether abandoned or wrecked, form sensitized locations for activist performance in which the status of corporeal projection itself is vitally at stake; such cinematic spaces, historically designed for immersive projection, may also constitute originating zones for the planning and launching of activist performance events and interventions, projected in transits from interior towards exterior space, into the surrounding contested streets, as during the activist occupation of the derelict Vox cinema in Athens during that city's deep unrest of the early 2010s. Such performance-inflected eruptions may also consume cinema spaces, in

history-obliterating oblivion, and lead to their erasure, as with Athens's Atikon cinema, destroyed during rioting in 2012, or Bangkok's Siam cinema, similarly subjected to city-rampaging incendiary acts and destroyed in 2010.

In external city space, the body in performance also resonates backwards in time beyond cinema's origins, with the late nineteenth century's panoramic media of projection, exemplified by such all-engulfing spectacles, for their in-movement spectators' bodies and vision, as the large-scale Panorama of the Battle of Racławicka (executed in 1893–4 and exhibited for the first time in Lviv in 1894, the year before the first celluloid-media public film projections, before being relocated to Wrocław following the Second World War). In its extreme instances of performative self-projection, within such

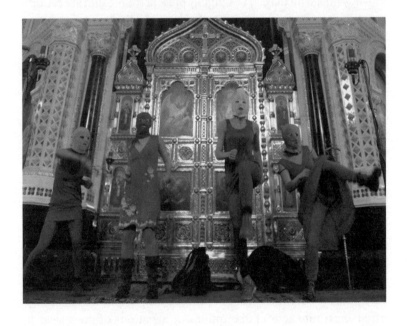

Pussy Riot, *Punk Prayer: Mother of God, Drive Away Putin*, 2012: film-image.

locations as large plazas that are open to spectatorial vision on all sides, the body may constitute a multi-directional corporeal panorama for the mediation of its subterranean and skin-inscribed markings. As acts of display in city space, such performances form amalgams of gestural corporeal material, intricately archived on the skin in variant forms, together with unique embodiments of performance itself, as immediate-moment instances of performance which often build on or intervene against the histories of performance cultures (acts of performance may well also be undertaken with no knowledge whatsoever of performance cultures' histories). Such amalgams are bound by film: film serves to scan and collect the markings of the body in performance, and accentuate them in such a way that their correspondences with performance histories and those of associated moving-image media can be tangibly present for the film spectator's eye. Whenever a performative body is openly displayed – screened or panoramically projected in external city space – film may act to endorse and sanction that performance simply by confirming its momentary existence and ensuring its future survival in moving-image form. Film constitutes an 'exposure' which emphasizes the performing body's own vision-oriented exposure in the city zones it inhabits in order to perform. The body may also exhibit its markings and incisions in spatial subterranes and sub-city sites, and thereby gain in spectral and subcultural presence, but it will then lose the screen-projected eminence it acquires in light-exposed performance.

The danger for the body's performative projection, in exposed public spaces and external central city space, is in the capacity for its visual evidence, predominantly that of film, to be appropriated and deployed for punitive aims of censorship and incarceration. Performances in which the body provocatively displays its markings often constitute activist disruptions or negations of the spaces in which they unfold and of the power structures underpinning those

spaces. Although film may appear to sanction the visibility of performance acts, it can also readily be transacted into a duplicitous medium which accentuates the vulnerability of such performances. Film is always manipulable and reconfigurable into 'hard' evidence for use, alongside other materials, in prohibition, as for example in the judicial scrutiny of the filmed fragments of the Vienna Actionists' collaborative *Art and Revolution* performance of 1967, staged openly in an auditorium of the University of Vienna, and encompassing such corporeal provocations as Brus's act of excretion and his singing of the Austrian national anthem while masturbating; in that instance, both the performer, Brus, and the ostensible film-maker, Kren, became subject to harassment (Kren had not in fact filmed the performance, because of a lack of film cartridges, and the film had been shot by another film-maker, but Kren, as the Actionists' habitual film-maker, attracted the resulting judicial fury). Alongside such overturnings of performance film's intended purpose, it has often been shot with the explicit, sole aim of gathering negative evidence, as in the use by the GDR's state-security agency's cinematographers of film as a medium to document insurgent punk-rock performances of corporeal provocation in exposed city space, thereby generating evidence to officially prohibit punk-rock performers and their associates from entering central East Berlin and, especially during the period 1982–4, to incarcerate them. Contemporary instances – such as the film made by the Pussy Riot collective of their abbreviated public performance in the Cathedral of Christ the Saviour in Moscow in 2012, edited to accentuate the derision directed towards abusive power by that performance of head-masked (slit to reveal only the eyes and mouth), wildly kicking figures, and subsequently forming evidence for punitive identification and prosecution of those figures – indicate the enduring potential of corporeally charged performance's film-making to mutate into a contrary instrument for suppression.

Film forms the arena of projection in which performative markings upon corporeal surfaces (skin, clothes) constitute seminal acts of transformation, both for the performer's status and also for spectatorial perception of corporeality in performance space. Once the body is marked, and that gesture confirmed by its filmic visualizing, it cannot be unmarked, and is then propelled into a disparate status, acquiring a new identity as well as entering another regime of vision and recognition. A mark upon the body may rest on its exterior layer, or, if the mark is that of a corrosive agent or weapon able to infiltrate flesh, sink into its interior strata and reconfigure its subterranes as well as its exterior surface. Performative markings on the body may devalue or stigmatize that body as well as elevating its status. Notably, in the sequence of Fritz Lang's film M (1931) in which the child-murderer Beckert is marked, during his abduction of a child, by a watchful criminal who takes chalk from his pocket before inscribing it onto the palm of his hand and then violently projecting that mark onto the shoulder of Beckert's overcoat, a corporeal act redefines the marked body's visibility and exposes it panoramically to all city vision. Beckert has initially been identified sonically, through his repeated acts of whistling one tune, by a street seller marked, as with the 'fully blinded' street musician who confronts Biberkopf in that same year's film Berlin Alexanderplatz, with a sign confirming his blindness; but, in order for Beckert's ongoing act of child-killing to be interrupted, that identification needs to be transacted from a sonic to visual idiom through corporeal imprintation. Beckert himself, together with the child he is about to murder, is the first to view that hand-inscribed projection – the letter 'M', indicating his identified status as a murderer – in a mirror positioned at a toyshop's entrance, and reacts with wide-eyed horror at his act of self-spectatorship; although the child he plans to murder then attempts to assist him in erasing that marking, it cannot be effaced, and remains an integral part of his body's surface, as though through an act of cattle branding.

Fritz Lang, M, 1931:
film-images.

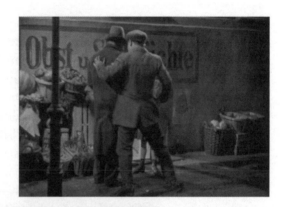

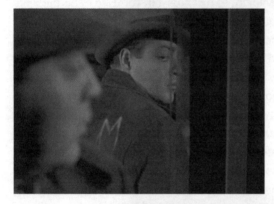

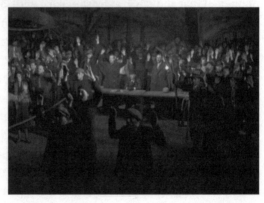

Once Beckert is corporeally marked, his visibility in the city abruptly veers from covert invisibility to glaring exposure, and the conjoined criminal and beggar communities who are pursuing him scan his body and trap it through a pervasive choreographing of city space. At the same time as he is pursued in the Berlin streets, the police are able to assign Beckert's crimes to him by discovering his own involuntarily inscribed markings in the form of lettering that became embedded into the sub-paper wooden surfaces of his lodging room as he wrote taunting letters to the police.

The marking of the child-killer Beckert's body exposes him to extreme ocular vulnerability, so that he is duly cornered by his pursuers in a storage warehouse, then transferred to the subterranean vault of an abandoned alcohol distillery for his trial by criminal judges, who have assumed judicial authority in the face of the police's previous incapacity to arrest Beckert. That subterranean space is occupied to saturation point by the amassed presence of an audience of criminals who have assembled to witness Beckert's performance of attempted self-exoneration; as well as separating the intentionality of his acts of child-murder from his own identity, Beckert also berates and negates his own audience, as one of self-assigned judges, by attributing intentional criminality to them. Since Lang notoriously populated that audience, at least in part, with 'authentic' criminals who risked arrest through their participation in the film, the status of that audience forms a volatile one: as performer-criminals, they are denounced for criminality by the actor Peter Lorre (soon to risk arrest in public space, for his 'marked' status as a Jew in Nazi Germany, necessitating his decision, in 1933, to flee that country) as the child-killer Beckert. The absorbed audience of Beckert's performance of self-exoneration is liminally poised as one of imminently active, lethal spectators; once that anguished performance is over, or is interrupted, they will collectively invoke his death sentence and rush to kill him. By suppressing and erasing his marked corporeal

presence as a child-murderer, they will also annul Beckert's own performative capacity, via vocal seduction, to enact the vanishing from city space of danger-exposed children. Beckert's audience will reconfigure its own status from that of spectators to killers; but in the very moment those spectators begin to traverse Beckert's performance space at speed in order to kill him, the police suddenly arrive and shift that audience's status from killers and judges back to criminals, and from that of an active to passive audience, with that shift marked by the mutation in their limbs' gestures of imminent killing to hands-in-the-air surrender.

Lang's M, with its sequences' pivotal corporeal markings, exemplifies 1920s and early '30s Berlin, and its culture of body inscriptions, declarations and imprintations, enacted alongside that era's visual culture of prominent city screens, hoardings and neon displays. The inhabitation of such city surfaces, especially for their young, sexually preoccupied population, demanded the intricate performance of ritualized dress codes and gestures, which films of that moment tracked and documented. Those performative rituals and gestures infiltrated the city's extensive subterranean nightclub and sex-venue cultures, alongside the more visible public spaces of body-exposing bathing and seduction at the city's lakes, which semi-documentary films such as Robert Siodmak's People on Sunday (1930) recorded. Corporeal transits between exterior city space and nightclub subterranes or other underground spaces became uniquely imprinted with dense projections of sexual obsession in the form of systematized self-markings, via bodies and costumes, intended to invite precise identifications of sexual practices and preferences, including those of lesbian and gay figures; in turn, those self-markings resonated with the framework of city projections – often in a state of upheaval, through the relentless disassembly and reconfiguration of city space that numerous sequences of Jutzi's Berlin Alexanderplatz emphasize – that surrounded them. That proliferating performative

culture of self-marking exceeded film's capacity effectively to render it, spilling into manifold iconographic cultures of visual art, photography, pornography and other forms, which Mel Gordon's scrapbook-format volume *Voluptuous Panic: The Erotic World of Weimar Berlin* documents in the form of an archival reconstitution of near-lost corporeal cultures.[15]

The spectacular intricacy of self-marked corporeal rituals throughout Berlin at the end of the 1920s, as a city-instilled performative culture oriented towards the accomplishment of multiple sexual acts, facilitated that culture's correspondingly all-engulfing disintegration. The future-directed momentum and extensive spatial infrastructure (especially in the form of many hundreds of nightclubs promoting sexual variants, each with its own distinctive performance idioms) of that sensorial culture rendered its plummeting into erasure, with the onset of the National Socialist era, acutely rapid, as though subject to the abrupt reversals integral to Lang's M, whose original title, *The Murderer Among Us*, had been opposed by the ascendant National Socialist hierarchies for its prescience of the institutionalized killing – such as the dispatching to Berlin's city-bordering Sachsenhausen concentration camp of much of its gay community – that would become prevalent two years after the film's release. That enforced cultural dismantling, from the beginning of 1933, took place through pervasive forms of negative ocular spectatorship, in which police, state-security agencies and public vision focused upon identifying elements of behaviour or appearance in disjuncture with approved National Socialist forms of corporeal culture; in that sense, both body-surfaces and city space became subject to a regime of relentless exposure, abrasure and excoriation that transformed the appearance of the city as a site of performance together with the projections of the human body itself.

The disintegration and vanishing of corporeally focused performative cultures – through political turmoil or other seisms, and

exemplified in their extreme instance by that of Berlin in 1933 –
entails the annulling of entire gestural vocabularies, practices and
rituals. Films such as M, and the city's back-courtyard-located films
of the same period, carry an emanation of the 'just-pre-obsolescence'
embedded within a dynamic culture of performance which, even in
a state of accelerating profusion and expansiveness, may still be
comprehensively razed, to survive only as scattered detritus; the aura
in M of perpetual exposure to violence, and the film's emphasis on
arbitrary shifts in roles such as those between judges and criminals,
or spectators and killers, indicate both the vulnerability of performance
cultures to reversals and upheavals, and the capacity of film to seize
those upheavals in accentuated sequences or in the form of illu-
minating fragments. Film, alongside other visual media, enables
archival renderings of performance and its corporeal self-markings,
but those moving-image traces often intimate the ways in which
performance cultures may be exposed to unstoppable mutation.

The body-marked performance culture exemplified by late 1920s
Berlin equally forms a contemporary one; its mutation's velocity
across space impels corporeality to manifest and project itself –
intensively marked with insignia, piercings, self-mutilations, tattoos
and sex-indicators – as fully in the contemporary as in those seminal
moments when film, in experimental flux, as in the 1920s and '60s,
welded itself to those body-instilled performance cultures. In their
filming, all acts of performative body marking constitute allied, syn-
chronous ones, with their cohering spatial arrangement often taking
a street-location axis, in such markings' manifestation in proximity
to (or as an integral part of) external-space riot protests. The body,
in its markings, especially those upon the face, may enact a densely
enunciated exclamation – in defiance of systematized spatial pro-
hibition and pervasive digital-media surveillance, or of wider projects
for ecological and human despoliation – in conjunction with textual

exclamations carried in the form of banners or transmitted between protestors via hand-held devices. The filming of self-marked bodies in such performative situations generates archival elements towards a vast corporeal assembling that originates with the first moments of moving-image cultures and positions all performance acts undertaken across that visual history within a simultaneity of the concertinaed contemporary instant. Body-marked performance cultures always provocatively exact a strenuous dynamic of interaction with their audiences, whose potential manifestations are signalled by M's subterranean sequence, in such forms as that of an audience whose status is negated by the performer, or an audience which rushes to kill the performer but is abruptly rendered, by film's freezing, into a petrified audience.

The human face forms the concentrated corporeal site preeminently configured for its own transmutation, as well as that of its audience's ocular capacities. The face also, above all other corporeal elements, attracts the film camera's attention. A face in performance may constitute an in-transit turmoil of infinitesimal gestures in which its markings (such as tracings or saturations of tattoos or dried paint, as in the work of performance artists such as Ron Athey or ankoku butoh performers) accentuate such blurrings and the ostensible impossibility of film fully to render them; Artaud, in a text written for his Paris exhibition of facial drawings in 1947, emphasized the condition of 'perpetual death' that the face in ongoing movement both enacts and annuls (death is negated if its movements become 'perpetual'), in which death itself, in its reversals and flux, forms the anti-representational boundary around which ocular and filmic fixity is erased.[16] The memory-artefact medium of the plaster death mask (such as Artaud's own, cast on 4 March 1948) carries a facial projection located only a hair's breadth from the contrary artefact of the life mask, as with that of William Blake, used by Francis Bacon as the source for his Study for Portrait II (1955), in which

the suspended face is surrounded by blackness, as though sub-terraneously located; the sequences of severed-head portraits by Richard Hawkins, such as *Disembodied Zombie George Black* (2000), correspondingly subterraneous to Bacon's life mask but now highlighted against virulent purple and yellow backgrounds instead of darkness, project death masks as performances of concentrated facial gesture, simultaneously emanating death and aberrant revivification.

Masks, as sites of facial gesture coagulated in suspended projection upon corporeal surface to form a new stratum or carapace, form the predominant component of the distinctively performative elements associated with late-2000s' and early 2010s' Occupy and Anonymous movements and groupings, especially in the form of the Guy Fawkes mask (derived from the graphic novels of David Lloyd and Alan Moore), which intimates wily conspiracy but also serves to consolidate alliances, via body markings, across activist-performers engaged in deriding financial abuses by states and corporations, among wider contestations. Masks form performance attributes only in relation to the body whose face they hide. Self-maskings, among other corporeal strategies, effectively screen away and avert processes of facial identification, via surveillance film and state-security or police cinematographers, of bodies in situations of confrontation, for example in infiltrations into financial institutions or during external-space uproar. In facial terms, self-masking, as with the Guy Fawkes mask, erases punishment-oriented visual regimes that pivot on filmic evidence; however, the lower body and its interior spaces may, now and in the future, be pervasively scanned by digital media for other intentional markings or involuntary attributes of individual identification. Such protective self-maskings also evoke a simultaneous adopting and adaptation – concentrated into one corporeal instance and projection – of all performance cultures' facial maskings, extending across millennia, such as that of Japanese noh performance, Greek and Roman festivals, and Cambodian

dance, among innumerable other cultures of masking; in some instances, the cultural act of masking marked an ephemeral time and space, such as that of carnival, in which everything (as in Weimar-era Berlin) appears nominally permitted, even if the mask's eventual removal, and the face's renewed exposure, will re-institute, with enhanced scrutiny and oppression, ocular regimes of the maintenance of state power.

Body markings, as in the performative sexual culture of late 1920s Berlin and in filmic sequences such as the death-imprintation of Beckert's body surface in M, may oscillate between self-projection and imposed projection, and possess contrary dynamics of ephemeral liberation and punitive retribution. But dual and linear forms of corporeal projection, in mediating performance, always cease to function in the face of film's capacity to rearrange their sequences in infinitely variable ways, and especially to conjoin, as simultaneities, apparently disparate or time-distanced representations of the body. In that sense, a filmed sequence of contemporary facially masked performance, affiliated to the Occupy or Anonymous movements' imperatives of annulling global financial duplicity, may be permutated with all other sequences of bodies engaged in performative acts which seek to exempt them from oppressive regimes, or to disintegrate those regimes. Formative moments of body-marked experimentation, with their respective corporeal or oppression-resistant capacities, may be consolidated by their compacting together, across time and space, by film's intersections. Film can also exact a salutary syncope or blackout, traversing consciousness and vision, and extending over more than a century of moving-image rendered performance cultures, in order to configure unprecedented amalgams of corporeal markings – with activist and sensorial potentials – for their spectator's eye, whenever it reopens from that syncope.

Corporeal self-markings may also be conjured in digital forms, in such manifestations as avatars and animations, so that all

contemporary spectacles of the self-adorned or self-mutilated body, especially those focused on and within the face – tattoos, piercings, incisions, excisions, eye enhancements – inhabit a shifting zone between corporeal and virtual entities in which surface may slip to interior, and interior to surface. The body, voided from the tangible and disassembled from an 'entire' status, is then rendered in abbreviated fragments, spectatorially attuned both to attention-concentrated spans of performance and to densely compacted filmic sequences, in which the body, together with all of its self-markings, must be projected and received with utter instantaneity. In such projections, the habitual accumulations and nuances of the body's self-markings, notably oriented towards their deployment against stultified, space-prohibiting regimes, may be entirely lost, but the body still remains a vital, momentary presence – always reflecting upon, and into, itself – that is sensitized for its incorporation within moving-image media. Even digitized bodies' self-markings leave indelible traces for film's performance-archival accumulations.

Alongside performance's self-markings, directed internally or across the surface skin of the performer's body, it may also exert its marks upon its adjoining spatial surfaces, so that corporeality and its space are vitally amalgamated by performance's gestures and movements. That intersection can be marked permanently or ephemerally, in the multiple forms of corporeal imprintation into space, but its residue may also be inscribed solely into its spectators' memory or ocular capacity, as a layering of performance's gestures *over* other, pre-existent visual memories, and potentially entailing those contents' supplanting, whenever performance possesses the capacity indelibly to sear the memory and the eye. Film's pivotal role – in exploring the interzones between performance's memorial and ocular detritus, together with performance's spaces of generation and expansion – may then be to seize the volatile transits by which acts of corporeal

marking extend outwards, from the performer's space to that of the audience.

In the extreme instance of that expansion, all spatial demarcation is scrambled and annulled; performers and spectators may then enter into a state of direct physical confrontation, as in the innumerable events of uproar constellating performance's histories, focused upon acts perceived as outrageous and obscene – as with the first production in 1896 of Jarry's *Ubu Roi* or in response to body-focused performance art such as that of the mid-1960s Vienna Actionists – or else upon acts viewed as politically contentious and provocative. Such corporeal confrontations have mostly been envisaged by their instigators as spatially directed from performer to spectator. For Artaud, in the final theoretical phase of his work, in 1947, direct and insurgent extensions of the performer's corporeal space to that occupied by the spectator became the sole means by which performance could validly operate, thereby entailing the abandonment of all other forms of performance. Artaud himself would be the performer exacting that confrontation: 'I realised the fact that the only language which I could have with an audience was to bring bombs out of my pockets and throw them in the audience's face with a blatant gesture of aggression.'[17] Just as the performer's own facial planes form the optimum site for self-marked inscriptions and incisions, it is the space of the spectator's face in particular, for Artaud, that offers the preferential location for performance's audience-focused corporeal assaults. Since Artaud's proposed medium of spatial expansion, from performer's body to spectator's body, is that of 'bombs', it will necessarily inflict damage upon, and potentially erase, the surrounding space of performance itself, whether that announced performance takes place within an auditorium or in external city space; additionally, no audience will survive the act of performance. At the same time, that spatial and gestural expansiveness of Artaud's act will constitute a performative 'language' that necessarily creates a form of rapport

(even a lethal one) between performer and audience, and, as such, one which a forewarned audience could readily anticipate to be articulated, in the space of performance. As an act of 'language', an intentional gesture that engulfed the spectator's body – via an incendiary projectile – could not be performed without warning (in that sense, it differs markedly from a terrorist's act of suicide bombing) and so must be declared before the proposed act, through the medium of writing, in the form of a performative manifesto text. But, at that stage of Artaud's work, with its resistance to processes of representation, language is conceivable solely as an act to be undertaken in the form of a unique, irreplicable instance, so that performative language act, in envisioning the lethal *marking* of the performer's body upon the spectator's body, is concentrated into the form of an immediate, intentional projection.

Performance's space may also be one in which its occupant-participants are called upon violently to mark each other, potentially curtailing the act of performance itself through that process. Yukio Mishima's spectacular performance of seppuku suicide, enacted in the company of four of his assistants on 25 November 1970 at the Ichigaya military headquarters in Tokyo, followed an extended period of spatial planning and self-choreography, and oscillated between external, semi-public space and internal, hidden space. Mishima, dressed in his self-designed military uniform, first gave a provocative manifesto speech from the vantage point of an elevated balcony, directed to a large audience of cadets assembled below; although those spectators, hostile to Mishima, vocally jeered his performance, they were unable to intervene spatially and forcibly end that performance, through Mishima's corporeal distancing above them. For the second phase of his performance, Mishima left the exposed balcony and entered the internal space of a military office, where he disembowelled himself before an audience of his own assistants and several captive bystanders; since Mishima's own act of self-incision

(precipitating the spatial and corporeal transaction of intestinal contents from interior to exterior) did not immediately lead to his death, one of those assistants then intervened to sever Mishima's head, thereby transforming his own status from that of spectator to participant. Since Mishima had alerted press agencies of his intention to create a disturbance on that morning at the military headquarters, the medium of film served to record the first phase of his performance, in the form of news-media cinematographers' footage of his balcony appearance, but was then unable to infiltrate the internal space in which the second phase of the performance took place (only the medium of photography, through policedocumentation of the performance's residue, in the form of Mishima's disembowelled body, rendered the spatial and corporeal choreography of that second phase). But the medium of film had already prefigured the second, spatially enclosed element of that performance four years earlier, as though presciently generating it, in the form of Mishima's own short film *Patriotism* (1966), in which he re-enacted a seppuku suicide undertaken in 1936 by a participant of an unsuccessful military coup. Film's relationship to performance and its space and time is never linear; it may reconstitute the event of performance, anticipating it from the past as well as documenting it in the present or retrospectively from the future. Film also fluidly reassigns the corporeal space of self-marking, so that acts undertaken between participants (as in Mishima's decapitation by his assistant) revert, via film's evidence, to performative self-markings.

Performance space's corporeal dynamics also hold acts in which audiences physically assault performers, often through a process of intensive corporeal marking, thereby curtailing the event of performance itself; such interactions between spectators and performers possess intimately intersecting dynamics to those of performers' assaults on their spectators, as envisaged by Artaud, or violent interactions between the participants of performance, as during

Yukio Mishima
death scene, 1970:
police photograph.

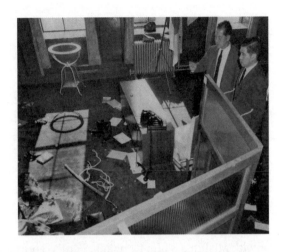

Mishima's action at the Ichigaya military headquarters, which he appears to have explicitly designed as a memorable, ocularly focused performance-art event with pre-arranged documentation. A provoked audience, confronted with an intolerable, body-directed act of performance, may intervene to curtail it through a marking or expulsion of the body of the performer, as for example with a performance of the production *Tokyo Ghetto* by the Kaitaisha company at a festival in war-marked Croatia in 1996, during which the relentless slapping of one female performer (generating an internal blood-capillary disruption which reddened the surface of the skin) by a male performer was abruptly arrested by a spectator's violent intervention.

Whenever film renders the space of corporeal interaction and marking that extends between performers and spectators, or between performance's own participants, particularly in situations of acute tension in which a performance may be violently curtailed, it may intervene at a minuscule distance (one film frame behind the body) from the instantaneity of that interaction, but it also possesses the capacity to reconstitute and actively overrule that space of performance and its corporeal imperatives from the perspective of another time,

Yukio Mishima,
Patriotism, 1966:
film-image.

as with Mishima's film *Patriotism*. Film's representational dynamics operate at variance from body-focused performance, while adding new strata, of memory and ocular depth, to that performance. But, in its sequences of the body's markings in performance, film may now constitute a vanishing and potentially obsolescent entity, already subject to its status's disintegration by digital media, and in clear distinction to the long-durational, ineradicable forms of performance, integrally bound to the human body itself. Through that capacity for endurance, performance may also now affront the digital world far more combatively than film, in its work of conjuring performative bodies in relation to distinctive, seizable spaces; but – across performance and film – contemporary corporeality, subject to the proliferations of digital culture, is unendingly rendered, in the form of infinitely deferred, in-transit bodies.

The contemporary prevalence of deferred or vanishing corporeal entities in performance culture – never attaining the gestural real-ization of definitive embodiment – intersects, via film, with the aura of corporeal 'uselessness' that has been at stake from the origins, in the mid-1950s, of performance art as a distinct, body-oriented

variant of performance forms. In the seminal context of Gutai performance art, Kazuo Shiraga's external-space performance *Challenging Mud* (1955) – in which Shiraga, dressed only in white underpants, wrestled gesturally with a large expanse of mud (or clay) in the grounds of an art centre in Tokyo – indicates that sense of the useless, just-pre-obsolescent body that must determinedly engage in a contestation whose success is pre-annulled from the first gesture. Shiraga's previous involvement in the Zero-kai ('Zero-society') artists' group further accentuates the status of a performance act which starts from zero, in the way that film had originated 60 years earlier, but cannot propel the body through the sequence of refigurations it desires. Shiraga conceived of his performance as situated solely in the immediacy of his intensive gestural contestation, rather than in the post-performance residue of the mud, imprinted adversarially

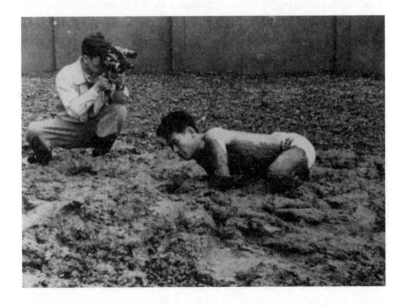

Kazuo Shiraga, *Challenging Mud*, 1955: performance photograph.

with his body's gestures, or in the performance's moving-image documentation. However, his performance's mutation into a moving-image media form had constituted an integral element of its process; the cinematographer filming Shiraga operated at a close distance to his ongoing act, with photographs of the performance showing the cinematographer's physical presence as a prominent one, as though he were a co-participant. The deteriorated film constituting the residue of that performance remains the pre-eminent form in which it subsists for exhibition, as with its incorporation in the Gutai retrospective exhibitions at the Jeu de Paume museum in Paris in 1998 and at the Guggenheim museum in New York in 2013. Film itself actively participates in the 'uselessness' of the body in performance – further highlighting the pivotal incapacity of performance to carry through the body's final transformation, projection or erasure – through the infiltration of its own moving-image dynamics of uselessness into performance, thereby contaminating and scrambling the 'aims' of performance. Film's bodies also infallibly 'fail' to seize or hold their presence within that medium, spectrally seeping from the image or else plummeting through the misalignments and malfunctions located between moving-image sequences.

Since film and performance may consolidate one another's 'uselessness' as corporeal media, by fissuring what is already an impossible process of accomplishment, only an arrangement in which the entities of performer and film-maker exactly coincide may render the body in a form so concentrated and immediate that it resists, to the maximal degree, the durational flaws and mischances that generate its aura of futility and redundancy. In that amalgamating of the work of performer and film-maker, collective preconceptions of the time and space of film and performance may be annulled in an open-ended upheaval of all linearity of past, present and future. But in such spectacles, that volatile revivification of performance

and film, veering erratically across time and space, remains subject to its saturation by the body's own aura of conducting a final, residual act, now seized in its last, convulsive movements; in a film-maker's performance, a disjuncture is invariably instilled into the ostensible simultaneity and spatial synchronicity of performance and film, notably foregrounding the impossibility of focusing memory's presence within that performance, so that all such acts may fall, at any moment, into 'useless' oblivion.

In October 2012, at the Volksbühne theatre in Berlin, the film-maker Werner Herzog undertook a performance, *Conquest of the Useless*, in which the film-maker's own capacity to embody film, via an act of performance, and at a moment in *extremis* of film's existence, was vitally at stake. That performance's title – drawn from the mountaineering memoir *Conquistadors of the Useless* (1961) by the French climber Lionel Terray, whose spectacular ascents of previously unclimbed mountains, prior to his mid-climb death, were often filmed – was also used by Herzog for the published journal of fragments (2004) in which he had interrogated his own physical and mental condition during the arduous shooting of his film *Fitzcarraldo* (1982), whose narrative pivots around the 'impossible' human propulsion of a large steamship over a precipitous ridge between two river courses in Peru. That 'useless' act, attempted in the isolated Peruvian jungle by Herzog and his collaborators – as one only tangentially replicating the nineteenth-century historical act it evoked, and transplanted to another location from that originating act – could be accomplished only through Herzog's obsessional, durational determination, and be evidenced, for spectators, solely through its filming from beginning to end, zero-point to zero-point; however, that eventual act of accomplishment (or conquest) is undercut in Herzog's journal by his voided sensation as the steamship is finally propelled down the far side of the ridge:

The ship meant nothing to me – it held no more value than some broken old beer bottle in the mud, than any steel cable whipping around itself on the ground. There was no pain, no joy, no excitement, no relief, no happiness, no sounds, not even a deep breath. All I grasped was a profound uselessness, or, to be more precise, I had merely penetrated deeper into its mysterious realm.[18]

In his performance as film-maker – and beyond his embodying of the memories imprinted in *Conquest of the Useless* – Herzog also occupied his performance space as a terminally exposed corporeal, detrital and archival trace of the 120-year-long persistence of film, in its status as a medium both for the recording and the confrontation of performance, through intricate processes of seduction and attrition. Herzog's darkened performance space consisted of vast-scale, layered projections of South American jungle landscapes and human bodies in the form of vivid, hand-coloured stereoscopic glass slides manufactured in the late nineteenth century (as with those made and projected in Berlin by the Skladanowsky brothers, in the years preceding their celluloid film-projection experiments), which, in their successive dissolves, accentuated the fever-hallucinations of Herzog's intermittent readings from his journal, in which his own body, during the film-location work of *Fitzcarraldo*, is positioned in perpetual transit, on torrential riverboat journeys or precarious flights, between unstable locations which may be swept away or vanish at any time. In that performance space, propelled backwards in time beyond film's origins to the era of stereoscopic and magic-lantern projections, Herzog spent intervals suspended in a hammock whose supporting rope extended – as with a tightrope walker's medium – from one side of that space to the other, or else stood intimately alongside vocalists from Sardinia and Senegal as they performed improvised chants of loss.

In Herzog's performance space, only a split-second syncope intervened between the pre-filmic immersive environment of

glass-slide projection, and the inverse, post-filmic environment of digital media, in which the experiences endured by Herzog during his film-location work in Peru 30 years earlier – undertaken with the aim of realizing a useless impossibility – appeared distanced by an infinite duration. That 'uselessness' of obsessional, performative film-making, exemplified by Herzog's work, in which the body is subjected to intensive ordeals in order to generate film that, even in its accomplishment, appears already sensorially emptied out, remains intimately conjoined to the status of uselessness of the body in the digital era's performance-voided, surveillance-saturated corporate space; all that has overwhelmingly shifted is the now-absent active envisioning of vital acts designed to infiltrate the hidden strata of the body's uselessness. In Herzog's space of performance, film itself held no presence: his journal fragments barely evoked the film-making process itself, focusing instead on the corporeal and sensory experiences dispersed at film-making's peripheries, and no film at all was projected in that performance space, as though contemporary moving-image media had now been definitively pre-empted by the immersive glass slides whose own projections pre-dated film, or by the presence, beyond the city-seeping perimeters of that performance space, of external back-courtyard locations, such as those of Herzog's own film *Stroszek* (1977). In that film-maker's performance, all that remained of film, in its ongoing status of incipient obsolescence, was the performance of its subtraction and vanishing from the corporeal traces of Herzog's memories. Once the film-maker is detached from performance space, nothing may remain.

The figure of the performative film-maker, exposed in isolation in the space of performance in order either to evoke and reconfigure a past film, or else to conjure a future, as-yet-unrealized film, forms a pre-eminent manifestation of the future rapport between performance and film. Films may not be made in the future, but corporeal

performances of films will be generated. Digital media may annul and render absent the distinctive capacities of film that Herzog interrogated in Fitzcarraldo, and also embodied (in film's absence) in his Volksbühne performance space, through his own inhabitation of that space and the intervention of pre-filmic, glass-slide projection forms. Film's aberrant and contrary history, of fits and upended starts, is exemplified in the corporeal performances of film-makers whose work extends, across decades, from within that history, but then contrarily traverses digital media's transformations of film and cinematic projection from the 1990s on; the film-maker's body then becomes an incipiently obsolescent entity – or already a fully obsolete one – at the same time that, via performance and before an audience, that body crucially transmits fissured, non-linear histories of film, at the moment of their fall. Any such performance constitutes an archiving of the body in the act of disgorging the traces of film, and all such performances, amassed together, form multiple archives of the body in its simultaneous intersections with performance and film. Even when a performance in the contemporary moment is enacted by someone at the originating point of their work in performance and digital moving-image media, who has shot only an instant of moving-image footage, and only began that performance a split second ago, the archival recording of performance's conjunction with the moving image is already ongoing, to amalgamate that instant of a moving-image sequence with that split second of a performance, in their projection by the body.

Whenever a performance is enacted but is not documented in any moving-image form, it still constitutes an element within a corporeal archive, embodied either in the isolated figure of one performer or through a grouping of performers. But that corporeal archive is fragile without a moving-image residue. The body in performance is a compulsively self-archiving entity, but it is subject always to temporal fragility and precarity, with its status of survival hinged on the

work of memory and on the often-involuntary imprintations of performance within the spectator's eye. Memory and the eye will not work together to form an archive; they are each engulfed, after registering performance's moment, by relentless new data, so that any performance's archival cohering, in memory and the eye, forms a miraculous, already flawed incident, with memory and the eye subject to divergent processings of that incident. Memory is subject to oblivion; the eye to unseizable or rapidly extinguished traces of corporeal projections that then demand extensive ocular work to reconstitute (such as those eye traces investigated in the fraudulent science of optography, notably in Wilhelm Kühne's pre-filmic experiments of the early 1880s designed to seize, via retinal dissection, the images registered by the eye at the moment of its owner's death, such as that of an assailant's oncoming face). As such, archives of the unfilmed body in performance comprise volatile forms, subject to acts of abrupt vanishing and erasure, and to the readiness of memory and the eye actively to contest and annul one another's capacities.

Corporeal archives of performance, from the mid-1890s, are amassed predominantly in the medium of film, with film's timespan spilling outwards in opposing temporal directions, pre-filmically into glass-disc moving-image sequences of physical gesture such as those of Muybridge, and post-filmically into digital moving-image media's infinite excess of performance's traces. The body in performance, sustained into ostensibly open-ended survival within material film archives and digitized archives, is preserved but transmutated by film and digital moving-image media, as that body infiltrates their domain or is immersed by it; film holds the power to instil spectrality and death into performance's residues (as well as revivify them), and digital moving-image media may instigate a viral proliferation of that process of corporeal erasure. Creating a filmic archive of corporeal performance is invariably initiated with

a seminal but duplicitous act (in the way that the body of Eugen Sandow, prominent among film's originating, spectacular corporeal presences, had already been fraudulently duplicated by the Skladanowsky brothers in 1895, even before the first act of public film projection took place) in which performance is doubled and potentially lost in film, however much (or all) of the musculature, skeletal structure, skin surface and blood-reddening of the body in performance – along with its subterranean strata – is transmitted into film's archiving of the body. A corporeal archive of the body in film may form a correspondingly precarious one to that of the unfilmed body in performance.

Corporeal archives of performance may be amassed most effectively when they extend beyond any totalizing or even intentional form, through their sensitized collecting of fragments from performance's gestural presence, for an instant or more, in a state of tension across film and memory, or across digital moving-image media and the eye, within liminal, shifting interzones that elude spatial stratification or stability as locations of performance. An aberrant archive in flux of performance and film may itself take on the propulsive movements of the body – transiting through corporeal arteries, vessels and sub-skin conduits, and with a perilous relationship to visibility – as it approaches its spectator's vision. Such archives of the body in performance, together with their spaces, then take on provisional, ephemeral forms, and disappear at the instant in which they most intensively project their corporeal charge. In that sense, vital archives of performance are those that recognize the attuned dynamics of film, in its unique capacity in particular to render the body in riotous performances of uproar, in external city space environments as well as in subterranes or internalized spaces. In the act of re-envisioning the corporeal archive – of film's multiple intersections with performance around the body, beyond stasis – that archive may itself be propelled into a condition of uproar, to

accentuate the pivotal instants at which the body, enraged or outraged, goes haywire, loses its balance and enters into riotous or activist confrontations with all the forces that oppress and constrain it, with those performative movements always accompanied and incised by film.

Riot Performance: Filmings of Human Uproar

Performance's movements and transits across space are vitally transmitted through corporeal rituals, gestures and acts whose presence is invariably intensified through their filming. But in situations of crisis, tension and social disintegration, performance can appear transformed in a split second from its familiar man-oeuvres and repetitions into raw insurgency and unpredictable protest, especially in exterior city space; film, throughout its existence, has intimately mapped such momentary transmutations of the human body into riot performance, and projected to wider audiences and across future time the images it has seized of human uproar. Corporeal insurgency as performance may be unprecedented and unique in its event, but it is vulnerably subject – as with all other performance cultures, but even more acutely so – to dynamics of instantaneous self-combustion and disappearance, and to the rapid assembling, then dispersal, of its witnesses. As such, film serves as riot performance's assiduous detritus collector, rendering its traces and memories into film's own images, and into film's time and space: always profoundly at variance with performance's time and space. Film's lens works to draw and focus the spectating eye into the immediate enacting, in city space, of protests against whatever has become intolerable, whatever has misfired so badly that the human body must now react against it, even at the risk of incarceration or death. From the origins of film – through the moving-image documentation of Europe's revolutions of the end

of the 1910s, of the worldwide, contagious street protests of the 1960s, of the suppressions of demonstrators in Beijing's Tiananmen Square and more recent sites of protests – riotous acts (and violent subjugations of them) have often been made to appear *performative* in a range of ways: for example, as enacted for audiences, and as deploying a repertoire of gestures and pre-set choreography. It may principally or only be the documentational presence of film, in its recasting of such acts, that retrospectively makes protest appear distinctively performative; such acts of protest might otherwise predominantly appear as a seething chaos of gesture that rapidly vanishes into space.

As with all gestures of performance art, a gesture of protest may be infinitesimal or all-enveloping, and can fluidly oscillate from one such dimension to another; its capacity to provoke uproar is not dependent on its own expanse. Film's pivotal work, in the representation of any riot or insurgent event, is to enable the fixed status of dimension to be erased, since the moving image's capacity to magnify, diminish or multiply is always pre-eminent in its seizing and reformulation of riot-gestures as performances. As with a performance-art action that is barely visible and demands utter concentration from its audience to perceive it (as in the work of Ana Mendieta, for example), an act of riotous protest can be located a sheer hair's breadth from imperceptibility, but still remain potentially magnifiable to infinite dimensions, if it has exposed itself to be filmed, then distributed and projected for new spectators beyond those of its immediate event. But in the context of its validity as a riot-protest performance, that act must always articulate a negation (never a passivity), so that it may manifest itself in any gestural variant extending from the most solitary, minuscule muscular spasm of refusal through to its amalgamation into spectacular amassings of crowds of bodies that riotously traverse city space to disdain its controllers' power.

If riotous uproar – as the only viable response to conditions of intolerable oppression or banalization – forms a manifestation of performance, especially when accentuated or even defined through the intervention of film, then it is performance at its most vital and urgent. Even when performance appears to be internally self-focused on mapping anatomical or ocular minutiae, it can still wield a response to situations of the malicious exercising of power, since such situations impact most directly on the body and the eye, and necessitate responses of refusal. And film's participation in that response forms a correspondingly essential element of the moving image's capacity (among other imperatives) to create revealing apertures, to hone vision, to deepen sensations and to expand or sharpen the duration of performance acts. Film renders riotous events into performative acts in order to exacerbate and disseminate those events' spectacular and spectator-oriented ability to overturn and nullify corrosive conditions of power. But in determining whether riots are always or ever demonstrably *performative* acts, film's integral status as a duplicitous and eye-beguiling entity needs never to be lost from sight. Film may always transform performance into something it is not, or was never intended to be. And the immediate, unforeseen firing of collective sensation that may provoke a riot or momentary occupation in city space can itself be retrospectively annulled by the unlimited duration and capacity for repetition that the moving image imparts to that event, in making a filmed performance of it. In order to document a riot, and in anticipation of police attacks upon it, protestors may film it; but the police may film the riot, and the protestors' bodies and faces, too, to document and identify future targets for oppression. Film's duplicity is present in the capacity for those two documents, and their performative elements, to be utterly irreconcilable.

In tracing the potential performativity of protest acts and gestures, filmed as spectacles, this part of the book traverses two variants of

city space that can be viewed as contrary entities. First, it examines the location of riots and protests within city spaces that are cast as performative sites of maximal emergency by the corporeal insurgencies occupying them, as well as through the act of their filming. In cities such as those of Europe, Japan and the USA at the end of the 1960s, such insurgency, in its multiple manifestations, demanded revolutionary or all-encompassing social upheavals, and moving images closely participated in and even formed those urgent demands; in contemporary cities, such as those of Moldova, Spain and Greece, material conditions of conjoined corporeal and infrastructural degradation intensify equivalently urgent protest-demands for wide-ranging social or financial changes, now articulated in new moving-image forms, such as those generated by social media. Second, with the rise since the 2000s of all-engulfing digital environments and technologies, and their future implications for city spaces as locations for riotous disorder, other forms of performative protest may emerge, in which time is denuded of urgency, corporatized space is devoid of all trace of riotous bodies, and any performance – whatever the virulence of its refusals – is instantly subsumed into digital culture. In such spaces, the presence or absence of film, as the primary propellant and residue of riotous performance, remains the key indicator in determining the future remit of public disorder.

Film's preoccupation with acts of riotous insurgency – and those acts' recasting as moving-image sequences possessing identifiably performative elements – emerged at the origins of the medium itself. In film's first decade, from 1895, the simultaneous seizing of riotous events as they occurred was impeded by the fixity of film-camera positioning, and the difficulty of rapidly transporting film cameras and celluloid film stock to the events' locations. But film-makers soon understood that they could now recreate riotous events, even when they were geographically and temporally distanced from them;

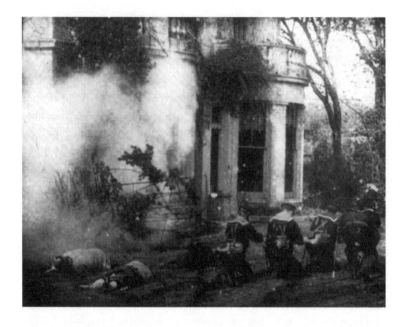

James Williamson, *Attack on a China Mission*, 1900: film-image.

such fissures in space and time necessarily instilled a performative dimension in those events which the medium of film now began to render. Notably, in England in November 1900, the Hove-based film innovator James Williamson publicly presented his new film *Attack on a China Mission*, re-enacting the riotous assaults on Christian missions and other buildings associated with European colonial power that had taken place during the Boxer Rebellion in China in June of that year, with a cast of twenty to thirty performers. The film was presented to its audience as an immediate, on-location document of the Boxer Rebellion itself, rather than a fictional recounting retrospectively inspired by the riotous events; by filming the chaotic confrontations of his performers in the grounds of a large, derelict villa in Hove, Williamson duplicitously recreated the locations of

attacks on European-style Christian mission buildings in China. Shooting four separate sequences from different camera positions for his film, he experimented with a spatial and durational framework that, had he been filming an actual riot during the Boxer Rebellion, would have located him in its lethal axis and exposed him to death. The capacity for film to recreate and manipulate riotous, revolutionary events would be explored extensively over the following decades, with greatly increased complexity in editing techniques and mobile camera positioning, as well as in the deployment of large groups of performers traversing city environments, most notably by Sergei Eisenstein in his films *Battleship Potemkin* (1925) and *October* (1928).

As well as re-enacting riotous incidents of protest or revolution, film-makers became absorbed with recording the detritus and residues of recently elapsed conflicts and tumultuous events; the French financier Albert Kahn's monumental, global project, extending across two decades, of dispatching cinematographers (as well as photographers) to many countries of the world, from 1909, to record moving-image sequences of environments about to vanish, in order to constitute 'archives of the planet', led to the elegiac documentation, especially in the cities of southeastern Europe, of residues from the riotous decimation of populated spaces at the edges of disintegrating empires. In that sense, Kahn's unrest-focused filmic project was immersed in the same dynamics – those of the capacity for the survival and potential reactivation of human traces and gestures – as all films of performance. Kahn's project of commissioning films showing imperial territories that were about to vanish, or had just vanished, through conflagrations of conflicts and riots, indicates film's seminal role in both prefiguring and posthumously anatomizing gestural events, notably in the spatial dimensions that configure their performative components.

In the decades after the First World War and the achieved or failed revolutions that followed on from it, such as that of the

Spartacus League in Germany, film-makers were no longer impelled to recreate or fictionalize formative events or riotous incidents; advanced camera and sound-recording technologies enabled them to capture on-location the performative, gestural and vocal acts that determined the future spatial entity of Europe and of other global locations in turmoil. Film became the medium that urgently documented performative bodies engaged in acts of protest before their abrupt disappearance into history's renewed abysses, leaving behind only celluloid traces. Film's role as the principal medium for the wide-scale dissemination (through newsreels and other mass-exhibition forms) of acts of protest became so powerful that its presence as a recording medium in situations of acute, volatile tension instilled film with a provocative, protest-inducing momentum in its own right, with performative consequences in the closely directed accentu-ation and synchronization of acts of protest. In the decades of its greatest influence, from the early 1920s to the end of the '60s, film irresistibly precipitated and magnified performative acts of uproar, as well as transparently documenting incidents of protest. Film pos-sessed a unique power to demand a spectacular event, of corporeal violence or spatial destruction.

Film's volatility as a medium of representation, in relation to the performance of protest, extended beyond the exterior spatial domain of street riots to those spaces in which films were projected, especially in contexts of artistic and radical political contestation. Among the notable cinema-located riots of the 1920s, in which a performative act of unrest is precipitated by the entity of film itself, the premiere of Germaine Dulac's film *The Seashell and the Clergyman*, at the Ursulines cinema in Paris on 9 February 1928, indicates the foreseen, pre-choreographed nature of its insurgence. Protesting his exclusion from being assigned a role as a performer in the film, as well as his aesthetic objections to the film's affiliation with the Surrealist move-ment, among other contested issues, Antonin Artaud (the film's

scenarist) initiated an invective dialogue against the film's director before undertaking a riotous performative act in which he and his ex-Surrealist associates ran wild in the cinema space itself, smashing its foyer mirrors. Such film-propelled riotous events within cinema spaces accumulated across the subsequent decades, always instilled with a performative dimension, and taking their most extreme form in the tumultuous projections, often raided by the police, of the Lettrist art movement in Paris in the early 1950s. At the premiere of Jean-Luc Godard's film *Sympathy for the Devil* at the National Film Theatre in London on 29 November 1968, Godard appeared before the screen to denounce unauthorized editing changes made to his film by its producer, then exhorted the assembled audience not to watch the film and instead donate their admission costs to the Black Panther movement, before concluding a vitriolic on-stage argument with the film's producer by punching him in the face, and leaving the cinema.

Film, across its history, may possess a pivotal capacity to incite and accentuate spatial and corporeal uproar in their many manifestations. But in order for film to accomplish its status as a medium of riotous unrest, it must first undertake intermediate acts that intimate its conjoined status with performance. Film may transform the spatial location of its images, and populate its frame with rapidly moving figures who initially appear to be rioters, but are soon revealed as performers of riotous acts; film's editing and reconfiguration of the spaces of unrest, together with its presence's activation of the figures poised within such spaces, intersect closely with the rapid transitions and shifts in perspective that are also integral to performance cultures; and it is often the corporeal figure of the film's director who must appear performatively in front of the cinema's screen, immediately before or after the projection, to contest or denounce some aspect of the film – for aesthetic or political concerns, or for reasons of gratuitous provocation – with such virulence that a riotous event will ensue in that space, directly in front of the

audience's eyes. An element of performance invariably interposes itself between film and the unrest it seeks to project.

In film's seizure of corporeally enacted mass protest and in the accentuation of protest's performative dimensions, the entire decade of the 1960s formed the optimum instant, as though it had been created explicitly as a global space and time for experimentation with the intersections and boundaries existing between film, performance and the human body in uproar, as well as for the inter-rogation of political, revolutionary and ecological concerns. Often, the film-makers who recorded street protests were those, such as Nagisa Oshima in Japan, who also documented that moment's per-formance art and other explorations of the gestural body. The 1960s also formed the final arena for celluloid film's 70-year-long engage-ments with the body in riotous performance, in which the limited duration of the celluloid film, in 16mm or 8mm formats, imparted an urgency and focus to the act of film-making as well as to the acts being rendered, often with performative emphases, by film; subse-quently, developments in video and then digital moving-image formats dissipated and dissolved that corporeal urgency. The riot cultures of the 1960s took the form both of sustained insurrections and of ephemeral outbursts. In Tokyo, riots extending between the 1960 signing and 1970 renewal of the USA-Japan Mutual Security Treaty elongated the culture of dissident protest, then accelerated it into a final sequence of violent late-1960s confrontations, staged (and filmed) in a last-gasp emergency exhilaration, as though no act of protest would ever take place again. But in other cities worldwide – Calcutta, Los Angeles, Chicago, Paris, West Berlin and Belgrade, among many others – riot protests possessed a curtailed existence, spanning several months, or even only a day, thereby impelling film to be integrally present, if any residual traces at all were to be made, to memorialize and transform those events.

The filmed performance of protest, in its originating and seminal instances, is often that of an isolated body, or even a solitary mouth, filmed up close and improvising an unforeseen, unprecedented vocal act that oscillates between panic and anger-powered inspiration. Unfilmed, such a vocal performance would disintegrate into its own duration, audible and visible only to its immediate spectators and then subject to oblivion; but filmed, and edited for wide dissemination, it may come to form a virally transmissible, unique act that is able to mutate into a philosophical as well as revolutionary performance. On 2 December 1964, the student activist Mario Savio stood on the steps of the University of Berkeley's Sproul Hall, before a large crowd and with a cinematographer's lens positioned only a foot or two from his face, to denounce the university's president and administration; propelled by irresistible momentum, his voice veering towards incoherence and finally sharpening to a near-scream (as the cinematographer zoomed towards his face), Savio continued far beyond that localized denunciation into the vocal performance – 25 seconds in duration – that both inspired much of that decade's later protests and also presciently infiltrated the technological future of protest in the digital era, in which the

Mario Savio,
Berkeley speech,
1964: film-image.

suppression of dissidence is accomplished automatically, without human intervention:

> There is a time when the operation of the machine becomes so odious, makes you so sick at heart, that you can't take part; you can't even passively take part, and you've got to put your bodies upon the gears and upon the wheels, upon the levers, upon all the apparatus, and you've got to make it stop. And you've got to indicate to the people who run it, to the people who own it, that unless you're free, the machine will be prevented from working at all.

Savio's projection of a dynamic corporeal protest that counters and negates intolerable processes of automated suppression through their abrupt arresting also possesses its perverse dimension; while the protests of the later 1960s would be mostly sited in the street, in the form of riotous transits of contested city space, Savio's own incitation (articulated in the final part of his 7-minute speech) conversely directs its participants towards internal space, into an occupation of Sproul Hall. And on that building's second floor, its space rendered into an improvised cinema, Savio proposes that (instead of fighting police, or formulating future protests) the demonstrators would become film spectators: 'We'll watch movies', and then explains that he had ideally hoped to show them Jean Genet's 1950 film *Un Chant d'amour*, but because it was then subject to u.s. censorship controls, other, unknown films would instead be projected to the protestors.

Filmed demonstrations of the 1960s, whether shot by professional cinematographers or by participants enmeshed within the protests themselves, invariably hold an aberrant element that enhances or conjures the performative dimensions of those protests. In 1969, the year following Paris's most intensive street riots, the French director

Louis Malle travelled to Calcutta to film a documentary about the city; his work on location there, with its ethnographic focus upon poverty and its physical manifestations, was interrupted by an eruption of street rioting enacted by rival factions of militant students associated with India's Naxalite variants of Maoism. Malle's cinematographer Etienne Becker (who had also shot parts of Chris Marker's street documentary *Le Joli Mai*) documented the rioting in high-resolution colour celluloid film, thereby creating one of the most 'professional' records of late-1960s riot culture, and Malle then incorporated the footage as a 7-minute sequence that possesses a disjointed and autonomous presence (the following sequence concerns leprosy) within his film *Calcutta*. As with the documentation of Mario Savio at Berkeley in 1964, Malle's Calcutta sequence of 1969 is initiated by a student's impassioned speech as other amassed students perform a choreographed chant in anticipation of the riot to come. But Malle's editing of the sequence, together with its laconic voiceover, delineates the riotous outburst as a futile and haywire mishap, as though it were being staged as a performance of pre-determined calamity. In his speech, the student activist immediately contests the protest itself as being manufactured and manipulated by oppressive forces. The rioting factions then group together to cross Calcutta with the ostensible aim of storming a site of power (the regional governor's palace), but soon encounter obstacles: their journey is initially interrupted by a lengthy religious procession of music and dance that forms a barrier to its trajectory, stilling the protest, so it can continue only after that interruption. Once restarted, the city-traversing riot then confronts a vastly outnumbering force of police and soldiers, who beat, tear gas and shoot the protestors (with apparent fatalities) so that they are arrested or disperse in disarray, their riot crushed.

Even during the period of worldwide riots at the end of the 1960s, fiction films as well as documentaries focused closely upon those

Louis Malle,
Calcutta, 1969:
film-images.

events, transforming often chaotic and still-ongoing riot acts into performative works with experimental narrative elements. Few film-makers, other than Chris Marker, had an acute sense of the global interconnections of that era's expansive riot culture and its film-inspired capacity abruptly to metamorphose, in inflammatory rushes, from continent to continent and from city to city, each time materi-alizing in the form of amassed protestors' spatial transits that

Filming of Louis
Malle's *Calcutta*,
1969: location
photograph.

reconfigured the areas they traversed, even if only momentarily, in
a parallel way to that in which performance cultures ephemerally
recast space. Marker's global travels from his base in Paris to sites
of late-1960s unrest generated an archive of filmed riots – from
sequences shot during the Paris events of May 1968 to violent con-
frontations between protestors and police around the construction
of Tokyo's Narita airport – whose sequences he retrospectively
juxtaposed, in such films as *Sans soleil* (1982), with choreographic
performances, such as those of Awa Odori street-festival dancers
in Tokyo. Marker's riot 'fictions' principally pivoted around his own
shifting self-identity and constant renaming as the invisible cine-
matographer figure filming, and thereby generating, those riot
sequences, which he also subjected to computerized image manipu -
lations, rendering them into the form of corporeal blurs and
affrontments, as though attempting to create a global riot image
able to elude any national specificity, as well as possessing the
potential to transform itself from a gesture of violence to one of per-
formance. While Marker's reworkings into multiple new-media
forms of his riot filming of the 1960s would extend across several
decades (he also continued to film street protests, notably in Paris,

into the 2010s), other moving-image representations of that era's protest cultures were shot and reworked into fiction films much more immediately, within that same era, and were often placed directly alongside sequences of performance art or choreography. In Michelangelo Antonioni's *Zabriskie Point* (1970), for example, the character Mark is involved ambivalently in Los Angeles student riots in which protestors are tear gassed and a police officer is shot, before he steals a light aeroplane and flies it to Death Valley, where he and his companion hallucinate a mass of sexually tangled bodies, performed by Joseph Chaikin's Open Theater group.

The intimacy between late-1960s riot cultures and performance acts, bound together and accentuated by film, and notably in the form of fiction films, appeared most explicitly in Tokyo and its Shinjuku district, which served simultaneously as the location for vast confrontations between militant students and riot police, along its wide avenues, and also for experimental performance art, in its adjacent labyrinthine alleys of galleries, studios and nightclubs. In 1969, the two seminal fiction films of Shinjuku's riot cultures, Nagisa Oshima's *Diary of a Shinjuku Thief* and Toshio Matsumoto's *Funeral Parade of Roses*, were shot and released (to independent cinemas in that same district, the spectators including the era's militant-student protestors). Each film was principally shot on location, on the district's avenues and plazas, or in its subterranean performance venues and nightclubs, and each positioned sequences of performance acts alongside those of nocturnal street riots: sequences of performances by the Jokyo Gekijo group, led by Juro Kara, in *Diary of a Shinjuku Thief*, and performances by transvestite dancers in *Funeral Parade of Roses*. Several sequences in Matsumoto's film deride student revolutionaries who avoid streaming into external city space to confront riot police, preferring instead to inhabit internal spaces, in the form of constricted rooms, where they watch television reports of riots, hypnotized by the screen's malfunctioning

images, or else project films to one another, as though impelled by Mario Savio's corralling of his Berkeley protestors into Sproul Hall's improvised cinema.

Although Savio, in 1964, had ideally envisaged a projection of Genet's experimental fiction film Un Chant d'amour for his Sproul Hall protestors, he could equally well have presciently envisioned a future film of Genet's own corporeal participation in the most violent and confrontational of Tokyo's late-1960s Shinjuku street riots, focused in particular on opposition to Japan's alliance with the USA in the ongoing war in Vietnam, and more widely on Japan's long-term subjugation to the USA's imperatives. By that time, Genet had abandoned his literary and theatrical work to take part in a range of global protests, as though he himself were presciently embodying the future title of Shuji Terayama's film Throw Away Your Books, Rally in the Streets! (1971). At the onset of that riot, on 17 December 1969, Genet positioned himself at the demarcating battle-line between the protestors and the riot police (both sides ready for a violent confrontation, wearing protective metal helmets and carrying weapons such as staves), and performatively took on the role of the police forces' superior officer, as though he were inspecting them, just before the violence started.[19] Although that momentary gestural incident was remembered and evoked by Genet's companions, from voice to voice, it went perversely unfilmed, at a moment when the Tokyo street riots were being pervasively filmed: by the cinematographers of such directors as Oshima and Matsumoto and by news crews, as well as by riot participants themselves. Although a film of that event could be fictionally imagined – as a spectacular incident of tension enacted within swirling masses of bodies, crammed between the multi-storey towers and advertising screens of Shinjuku's avenues, or even as a fragmentary annex to Un Chant d'amour, in which Genet's sexual desire for the Tokyo riot police overwhelms his taunting of their power – that irreparably absent film still forms

a determining void within the era's dense binding of performance, film and riotous uproar.

While Marker sustained and revivified the performative acts of Japan's late-1960s protest cultures across the following decades, by reconfiguring his archived film sequences of those acts into new technological forms and delicate explorations of memory, the Japanese film-maker Koji Wakamatsu also reinvented those events, from immediacy to history, and across future time.[20] During the era of Tokyo's riot culture itself, Wakamatsu's preoccupations, in his fiction films such as Sex Jack (1970) and Ecstasy of the Angels (1972), had already been focused on the capacity of the protestors' gestures to transmutate into terrorist acts; his casts of fractious and sexually preoccupied student revolutionaries are often constrained in small rooms, as with those of Matsumoto, but they will finally break out for acts of terrorism or outlandish sexual violence. Wakamatsu's conception of that era's global interconnections between manifestations of revolutionary protest pre-eminently allied Japan with the Palestinian refugee camps. Almost 40 years on, in his film United Red Army (2008), Wakamatsu positioned extensive sequences of archival film, from Japan's 1960s era of riotous protests, alongside a narrative performed in a semi-fictional form of the 1971–2 descent of Japan's United Red Army terrorist movement into lethal self-disintegration, during which a high proportion of its members, accused of inadequate revolutionary commitment, were killed by other members at a training camp in a remote mountainous area; a small group of terrorists then barricaded themselves into a mountain lodge and endured an extended siege by the police before being arrested. In concentrating and accentuating the performative elements of riotous protest, as in United Red Army, film also holds the potential to create future-oriented projections that can take unforeseen forms, in explorations of memory, violence and vision.

Koji Wakamatsu, *United Red Army*, 2008: film-image.

Amateur film sequences shot from within the furore of riot protests emphasize the performative dimension of the depicted events in distinctly different ways to documentary or fiction film, since they also manifest the performativity of the cinematographic act itself, as the wielder of the film camera, caught in the volatile uproar of the demonstration, undertakes sequences of corporeal gestures as a rioter while simultaneously attempting to shoot coherent images and avert damage to the camera. Because of the prevalence in late 1960s Japan of inexpensive, lightweight Super-8 cameras among students, artists and activists, amateur filming from within the shifting spatial parameters of that era's Tokyo riots forms the pre-eminent example of that moving-image form up until the mass-filming via iPhones, Samsung Galaxys and other hand-held devices from within contemporary protests. In the late-1960s context, the limited duration of Super-8 film cartridges (only 3 to 4 minutes,

depending on whether the cartridges were manufactured by Fuji or Kodak) necessitated a keen temporal sense of concentration on the part of the riots' film-making participants. Even so, that performative filmic 'eye' operating within the riot often generated ocular mal-functions: blurred, corporeally shaken images, their sequences occasionally curtailed by the abrupt destruction of the film camera by the hands or weapons of riot police. Documentary footage of riots, such as that incorporated in Malle's *Calcutta*, visualized the violent confrontations and headlong charges from a safe distance panoramically, and then redeployed them in an edited form, as though the riot movements were being choreographed as a per-formance without superfluous elements; amateur footage from within the heart of a riot, by contrast, often seized chaotic or static time, with the rioters in flight across city space, or else constrained by riot-police barriers. Occasionally, as in several sequences at the close of Oshima's *Diary of a Shinjuku Thief*, footage shot by professional cinematographers from within ongoing riots could take its place in a 'fiction' film, even when the riot-shaken form of the footage appeared identical to that shot by an amateur hand.

The amateur footage of the 1960s global street riots possessed almost no status or visibility in the subsequent decades; in the Japanese context, only its intermittent contextual utility, for such exhibitions as *Japanese Art, 1960s: I Don't Give a Damn Anymore!* at the Mito Contemporary Art Center in 1997, curated by the architect Arata Isozaki – in which the culture of riots was placed directly alongside documents from the performance culture of that era, with one gallery devoted entirely to the projection of amateur riot footage – sustained its existence. Much footage must have been discarded or left to deteriorate, in a parallel way to that in which the Japanese director Teinosuke Kinugasa misplaced the sole print of his influential film *A Page of Madness* (1926), before finding it in his garden shed 46 years later. But with the eventual capacity for the digitization of surviving

amateur footage of riots and its subsequent insertion into specialist websites for enthusiasts, and notably its incorporation into such resources as YouTube, it was transformed from a detrital to an archival moving-image entity in a collective re-amassing of riot participants' dispersed film materials, as though film possessed the enduring ability to reinstate a riotous performativity, after decades, even when the rioters' own aged bodies had now lost their capacity for violent resistance.

Amateur riot footage of the 1960s possesses an acute sense of intimacy alongside its predominant incoherence; except in vertically veering shots that reveal the surrounding city (buildings and towers

Amateur Tokyo
riot footage, 1960s:
film-images.

in Tokyo, Hong Kong, Chicago, West Berlin), it primarily forms a record of human bodies in dense interaction, composed of gestures, collisions, joltings. Sonorized 8mm footage holds fragments of cries, exclamations, incitations and chants (in multiple languages), as well as splinterings, beatings and falls. Participants' bodies impede one another, or are caught up in swirling stampedes and propel one another. Often, other participants' cameras are visible within the uproar, just as in the moving-image documentation of seminal performance-art events from that era, such as the Vienna Actionists' Art and Revolution performance (1967), a number of other film cameras are visible, even when only one resulting document has survived. As well as constituting often-anonymous corporeal performances in their own right, composed of intricate interactions and dialogues, such amateur riot sequences also form counterparts to the ways in which film-makers in that era intentionally enmeshed themselves within volatile performances staged for public audiences. For example, the film-maker Takahiko Iimura – in a performative film-making project he titled 'Cine-Dance' – weaved his own body and his 8mm film camera through Tatsumi Hijikata's choreographic performance in Tokyo in 1963 of The Masseur, intruding upon and impeding the ongoing performance's participants in order to provoke a confrontation between the filmic act and the performance act, with the aim of inciting those acts creatively to infiltrate one another (though, in the resulting film, Hijikata, performing in his own work, appeared entirely oblivious to Iimura's presence). Iimura conceived of his work in relation to ideas of 'expanded cinema', in which the acts of film-making and film projection annul all fixed parameters and expand to intersect with performance, space and the human body, for example through performative projections of moving-images over human figures. He commented: 'One example of "expanded cinema" is the experimental combining of film and performance to arrive at a "film performance" . . . I was creating "Cine-Dance", a

Takahiko Iimura,
The Masseur, 1963:
film-images.

rare combination of media and dance.'[21] Iimura also shot several performance films in external city space, such as *A Dance Party in the Kingdom of Lilliput* (1964), in which he and his film camera trailed and collided with the body of the performance artist Sho Kazakura, with a parallel performative intimacy of filmic interposition.

Film's presence at the location of an act of rioting is infallibly one that transforms that act, which may be magnified from infinitesimal to all-engulfing dimensions by its filming, or else reduced from a carefully formulated programme of political protest to split-second madness and disintegration. In all instances of a riot's

filming, its performativity is accented in intimate conjunction with its participants' distinctive corporeality and the city space they traverse. A riot may be filmed and retrospectively edited exactly as though it were a performance being shot, but that film must then take the form of a dynamic moving-image act that adopts multiple perspectives across the event's duration, or else infiltrates the skin of the event and locates itself at its heart, as with those 1960s amateur documents filmed from the core of riotous turmoil. But even at such moments of apparent intimacy and extreme engagement, film always appears still to maintain a minuscule distance from what it reveals, at the riot's heart, and may always retreat backwards to the cold appraisal of futility instilled in Malle's filming and narration of his *Calcutta* riot sequence.

The expansive range of subjects at stake for contestation in 1960s worldwide riot cultures mirrored the way in which performance art could take its focus in any subject, from the most gratuitous or incidental gesture to profound ecological or political unease. Just as multiple styles of filming were required for the documentation of performance art, the filming of riots demanded a mutable approach, in terms of the proficiency of its shooting (by professional cinematographers or by protest-enmeshed amateurs), of the location of its shooting (in the chaos of teeming city avenues, or on the dispersed terrains of university campuses) and also of the riot's particular subject of contestation. But in all instances, the filming of riots distilled and manifested those events' performative aspects and focused on corporeal presences: enmeshed amalgams of human figures, or else isolated, wounded bodies. Beyond that fundamental corporeal component, the sheer variance and proliferation of the subject-matter and intended targets for riots, across international protest cultures of the 1960s and into the '70s, vastly exceeded the potential variance of the film-making act itself. While the subject

matter of an act of performance art may be an intangible mystery (as in the work of Josef Nadj or Zhang Huan, for example) and benefit from a self-instilled aura of enigma that film may serve to enhance, the subject-matter of a protest is infallibly precise. Even when a protest's target is announced philosophically or poetically, as in Savio's call for 'the operation of the machine' to be annulled, a specific situation (that of the University of Berkeley's annexing by corporate power) must be resolved through the called-for protest.

In West Berlin, across its first two decades of topographical isolation after the 1961 construction of the Berlin Wall, the expansiveness of subjects for riotous protest attained exemplary dimensions, as though the excision of that outlandish city fragment from all habitual channels of communication had transformed it into a unique laboratory for performative uproar and its filming. Protest-attuned students from throughout West Germany amassed in the city to avoid military service, alongside other displaced international population elements (including performance artists, such as Brus, who had fled their own countries); the secret police of the surrounding East German state worked covertly to intensify protests in West Berlin and thereby destabilize it. While the flaring of riotous protest in other cities proved intermittent, and temporally concentrated especially around the end of the 1960s, West Berlin remained in near-perpetual riotous upheaval across those two decades. Protestors insurged against a proliferation of subjects, among them despotic regimes (notably in the form of a visit to West Berlin by the Shah of Iran, which led to a brutally suppressed demonstration, on 2 June 1967, that set riot police and protestors into an open-ended confrontation for decades to come); colonial or attritional warfare, such as the USA's involvement in Vietnam, together with the complicity of the West German state in such conflicts, and the refugee crises they generated; nuclear power; dire and scarce accommodation and material living conditions in West Berlin itself, during an era in

which experiments in squatting, occupation and communal living were instigated; manifestations of petrified political power, along with its officially sanctioned and corporate spaces, in the face of anarchistic or nihilistic desires to disintegrate or negate that power and its spaces; and the then-ongoing rise of mass-consumer and media cultures with their perceived enslavement of worldwide populations. In some instances, the targets of riots could be amalgamated within vastly engulfing protests, such as those held on the first day of May, which rendered West Berlin riot space near-identical to city space. Such protests were filmed with the acute variability of those held in Tokyo, from professional documentary cinematography to blurred protestors' footage shot with hand-held cameras from within riots; as with the filming of Tokyo's unrest, the West Berlin footage accentuated the performativity of the city's culture of riotous protest, notably in its alliances with militant theatre companies, performance artists and visual artists. The filming of riots also exposed and left tangibly raw the impasses and irreconciled acts of violence that, as with Japan, would propel 1970s West German terrorism from the 1960s culture of protest; such pivotal moments were retrospectively recreated, decades on, from the original footage of the riots in the form of fictional feature films such as Uli Edel's The Baader Meinhof Complex (2008).

The student activist most closely associated with inspiring West Berlin's late-1960s culture of city-wide riotous protest, Rudi Dutschke, was filmed prominently participating in street protests, and also in the form of a lengthy interview shot in a television studio for the West German media's ARD channel, in which he vocally narrated and invoked the revolutionary imperatives of the protests with performative passion in a parallel way to that in which Mario Savio, through the filming of his brief incitation outside Sproul Hall, had invoked the origins of the Berkeley protests. Once those two moving-image sequences – Dutschke's denunciation of both the

Uli Edel, *The Baader Meinhof Complex*, 2008: film-images.

West German and East German state systems and his mystical advocacy of a radical religious communism that would annul both systems, and Savio's denunciation of the 'operation of the machine' and his advocacy of 'putting bodies upon the gears and upon the wheels' of that machine in order to arrest it – become separated out from all specificity generated by the film-footage of associated riotous events, those sequences form monologic performances of intense mystery in which all that is now left to be projected, by the

voice and the moving image, is the human body's urgent resistance to oppressive power.

On the afternoon of 11 April 1968, several months after that ARD interview and at a location close to the junction of two avenues in West Berlin, the Kurfürstendamm and the Joachim-Friedrich-Strasse, Rudi Dutschke was approached by an assassin who interrupted his transit of the city by bicycle and, in the course of a short dialogue, confirmed his identity and berated him ('you dirty Communist pig') before shooting him three times in the head and shoulders. The widely disseminated film footage of recent West Berlin riots, inti- mately associated with Dutschke's incitations, had been presented by the right-wing West German media as evidence of an imminent, calamitous social fall, which had driven that assassin to his act. Having been shot, Dutschke staggered for some distance along the street, expelling cries and words, before collapsing. A news cinematographer rapidly arrived and, after Dutschke had been taken away, filmed the direct aftermath of the assassin's act as though it were the detritus of an improvised street performance: the aban- doned bicycle, two shoes surrounded by ineptly inscribed chalk lines, a lone bullet casing, the erratic trails and drops of blood on the tarmac and the gathered audience still gazing intently at the scene. Dutschke temporarily survived his attempted assassination (which itself immediately precipitated water-cannoned riots in West Berlin), dying of its epileptic consequences a decade or so later; but that act's filmed location – a concentrated axis holding residual traces of violent gestures and exclamations – became a spectral, terminal site for West Berlin's culture of riots as it transmutated into its future, excessive forms.

Twenty years on, public space on the far side of the Berlin Wall, notably around East Berlin's Alexanderplatz, became inhabited by mass-protests on a vast scale, with hundreds of thousands of

Rudi Dutschke
attack scene, 1968:
film-image.

participants demanding the radical reform or erasure of the GDR
state. Those protests were shot extensively by a wide range of film-
makers, from the GDR secret police documentation to that of the
participants themselves, whose footage emphasized the performative
uproar of displayed placards and marionettes that transformed
figures of authoritarian power into derided non-entities. Many
protests of that era mutated into localized outbursts of rioting,
especially around the churches of the city's Prenzlauerberg district,
such as the Gethsemanekirche and the Zionskirche, with resistant
participants water-cannoned and beaten by the police. Those riotous
acts interconnected with all of Berlin's past filmed protest events,
such as those of the Spartacist uprising of January 1919 or the East
Berlin workers' uprising of June 1953, to form an immense corporeal
amalgam of unruly figures – in transit across barricaded or waste-

Berlin riot, 1968:
film-image.

landed city space – that annulled all contrary dynamics of political imperatives. Once the East Berlin protests of October–November 1989 entered the domain of the moving image, those events gained a momentum in direct contravention to the stasis of the state system, which infallibly embraced petrifaction, embodied in filmed sequences of Honecker's loving embraces of visiting leaders of other Communist regimes.

All of the European Communist regimes that were successively eradicated between November 1989 and December 1991, their exits precipitated by riots and protests, left filmic traces that accentuated those events, to greater or lesser degrees, as distinctively performative spectacles in which protestors ostentatiously climbed on tanks, stood in front of resonant buildings or gesturally cited historical moments evocative of liberation from oppression. Many Central or Eastern European artists associated with performance, theatre and choreography took active roles in those protests against stultified Communist regimes, so that the events' status blurred still more irresolubly into that of performative acts; a number of such figures, Havel in Czechoslovakia above all, eventually assumed political power itself, as though performance and power could always infiltrate one another at will to form a conjoined entity, once moving-image

sequences had tracked and authenticated that aberrant mutation. At midnight on 2 October 1990, the vanishing of the GDR state abruptly conjured away too the intricate habits and gestures of everyday life in East Berlin: an act which many inhabitants of that now-spectral city would experience as an enforced uprooting and source of disquiet, as foreshadowed by nocturnal footage of scattered riots in Alexanderplatz on that same night.

From the balcony of the palatial Central Committee of the Communist Party building in Bucharest, on 21 December 1989, Nicolae Ceaușescu gave a public speech, filmed and transmitted live by Romania's state media, in which he addressed an immense crowd in the square below, flanked by his regime's figures of power; the amassed audience watching the spectacle became increasingly unruly, and started to hurl insults and unleash explosions. Ceaușescu, initially dumbfounded, finally responded, in his speech, by incrementally offering his insurgent audience increased wages and other enticements. Those expansive proclamations had been prefigured by the vastly inflated assertions, notably by French media systems, of the number of rioters (up to 60,000) massacred by the Romanian state police and secret police during rioting of the preceding days in the city of Timișoara, as though the number of the dead were only tenable if it were infinitely expanded. Following the abandonment of Ceaușescu's speech, much of central Bucharest descended into violent rioting and confrontations between protestors and secret-police forces, filmed by the police, by the protestors and by incidental tourists. When the protestors eventually stormed the Central Committee building on the following morning, Ceaușescu fled by helicopter from its roof; captured and held covertly for several days, he was then cursorily tried and executed on 25 December, in the courtyard of a military building, his executioners so eager to perform the act that the cinematographer following them into the courtyard missed it by a split second, and could only film the bloody aftermath.

Nicolae Ceauşescu's spectators, 1989: film-image.

That footage was almost immediately transmitted on the country's media system and via worldwide media. At every stage of that excessive, haywire spectacle of publicly disintegrating power and sudden death, film had been intimately present, or only just behind its acts, to exacerbate and project it.

The filming of the protests and often lethal riots of 1989–91 that surrounded the collapse of Europe's Communist regimes, especially that of the USSR, had their counterpoint in experimental films that traced a contrary manifestation of performative protest in the form of an internal dissidence, located within individual corporeal and mental parameters, that refused to ally itself either with the old or new power-structures of Europe. Over the final years of the USSR's existence, from 1986, the young film-maker Artur Aristakisyan shot 16mm footage of beggars and mentally deranged outsiders living in desperate poverty in a peripheral district of

Chişinău, then capital of the USSR's Moldovan Soviet Socialist Republic. In his voiced narration of the resulting film, *Palms* (1994), spoken in the form of an invocation to his already conceived but soon to be aborted son, Aristakisyan evokes his anti-community of filmed beggars and outcasts as one that utterly rejects all partici-pation in a maleficent 'system' of social, political and human culture. That refusal is so exacting that each beggar performatively undertakes an internal process of self-created rioting, projected through their gestures of begging or their obsessional acts as they wander Chişinău's desolate avenues, bus stations and wastelands, in solitude. Aristakisyan's narration relentlessly warns his unborn son never to participate in the 'system', and instead to go mad or become a beggar. His son must also never engage in any sanely comprehensible act of protest – 'My son, don't become a human rights activist . . . I beg you, do not try to improve this system' – since then he would immediately be recuperated to form part of that 'system' and its sanctioned annexes of dissent. Aristakisyan narrates compacted histories of his beggars' individual calamities as they are filmed traversing the scoured, semi-destroyed city (devastated in Second World War assaults and by earthquakes), performing infinites-imal ritual gestures as part of their begging, and often becoming enmeshed in quarrels among themselves. Aristakisyan transferred his monochrome, bleached 16mm footage to 35mm format, with the result that his film appeared to have been shot many decades earlier, as though by Kahn's 1910s cinematographers of figures and cities about to be razed, rather than at the end of the 1980s. By the time Aristakisyan had finally finished editing his film, in 1994, the USSR had disintegrated into non-existence, and Chişinău, following its own violent independence protests in 1991, had become the capital of a new country, Europe's poorest: Moldova. But for Aristakisyan, the status of his world of internally rioting beggars remained entirely unchanged; he incorporated into his film sequences

Artur Aristakisyan, *Palms*, 1994: film-images.

of his beggars displaying their imminently obsolete USSR identity documents. A new variant of the 'system' emerges, but it is identical to that which precedes it; only madness or extreme poverty, and the filmed gestures that perform it, enable Aristakisyan's isolated figures to live.

Artur Aristakisyan,
Palms, 1994: film-
images.

The beggars of Aristakisyan's film *Palms* possess an unrelenting
interior regime of riotous negation towards the 'system', but that
refusal still manifests itself through corporeal insurgencies across
city space, as legless beggars propel themselves at great speed on
minuscule wheeled platforms or converted water troughs, weaving
through Chişinău's human figures, or else infiltrate the city's stalled

trolleybuses to beg for coins from passengers; they must expose themselves as denuded outcasts in order to achieve their inner revolution. An internal riot conducted by individual beggars and the mad, as envisioned by Aristakisyan, can thereby conversely emerge from acute solitude to inhabit exterior space. In its extreme instance, it may then become a vast, performative spectacle in its own right, with the capacity to disrupt and upend the public ceremonies and spaces that optimally embody social power, as in Brecht's musical play The Threepenny Opera (1928), in which the angered beggar king, Peachum, threatens to unleash a plague of rioting beggars across London to mar the coronation of the new Queen of England, declaring: 'How will it look if six hundred poor cripples have to be clubbed down at the Coronation?'[22] That planned disruption of the new power regime is adroitly averted in Brecht's play, but in the film version of The Threepenny Opera (1932) – directed by G. W. Pabst in both the German and French versions, and with Artaud (in the French version) performing the role of the apprentice beggar Filch who, initially reluctant to take on his ragged costume and crutch, is immediately transformed by them to his satisfaction – it takes place, as a public spectacle at the city's heart, with the riotously propelled beggars transecting and annulling the coronation procession.

The era of revolutionary public riots and internally focused refusals, performed and filmed from the end of the 1980s to the early '90s, extended far beyond Europe. Advances in film-camera technology, especially in terms of zooming and high-definition focus, together with the immediacy of moving-image dissemination to worldwide audiences, now enabled a detail or gesture from a protest – even one of infinitesimal dimensions, in the context of its surrounding public space – to become the embodiment and exemplar of that protest. Up until that era, in the documentation of riotous events, only the amassing of vast crowds and their strategic traversal of filmed city space generated a sufficiently dynamic moving-image

sequence to enable its spectators to identify it as representing an epochal or iconic act. In a sense, that focus from the late 1980s on documenting incidental performative details from a wider protest returned moving-image culture to its originating era and to films such as James Williamson's *Attack on a China Mission* (1900), in which the eye of the spectator had to concentrate on scanning the sequences closely in order to isolate pivotal details or gestures of the depicted riot. Whenever durational protests with many thousands of participants took place in infinitely open plazas, as in Tiananmen Square and its surrounding areas in Beijing in 1989, the work of identifying and focusing upon momentary but seminal events, and transforming them via film into enduring, historic acts, fell to zoom-wielding cinematographers.

Above all, the celebrated filmed sequence from 5 June 1989 – in which an isolated protestor or passer-by, carrying several shopping bags, tenaciously blocked a line of tanks, which had already exited Tiananmen Square after taking part in the previous night's suppression and expulsion of demonstrators, and was now heading along an adjacent avenue – assumed the dimensions of a historic, defining act of resistance within a far wider protest, performed apparently without the knowledge that it would be captured from an overlooking hotel balcony by a BBC film crew (among other documenters), and rapidly transmitted to worldwide media systems. That sequence's fascination for its audiences emerged, at least in part, from its irre - conciled, suspended status; although the 'tank man' successfully blocks the procession of tanks, the military power at stake is evidently so strong and deadly – many protestors had been killed on the previous night, their deaths filmed as fragmentary, chaotic sequences of bloodied bodies on stretchers – that it must imminently overwhelm and engulf that figure. But that potential outcome is located beyond the 'iconic' moving-image sequence itself, which cuts off in mid-protest. A less familiar annex to that sequence, in which a figure

riding a bicycle, and then several other figures, hurry the 'tank man' away from the confrontation, out of shot, towards the far side of the avenue, belongs more recognizably to the wider protest's prevalent moving-image fragments displaying sheer chaos. The fascination generated by the sequence of the tanks' blocking also results from the contrary elements of performative playfulness and physically adept manoeuvring in the figure's movements, set against the knowledge of the lethal danger that will, almost infallibly, ensue from his gestures (in many filmed sequences from that era's protests, the drivers of tanks unhesitatingly crush protestors).

The never-identified Beijing 'tank man' contrasts with the identification in *Palms* of Aristakisyan's beggars, whose designation as document-carrying citizens of the USSR is about to be erased, along with that obsolescent empire; without the primary assignation of an identity, the 'tank man' cannot ever be satisfactorily jettisoned into closure or death. The filming of his one-person riotous act of resistance within danger-instilled public space is simultaneously that of an only momentary obstruction (once he has been pulled aside, the tanks will continue their traversal of the city) and of an enduring enigmatic presence. Without the intervention of film cameras to locate, zoom into and delineate the performance of that act of protest, enabling the transmission of the resulting sequence to its mass audiences, the act would subsist only as a blur within its immediate witnesses' memories. Film determines the hallucinatory performativity of that act of defiance, hinged gesturally between physical comedy and raw desperation, and also its status as an irresoluble future impasse, which ensures that – whatever the degree of visibility or suppressed invisibility of that sequence in contemporary China – all filmed performance acts now necessarily, even involuntarily, form prolongations of that sequence.

The human body and its filming in contemporary performance art in China enact an amalgam of corporeal spectrality and exterior

Beijing long shot, 1989: film-image.

Beijing zoom shot, 1989: film-image.

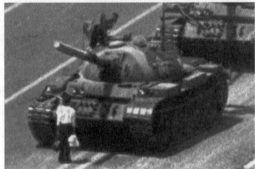

delineation, as though the body's parameters cannot ever now be self-autonomously marked and are already pre-inscribed, like the filmed police chalk marks around Dutschke's fallen body in his West Berlin street attack of 1968: marks that remain fixed in public space, even when they appear maladroitly non-aligned with the originating body itself, which has evidently picked itself up, wounded but still

living, to stagger along the street for a time while emitting cries before collapsing elsewhere. Film, in documenting contemporary performance art in China, also demonstrates a pivotal incapacity to avert the pervasive spiriting away of the body in a process that propels the corporeal into ghostly and dispossessed zones, or else into convulsions and inner rioting. Moving images of the human body then take on a contrary status that resonates with many other instances of the intricate interconnection between performance and film. Film possesses its own autonomies, and in contemporary performance art in China exists both to re-materialize such sequences as that of the 'tank man' (a corporeal figure spirited away in mid-action, either into death, if his manhandlers were plainclothes police agents, or, unidentified, into disappearance), and simultaneously as the pre-eminent medium of promotion for an art market in extravagant, excessive expansion. Since an ascendant art market demands endlessly proliferating space (both city-located and digital), film forms the optimal medium to fill art gallery expanses. Film appears rarely assigned to named documenters in contemporary performance art in China; it is predominantly presented (as with the Spiral Jetty film) as the performer's own work, even when its rendering of a performance act has evidently been anonymously delegated. But at the same time, the film-making act may manifest a void or passive disengagement with the essential capacities of film – for aberrant future transmutation or memorial marking of the past – beyond the instant of immediacy in which a performance is documented.

The performance art work of Zhang Huan, mainly undertaken between 1993 (the moment when performance art, together with its filming, began to exist as a distinctive medium in China) and 2005, and often filmed in exterior spaces such as courtyards and city plazas, as well as within gallery spaces, evokes an intolerable corporeal presence which must be ligatured and drained, as in the performance 65 kg (1994), in which Zhang's body was raised to the

Zhang Huan, *65 kg*,
1994: film-image.

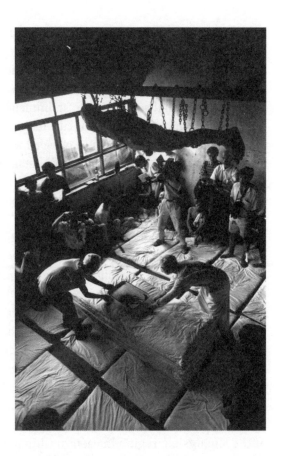

ceiling of a derelict house by metal chains, its mouth bound, while
figures in medical dress extracted a quantity of his blood and heated
it in a rectangular pan, so that the smell permeated the space. Zhang's
work has also presented the surface of his own body as a dense
inscription of written characters, marked especially onto his face,
so that film, in documenting that inscribed body in performance,
confronts a corporeality that is simultaneously projecting itself
directly towards the film camera. In Zhang's recent work, beyond
performance, filmed in exterior city space in the process of its

creation, as well as for promotional sequences and by museum visitors, the human body, and especially its head, is transformed into ash, as in Ash Head (2007), through an extended action involving the laborious collection of incense ash from Shanghai's temples, before its sculptural accretion into an immense and horizontally bisected head, mounted for potentially mobile display – emitting the strong odour of incense – on a wheeled wooden platform like those that propel the legless beggars of Aristakisyan's film Palms at speed through Chişinău's streets. Zhang's bodies comprise detrital, stilled forms that possess emissions and escape-velocity capacities to counter that petrifaction.

Yang Fudong's work, in its exploration of the conjoined forms of corporeal and filmic spectralities, undertakes a sustained experimentation both with the ability of multiple projection screens to display sequences tracing dispersed residues of performance acts, and also with the capacity of film to transport the contemporary moment of performance backwards in time, into ostensibly obsolete eras which may elude or else intensify the power of subjugation. In the first part of his film installation work Seven Intellectuals in Bamboo Forest (2003–7), Yang draws on ancient Chinese legends of escapes from stultified societies into spectacular natural landscapes, positioning his group of seven young performers on the mountain peaks of the Huangshan region in eastern China, dressed in clothes archaically evocative of the 1960s and filmed in a cinematographic style that conjures that same era, as they conduct impasse-ridden philosophical reflections. Yang's work fragments the aura of the cinematic in relation to performance art, using 35mm film (rather than digital image-making) to shoot sequences that are then disassembled across ten or more screens in their art-gallery installation, as with his work The Revival of the Snake (2005), so that the narrational elements habitually associated with lavish cinematic sequences are immediately cancelled out to leave residues of corporeal enigmas

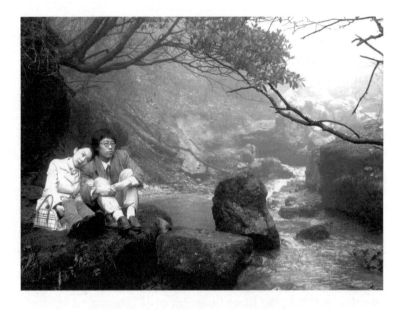

Yang Fudong, *Seven Intellectuals in Bamboo Forest*, 2003–7: film-image.

poised between performance and film. In Yang's later work, such as *First Spring* (2010), shot in monochrome film for the Prada fashion company, elegant performers are seen tightrope-walking in slow motion above an anachronistic city street, while other figures in the street below perform acts of almost-stilled encounters, gazings and separations. Film is deployed to disorient the viewing eye across time, and to accentuate the dispersal and evanescence of performance.

Among the youngest artists experimenting with the corporeally mutating interconnections between performance art and moving-image media in China, Lu Yang's work emphasises an obsession with ritualistic body-enhancements evocative of those of Berlin's Weimar era. In her torture-oriented 'bio-art' work, *Zombie Music Box: Underwater Frog Leg Ballet* (2010–11), electric shocks were select-ively administered by the performance's overseers, via computer

technology, to the legs of eight eviscerated, decapitated frogs, arranged in a line within an elongated aquarium, causing those legs to perform consciousness-razed jolts and kicks that simultaneously evoke both the infliction of subjugating torment and also a playful form of musically enhanced choreography; that choreography was simultaneously filmed and projected onto a screen within its exhibition spaces, with a focus on particular gestural details. A series of moving-image annexes to the performance itself, such as *Frog Zombie Experiment* (2011), crediting Lu Yang as 'director', also showed the process of revivification in detail, in the format of research documents shot in laboratory conditions, with anonymous rubber-gloved hands wielding electrified prods to induce the frogs' choreography. Lu Yang's sequences of fragmented body elements propelled into convulsions, devoid of all autonomy, irresistibly evoke the contemporary condition of the human body in protest-erased China, and, further back into obsolescent time, the filmed sequences of Tiananmen Square's protests of 1989, but they also form sequences – focused directly upon the status and vulnerability of corporeal life itself – in which all political intention is itself annulled, as Lu Yang notes: 'I'm totally uninterested in politics, as long as it doesn't influence my immediate

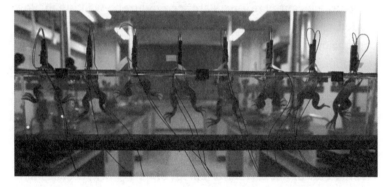

Lu Yang, *Zombie Music Box: Underwater Frog Ballet*, 2011: film-image.

and tangible interests.'[23] Even so, the contemporary gestures of performance art, in their filming, are welded so indissolubly into historical moving-image sequences of riots and protests, such as those of Tiananmen Square, that only a haywire, infinitesimal jolt between shots may re-manifest those sequences.

Film's vital capacity is to conjure riotous performance from any enacted gesture, extending from the optimally enraged to the terminally pacified; it may even transform the abrupt, spectral convulsions of Lu Yang's decapitated, eviscerated frogs, their limbs propelled out to their extreme extent, or Brakhage's autopsied bodies manoeuvred by their attendants, into those of a riotously gestured protest – against all cruel subjugation, across all domains of life – that is simultaneously outlandish and voided. Throughout film's rendering of city-space protests, from the 1890s to the 1990s, an intricate gestural language consolidated itself, of spasmodically pumped fists, maximally opened mouths, legs extended to drive the body into or out of confrontations, arms tautened to display placards or strike blows against opponents and police; the performance of such gestures, always magnified and enhanced by film, in their recording and projection, constituted unmistakable evidence that a riot or protest had occurred. The filming of riotous chaos – blurred gestures and cries, shattered film-camera lenses – equally demonstrated that evidence. Even when film cameras adeptly zoomed, beyond all recognizable landmarks, into the details of apparently improvised protest-gestures – as in the footage of the 'tank man' – and thereby spatially disoriented the sequence's spectator, the act performed invariably returned the eye to the identifiable vocabulary of riotous protest in which, for example, an agent of oppression was impeded, at least momentarily. But with the rise, from the 2000s, of ubiquitous digital moving-image recording within external city space, and of profound transformations within the regimes of

visibility in such space, that gestural language of performed protest is now rendered obsolete, and a distinctive new form of image-making – focused upon corporeal gesture and its spatial arrest or evanescence – now supplants it, thereby exerting an innovation, maleficent or not, that extends across the conjoined forms of performance, film and protest.

The defining pervasiveness of digital image-making, to record acts of protest performed in external space, is certainly not a newly manifested phenomenon: in contemporary space, there will always now be somebody, or many people, or robotic surveillance media, filming the performance of city-located uproar; but, across film's entire existence, there almost always *was* such an external act of recording occurring, in some form. That act may have taken on a notably different temporal idiom from its contemporary manifestation, restricted especially by the technological parameters of celluloid film-making, so that only curtailed extracts of several minutes could be selected for recording from a wider protest that may have endured over hours or days. Such parameters themselves incited the styles of moving-image documentation, with the limited recording duration inducing concentrated experiments with camera movement that responded to or allied themselves with the dynamics of ongoing protest-events; the relative dearth of image-seizing celluloid material generated a compulsion to distil an event as a specifically filmic entity, into pivotal fragments and gestures, rather than to encompass its totality. That film-making act also often possessed a disparate temporal intentionality to that of the contemporary moment, in, for example, the official duty of totalitarian state-security agencies to generate moving-image documents as archival data that could, at some delayed point in the untold future, form evidence to castigate the protests' participants, rather than for an immediately punitive response.

The sheer compulsion to gather and project moving-image sequences of dynamic city-sited protest also binds the history of riot

film-making with the recording acts of the contemporary moment. Protest always forms an irreparable aberration within the stable life of the city, and its abrupt insurgence into the domain of regulated environments constitutes a perpetual source of ocular fascination, and of the desire for that aberration's preservation in moving-image form, whether the observing eye endorses, repudiates or manifests oblivious indifference to the protest's contestations. That spectatorial, film-generating attraction will upend all pre-set routines and agendas, as in the decision of Malle and his film crew to abandon their pre-dominant engagements with documenting such issues as leprosy and waterborne disease in Calcutta, to instead shoot – and integrate into Malle's film, *Calcutta* – a factional Maoist student street riot with its violent suppression; that overturning of an in-progress routine is also evident in moving-image sequences in which a mundane occupational task is being filmed for evaluation, before the camera abruptly turns to instead record unique, spectacular evidence of parts of a city being destroyed by terrorist attacks or earthquakes. Insurgency within external city space irresistibly propels an ocular gathering around itself, whether it has its origins in an individual figure, as with the sequence of Biberkopf's eruptive gestural and vocal performance in *Berlin Alexanderplatz*, or else in unforeseen mass traversals of rioting figures spilling across the face of a city, thereby engendering a chaotic uproar that equally seizes the eye and the eye's recording media, filmic or digital.

Such contemporary manifestations of uproar, in their digitized forms, now take on pervasive and engulfing dimensions that exceed those distinctive sensorial and ocular compulsions which, over an extended period, precipitated the filming of riotous protests and of gestural eruptions in external city space; the oblivious excess of contemporary moving-image capture may also transmit itself back to the performed action itself, in its ongoing form, thereby integrally amending the status of performance and creating a new,

unprecedented language of performative gesture that responds primarily to its infiltrating inundation by recording moving-image media, rather than to the articulation of its own contestations or to the environments surrounding it. The pervasive compulsion to record an ongoing eruptive act in external city space – for its immediate dissemination via social media – invariably pre-empts and annuls the corporeal witnessing of the act itself, together with its potential ocular and sensorial consequences. A device for the recording of such acts is now always intimately to hand, in such forms as iPhones, to be operated invariably with ease and with a pre-set homogeneity of shared style regulated by the device itself. Film-makers of socially suppressed performance art and of riotous protests in the 1960s, such as Kren and Marker, shooting in the streets of Vienna, Tokyo and Paris, operated, on the contrary, with impossible constraints and idiosyncratic imperatives – transmitted into fragmentary, concentrated forms – as well as with an intimate knowledge of the particular contestations and strategies at stake in the acts they rendered, which their films could themselves act to resist or endorse.

The sheer excess of contemporary digital image-capture, of performative acts and protests in external space, is itself intimately bound to the history of moving-image experiments in the recording of the gestural and sequential movements of human bodies, often in states of acute crisis. Above all, that excess interconnects, even before the first celluloid film projections of 1895, with Muybridge's seminal *Animal Locomotion* project, staged in a large, adapted yard in the grounds of the University of Pennsylvania in Philadelphia across the years 1884 to 1887, and using multiple cameras to record a proliferation of sequences of human (as well as animal) actions and encounters in space, undertaken by models and students whom Muybridge directed into performing intricate, often outlandish gestures. Even when Muybridge had comprehensively recorded all

of the gestures needed to justify his Philadelphia experiments, he had excessively pursued his project. In the 1970s, the prominent experimental film-maker and theorist Hollis Frampton interrogated that defining excess of Muybridge's project:

> Quite simply, what occasioned Muybridge's obsession? What need drove him, beyond a reasonable limit of dozens or even hundreds of sequences, to make them by thousands? . . . Time seems, sometimes, to stop, to be suspended in tableaux disjunct from change and flux. Most human beings experience, at one time or another, moments of intense passion during which perception seems vividly arrested: erotic rapture, or the extremes of rage and terror came to mind.[24]

Frampton proposes that, from a propulsive visual excess, occasional images will abruptly freeze to expose the performative body in sensorial states that are themselves vitally excessive, but also revelatory, projected in 'arrest' to their spectators for only a moment, before they vanish. For Frampton, the excess of Muybridge's

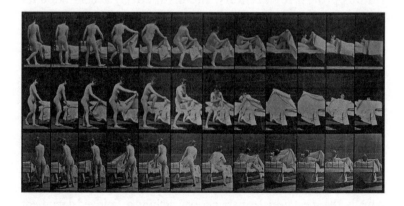

Eadweard Muybridge, from *Animal Locomotion*, 1884–7: image sequence.

Philadelphia sequences materializes a pivotal, frozen image that is not contained in any of those many thousands of sequences, and even belongs to another, earlier era: that of Muybridge's act of raising a gun to kill his wife's lover with a single shot, in 1874. Similarly, Francis Bacon's paintings of the 1950s and '60s transformed the inciting excess of Muybridge's corporeal sequences into Bacon's own performative spaces, in the forms of rooms of isolated or sexually conjoined figures. In their contemporary perception by their maker or spectator, excessive moving-image sequences of performance – particularly those generated to infinite excess, a billion images per global second, by smartphone cameras in exterior spatial environments – are not necessarily received in their expected representational forms; their sheer excess may instead propel them transformatively into another domain of performance, as momentary images of uniquely intensified acts and gestures, such as those of sexual passion or anger-instilled protest. Excess possesses an integral capacity, across performance and the moving image, to induce and imaginatively provoke extreme sensations and experiences.

Since film became the medium which principally documented riotous protest for a century, and distinctively accentuated its performative capacities and gestures, most formatively in the 1920s and '60s, its eventual supplantation by digital image-making necessarily implies a new dimension both in the representation and in the actual ongoing entity of protest, notably in its potential rendering into the domain of performance. Although the term 'film' remains widely used in the post-celluloid era, encompassing digital projections of entirely digitally recorded performance documents in which film played no part, the imperatives and intentions of the filming of performance were often entirely disparate, and even contrary, to those of digital image-making, both spatially and temporally; equally, the spectatorial experience of watching a digitized document of performance is entirely dissimilar from that associated with film

and may lack film's dynamic compulsions, jolts and concentrations, especially in its shooting of acts of human uproar and protest, but possesses instead a sense of potentially infinite duration and a new, excessive capacity for instant interconnection with all other digitized performance documents.

The profound transmutation, in the perception of corporeal, performative forms, embedded in film-making's yielding to digital image-making, is especially exposed in the enduring memory of riotous protests, and its vanishing. Celluloid film always formed a contrary and uniquely beguiling medium for its spectators, above all in its evocations of the human body. Film possessed the capacity to transform awry or split-second gestures from protest events into monumental and emblematic representations, as in the filming of demonstrators tending to the mortally wounded protestor Benno Ohnesorg at the West Berlin protest against the Shah of Iran's visit in 1967. In its expiring as the pre-eminent visual form for the documentation of protest – and for the conjuration, for its spectators, of protest's performative dimensions – film may emit a last-breath, malediction-propelled release of narcotic forgetfulness into the near-fully digitized world, whose sense of memory is precarious and always subject to malfunction. For the memory of riotous protests, that filmic oblivion can annul the lineages, breadth and textures of those events, which were always, in multiple and specific ways, directed *against*, as in West Berlin's uproars of the 1960s and '70s against such targets as state power, dire living conditions, ecological destruction, dictatorial oppression, nuclear power and philosophical impasses, among many other contestations. Such specific focal points of protest – emphasized by film-makers and bound to distinct styles of film-making as well as to the protests' performative elements – become lost in the digital world, their specificity engulfed by the excess of digital image-making. Film always perversely destroys itself and scatters its traces, and when the filmic history of riotous

protest is retrospectively voided, those protests' performativity is also voided, along with the originating events themselves.

The instant when a protest comes to a halt – either because its targets for contestation have been annulled, or because its spaces have been emptied out or else densely constricted – is that at which the loss of the corporeal velocity and gesturality always integral to protest's filming and to its performative dimensions becomes most tangibly felt: in its vanishing. In particular, that loss comes about through the riot-police procedure known as 'kettling', enacted pervasively and on an increasingly global basis since the mid-1990s and notably in central London during the G20 demonstrations on 2 April 2009, with many thousands of demonstrators implosively sealed into space, then filmed or photographed for potential future prosecution while being channelled through the single escape-aperture eventually allowed by riot police. As well as involving the specific, irreplicable movements of individual and agenda-driven bodies engaged in protest, collective gestural riot movement generates a distinctive presence in its own right, once transferred to the moving-image medium and rendered by film-camera manoeuvres that enhance that riot movement's eye-directed velocity, thereby choreographing such sensations as exhilaration, fear, triumph and ecstasy, which are not dependent on any particular subject of contestation for their intensity of sensation and for the immediacy of its transmission to onlookers and spectators. Performance itself does not integrally need a specific target of activism, revolution or political protest in order to be experienced with such sensorial intensity; voided of its targets, it may still convey that charge, provided that it holds dynamic gestural movement. Above all, the spectacle of great pulses of human bodies moving at speed through external city space forms a pre-eminent performative act that irrepressibly binds itself, especially in its filming, with all previous and future spectacles of the mass

corporeal traversal of city space. Once such movement is stilled, the vital attributes of both protest and performance are set askew, and subject to interrogation or recasting. The process of the self-willed stilling of protest – embodied by Erdem Gündüz's Taksim Square standing-still performance action of 2013 – engenders an anti-riot composed of petrifaction simultaneously of the body and the city. Across the earlier history of performance, the formative work of the Japanese choreographer Masaki Iwana, from the mid-1970s until 1982, involved him standing, naked and deathly still, in external environments, for extended periods, in the form of an inverse choreography from which even the barest gesture was razed. Anselm Kiefer's sequence of *Occupations* performance artworks of 1969 entailed him standing, dressed in a military coat and jodhpurs, in the foreground of locations ostensibly charged with volatile history, and performing 'Hitlergruss' salutes (documented in photography, rather than film, but appearing as the detritus of lost films from which only one image survived, of each eroded sequence), remaining otherwise still.

For vast corporeal movements across city space, an arbitrary act of stilling potentially generates filmed catastrophe. On 24 July 2010 the several hundred thousand participants of the final Love Parade – a city-traversing annual techno music festival, initiated in West Berlin in July 1989 with a focus on campaigning for gay rights and nuclear disarmament, then sustained intermittently over the subsequent two decades in Berlin and other German cities, its original campaigning imperatives annulled – attempted to cross the city of Duisburg to reach the festival's assigned space (the first time it had possessed a fixed, rather than in-transit site), in the grounds of an abandoned railway freight yard accessed by a subterranean system of long tunnels, lined with corporate advertising hoardings. Many of the young participants wore badges inscribed 'dance or die!', indicating their intention, in their journey to that site, to form

part of an immense choreographic co-performance, rather than to constitute an audience. The police strategy of repeatedly kettling into stasis and then releasing the participants as they arrived at the tunnels, together with the site's architectural anomalies and the excessive onrush of bodies, led to a phenomenon of 'crowd turbulence' in which 21 participants were suffocated to death; the catastrophe was filmed both chaotically from within the crush, and also by surveillance cameras which omnisciently monitored the abrupt temporal transformation between the crowd's innocuous flux and its deathly stilling.

Catastrophe and disaster are predominant forms and obsessions of performance art, which is sensitized both to the vulnerability of the isolated human body and the times and spaces across which it endures disintegration and self-wounding, as in the work of Günter Brus, and also to vaster, all-engulfing corporeal calamities of the magnitude which Zhang Huan's work invokes. As with its documentation of a work of performance art, photography has the ability to concentrate into a single image the transmutating uproar of a riot, as it descends into slaughter or into kettling by riot police, in Beijing or London; photography may pinpoint the split-second corporeal gesture or facial convulsion through which the realization of oncoming calamity, and the accompanying erasure of a riot's aspirations, become articulated. Moving-image sequences – from those of the celluloid films that documented 1960s protests to digital-image sequences of contemporary gatherings – possess instead the intimate capacity to embody the time and space of the act of corporeal amassing, and notably the immediacy generated when velocity is abruptly overturned into violent stasis, but with a final detachment – that belongs also to the moving-image documentation of performance art – whenever such sequences record, as though obliviously, and foreclosing the possibility for intervention, the interval of calm preparation that will lead to a catastrophe or a wounding.

Just as all filmed riotous mass-traversals of city space form elements within a historical and future-propelled genealogy, with its global vocabulary of gestural protest, the filming of demonstrations reduced to kettled stasis also possesses its future-oriented history, encompassing the detrital traces of suppressed acts. The eyes of such films' viewers have to scan the static sequences of often-enraged kettled figures in order to identify such sequences' status and their potential outcome. Once a riot has been kettled or forcibly stilled, its corporeally exposed participants are excluded from the capacity for the active performance of exclamatory, exhilarated protest which is that principally of rioters dynamically crossing cities. If those participants perform at all, filmed intimately from within the arrested protest, it may take the form of a performance of pinioned immobility, as in the work of Gündüz or Iwana, or else one of desperate gesture. And film, in its riot police or surveillance idioms, marks such figures' eventual liberation from kettled immobility as one in which the body will no longer take on the role of an active agent of performative protest, in the digital world, but that of an entity always maximally open to punitive control through the power of visual media.

Film forms a perverse medium for the conjuration of performance from protest, enacted even directly against that protest's intention. Protestors may adamantly believe themselves not to be performing at all, but solely engaged in acts of contestatory engagement that demand the exposed engulfing of their bodies by situations of danger, often with lethal consequences, as in innumerable protests against the twentieth century's totalitarian regimes worldwide. But, once such acts have been filmed, they can be immediately transposed, as malleable entities, into performative (as well as representational) domains, as celebratory rituals, reckless spectacles or infinitesimal gestures of choreography; those acts, once edited and narrated into moving-image sequences by their documenters – propelled across

all time and corporeal space, from one extreme limit of human activity to another – and transformed once again by the perception and imperatives of their spectators, then inhabit the performative, and exist as performances. Nothing is more subject to being overturned by film, into performance, than the delicate passion and fierce anger of protest, together with its liminal transits between darkness and illumination. Conversely, the most everyday, mundane acts undertaken in city space may also be reconfigured by film and its spectatorial dynamics into gestures of performative protest. In viewing the very first films of external city space, such as that by Louis Le Prince of figures traversing the river Aire bridge in Leeds (1888), or that by the Skladanowsky brothers of amassed figures on foot adeptly weaving between horse-drawn trams in Berlin's Alexanderplatz (1896), the spectator may envisage a revolution in gestural formulation, poised in nihilistic or socially committed uproar against the surrounding city space, and performatively enacted, in complex encounters and evasions whose apparent innocuousness is itself a performative strategy: a screen, positioned at the distance of a transparent membrane (as with the first film-projection screens of 1895, doused with water to increase their capacity to materialize moving images) from revolution. That envisaged revolution may then be deferred for almost a century, and its spatial location unrecognizably overhauled several times in the interim, as with that of the Alexanderplatz, but film has the capacity to hold and abruptly wield its prescient, performative traces. In its relationship to performance, film possesses no linear, forward-oriented axis: it simultaneously positions itself in the future, the past and the immediate moment, and in blurrings across them. Film's inherent volatility is only accentuated still more acutely when it projects riotous protest into performance.

In counterposition to film's volatile presence, protest possesses sustained visual forms with distinctive gestural and corporeal

vocabularies; that endurance of seminal forms and articulations always allowed film to instil performative dimensions into protest, especially when protest's manifestations became mass, near-global phenomena, as with the Occupy movement around 2011 and its nationally focused catalysts or offshoots, such as the Indignados movement in Spain. Beyond the digital media of immediate communication that allowed the pervasive filming of the acts of such protest movements and also enabled them to traverse cities and rapidly re-cohere elsewhere, protest always remains a corporeal event. It holds characteristic performative tensions, such as those of contrary responses to the perpetual imminence of an outbreak of violence, for protest movements aligned to non-violence. Protest also holds distinctive spatial tensions in its role as a sensitized location for performance, as in protest movements' spatial self-definition in stasis and 'occupation' (for example, the extended inhabitation of the area outside St Paul's Cathedral, for London-focused Occupy protestors in 2011–12), in preference to direct assaults on banking zones or sites of political power. As with Mario Savio's speech calling for the peaceful occupation of Sproul Hall, rather than an all-out confrontation with Berkeley riot police, in 1964, the act of occupation is always precariously positioned, in its performative siting, between the instigation and gradual consolidation of a protest community, and the foregone conclusion of the violent spatial razing and extirpation of that community by its subjugators. Alongside those fissured spatial dynamics, which are primarily external and city-located, all protests also share an engagement with the moving-image sequences that embody and constitute the future markers of protest, in its many manifestations.

The near-invariable endurance and recognizability of protest's gestural forms grants film the capacity intimately to interconnect pivotal past moments of protest across a century or so of time, and to layer the traces of protest over and within one another, to expose

their performative dimensions. The moving-image sequences of rioters propelled at speed through the avenues of Tokyo in 1969, shot from inside that chaotic momentum and closely conjoined with the performance culture of the era, may readily infiltrate the contemporary sequences of Occupy protests in European or South American cities, such as Athens and Santiago de Chile – celluloid traces against digital-image traces – to interrogate their oscillations: between spatial inhabitation and performance, between velocity and stillness. But in all amalgams of imageries from protest's performative and filmic histories, a vital malfunction and resulting syncope irrepressibly occurs, generated by technological incompati-bility or through spectatorial imagination, creating an illuminating aperture within time which, once the eye accustoms itself to viewing riotous uproar via the lens of malfunction, reveals the intersection of protest, performance and film.

Performance and protest are always a hair's breadth from forming past or current amalgams, once welded via the intervention of film. But after the repeated impasses and dispersals experienced in recent years by the Occupy movement (in its extirpation from the corporate-bordering space it sought to inhabit worldwide) and with the accelerating urgency of ecological, financial and dehumanizing crises, emergent protest movements will now take on new forms, with fundamental implications for performance and its rendering in the medium of moving images. In the domain of digital culture, the pivotal dilemma faced by such urgency-instilled protests is that they are planned and spatially coordinated, then recorded and disseminated in moving-image sequences, via the identical digital technologies and media that are deployed by corporate and govern-mental powers to annul those protests and the forms of space (including digital space) conceived for the enacting of such protests. Just as film presented a doubled presence in its relationship to protest

– in creating or accentuating protest's performative dimensions, but also in its role as the primary surveillance and identification medium of punitive state-security agencies – digital culture also conjures the potential for protest, in terms of expansive activist-networks and their envisaged spatial locations, but simultaneously voids those spaces together with their performative, spectatorial and sensorial dimensions. To exert its planned presence and project its contestations, protest must now be located within the *imminent* future and its spaces, but those spaces are invariably undercut in their advance appropriation by corporate and governmental powers.

In looking backwards across the interconnected histories and imageries of filmed protest – such as those of performance-imbued 1960s Tokyo-traversing riotous demonstrations, interlayered with those of contemporary Occupy inhabitations and kettlings – the forms of protest may appear opposed in their contrary gestural mani-festations, but each image-layer belongs to readily identifiable idioms of protest, pre-eminently through their performative articulations, in choreographed chants and declarative manifestos, in coordinated rampages and synchronized riot battles, and in spatial appropriations and the ritual surrendering of them. Sequences, shot with 16mm cameras in mid-riot, of blurred, acetylene illumination over frenetic bodies assaulting a police station, in the monochrome, blood-constellated avenues of Tokyo, from Oshima's *Diary of a Shinjuku Thief* (1969), may be set in intimate conjunction with digital hand-held camera sequences from Corey Ogilvie's *Occupy: The Movie* (2013), in which protest figures, in triumphalist speeches to activists, apportion to their movement the near-effortless capacity definitively to destroy corporate and banking systems, before duly disappearing into oblivion, while those systems remain. Film creates the infinite archival capacity for such seminal image-conjoinings across the gestural history of protest, in which protestors, often far more so than their adversaries, are the performative self-erasers of their contestations.

In many ways, the imminent future of protest fundamentally reorients the relationship between performance and film, in urgently under-pressure external city space, for the first time since the performance of acts of uproar, witnessed or imagined, began to coalesce into a sustained preoccupation for film-makers, at the twentieth century's beginning. If film becomes absent – in its apparent obsolescence in the digital world, as a distinctive, protest-carrying visual medium – the axis of protest's representation then shifts into an unprecedented terrain, taking with it, on that tightrope-walking journey, the performative dimensions of protest. The forms of imminent protests are always determined by the technology used visually to render them, in ephemeral and mutating manifestations: viral acts, politically inflected flashmobs, pre-usurped occupations. Such protests risk never cohering in space, but when they do, they present exacting ocular demands for their intentional or accidental spectators, in the instantaneity of their perception and the simultaneous desire, embedded within the act of spectatorship, to record that protest – as a performative event – in the form of a smartphone image-sequence whose multi-directional transmission then fractures all non-vertiginous perception of the space of protest. An imminent act of protest must optimally concentrate its contestation (whether focused on ecological issues, economic crimes, or infrastructural disintegrations) into extreme brevity in order for it to retain any surviving contestatory residue as it becomes transmitted and re-transmitted; otherwise it is immediately consigned, as an undifferentiated element, into the all-engulfing excess of burnt-out, detrital data. But all such acts of imminent protest, even in their abrupt plummetings into redundancy, constitute performances of the human body, in its intersecting encounters with corporate and digital entities, and in its exposure to the transforming power of space.

The human body, performing an act of protest in a spatial situation of acute, even-lethal tension – with that act rendered into a moving image form that enhances its spectacular or ritualistic performativity – constitutes the sole element, from the twentieth century's protest cultures, that traverses into the fully digitized world. Opposing corporate power – always instilled in digital media and their subjugating omnipotence in public space – forms a contestation, in corporeal terms, which inherits the manifold contestations of ecological despoliation, nuclear industries, authoritarian regimes and other targets of twentieth-century protests, filmed mostly in the form of riotous transits across external city space. The corporeal endures in contemporary and future protest cultures, and the corporeal forms the basis for all performative experiments in space. But space itself fundamentally shifts in digital culture, and the visual media through which performative protest is rendered also enter rapid transmutation. In that sense, the human body, in its exposed situation of enacting gestures of refusal within external space, forms a just-pre-obsolescent entity, exemplified by the figure of Bruno S., transiting West Berlin's peripheral space and infiltrating back courtyards to perform street-musician acts, filmed in Herzog's *Stroszek*, as a rectifying 'protest' against the imposition upon him of the nullifying status of psychosis, before that infiltrated space is expulsively closed off (with the potential for performance also expelled from that space). The human body will not survive to perform as an intact, volitional presence – as it has done over the history of protest, notably through an identifiable vocabulary of gesture – in future protest cultures; it is relentlessly fragmented by digital media whose devices multiply dissect it into disembodied bits, and it is also subject – in its enduring desire to enact protest – to a countering regime of spatial cordoning and erasure.

The violent extirpation of Occupy protest communities from corporate-bordering spaces worldwide intimates how a sub-city of

protest can never be created, to endure and to perform its contest-
ations, in future external space. By establishing itself within space,
and positioning its inhabitants as the foregone conquerors of
oppressive corporate power exemplified by worldwide financial
systems, that community has already annulled itself. A perfor-
mative sub-city anti-community of madness and beggars, like that
envisioned in Aristakisyan's film *Palms*, may be infinitely more
destabilizing for a global corporate culture whose system of sub-
jugation pivots on fixed principles of sanity and shared financial
rationales, projected in the form of moving-image animations to
city populations from Chişinău to Bangkok via the medium of large-
scale animated screens now installed pervasively in plazas and at
intersections. Similarly, mobile mass protests traversing external
space, as during London's G20 demonstrations, are increasingly
subject to sophisticated constriction and kettling procedures – as
alliances between the omniscient surveillance power of digital
moving-image devices (exemplified by closed-circuit recording
systems), and the expansive power of riot police to spatially surround
and then erase manifestations of protest – which both strangle any
element of protest performance in mid-action, and also void from
protest the exhilaration once attached to riotous, breakneck man-
oeuvres across cities. Such transits, throughout the history of riot
cultures, were always also precarious, as film demonstrates, notably
in Malle's *Calcutta* sequence of hapless protestors finally tracked
down in their exhausted dispersal and individually clubbed or shot
by riot police. In the future subjugation of riot cultures, amassed
protestors are maintained intact by their adversaries as a collective
'body' to be annulled; the intact body of the individual protestor
is adhered with all other protest bodies in order to be effectively
kettled into erasure from corporate space. In that sense, from the
perspective of protest cultures, future digital-surveillance areas –
often constituting the totalities of cities, with their arterial avenues

and streets – become 'elsewhere' spaces: corporeally uninhabitable, unperformable, unfracturable, unprotestable: unpublic spaces.

Contemporary and future city space requires the mad, subterranean insurgency of the uncontainable beggar population, ready, in *The Threepenny Opera*, via veering, erratic transits – without any specific contestation, but propelled instead by a total contestation – to engulf pre-eminent sites of power, as a permanent nothing-to-lose threat to the dehumanization of space. All spatial systems can be immediately inversed and razed, most especially when they are static; the violent expulsions endemic to many Occupy initiatives also apply to the stability and consolidation of corporate space, together with its image cultures of 'sane' digital data. And the future of human uproar – always exemplified by riotous protest, as a seminal corporeal and performative act – also requires the memory, even in its obsolescence, of film. The exploration of the relationship between performance and film, in their intricate conjoining with protest cultures over a century or so, shows the extent to which they propelled the ephemeral, momentary forms of protest into the future by sustaining and accentuating protest's traces. Film, even (and especially) in its expiring, holds a unique capacity to re-conjure and project the archival presences and detrital residues of worldwide cultures of protest, with their vital movements, into performance.

Image Interzones: The Digital World and Performance

Film is conjoined in space with performance, but that spatial rapport is always an interzonal one of shifts, transformations and disappearances; film's supplanting by digital media generates an entirely new entity for performance's documentation, for the presence of the moving image within performances, and for the visual memory and survival of performance. In performance's role within riotous events, film served as the medium that dynamically accentuated the performative dimension of spatial protest and unrest, and sustained performance's alliance with protest; that performative element of riot cultures could not have been manifested without film's catalyst, just as the entire history of riot culture is determined and visualized by film from the moment that film appeared as a creative and documentational medium. Performance's history is meshed into that of film, and that multiplicitous history is volatile and often fractious with incendiary traces. Notably, performance's alliance with digital media (in their distinctively post-filmic forms), together with performance's existence in the world configured by digital media, remain emergent relationships that took on tangible form only from the 1990s, with experiments such as those of the Dumb Type performance group in Japan. Film maintains its integral alliance with performance, alongside digital media, but that alliance is sharply marked by figures of accelerating disintegration, loss and oblivion, through film's final tightrope-walk fall into the abyss of obsolescence; but in obsolescence, new and vital media are generated.

Performance, with its direct conduit through corporeality, forms a far longer-existing, more tangible medium than film, whose duration is that of an eye's momentary blackout alongside performance's multi-millennial, global histories; film – devised through excess and aberration by 1880s and '90s inventors and tricksters such as Muybridge and the Skladanowsky brothers – constitutes a phantasmatic medium, driven by and into obsession, spectral, projected by and into the eye, so that it barely exists, but resolutely amasses uncontainable detritus, in the forms of archives, ocular and memorial afterimages and its ruined and abandoned auditoria. Viewed temporally, film may form only a time-bracketed annex from within the histories of performance, by which performance demanded moving-image apertures for its spaces, together with a medium for visually adhering performance's corporeal and durational ephemerality; once performance had absorbed film comprehensively into its spaces, and ensured its own survival in film archives, it then discarded film in the same moment that digital media emerged. From that temporal perspective, performance art's enduring fascination with film, as an entity utterly distinct in its visual aura and compulsive history from digital media, would then constitute the terminal survival of film, in its subsidiary relationship to performance. But performance and film never co-existed within the same linear temporal continuum; their times operate at tangents and through collisions, via intensive encounters and disjunctures. Film's time could be viewed alternatively as one always rushing ahead of performance, in a riotous acceleration of experimentation, in the face of its own extinction and its forcible co-opting into the engulfing domain of digital culture.

Film's vanishing in the contemporary moment – if film now really is disappearing, rather than performing a conjuring trick of the same magnitude as its emergence in the 1890s – results from a malfunctioned, misfired syncope, as though the ocularly focused

interval of its existence were irresistibly mutating into another opening of vision. The status of film's ostensible obsolescence is that of a medium which, surpassed, spectacularly disintegrates rather than fades away. If digital media expel film from viability by rendering it obsolete, then that expulsion forms an expansive one through which film makes a panoramic, performative exit of material decay and memory trauma. Film will not go quietly. Its expulsion forms a counterpoint to the ways in which digital media work to annul and extirpate human bodies, from city space or riotous gatherings. Film's vanishing comprises an event of spectatorial horror (since nobody wants film to disappear), that horror notably emerging from film's pre-eminent locations such as those of derelict or reused cinema spaces. But that act of vanishing is also incorporated within an overwhelming power of technological compulsion that accepts the digital world's transformations of performance, film and the human body, among untold other entities. In that transformation's technological imperative, film and digital media cannot exist simultaneously, even in a state of productive tension, in the way that film and performance co-existed, for a century or so. Film must vanish, its supplanting assured by the pervasive presence of digital media's corporate moving-image screens in city environments. But film's vanishing may not solely be a process indicating frailty, in which film is simply overridden into passivity by digital media and its technologies. Film may aberrantly expand (annulling itself through that act), as Robert Smithson foresaw in 1971: 'It's not hard to consider cinema expanding into a deafening pale abstraction controlled by computers.'[25]

Whether film actively transforms itself into digital media through an expansive sleight-of-hand manoeuvre which its 1890s instigators would be familiar with, or else is cruelly rendered obsolete and erased by digital media in a spectacular performance of disintegration that wounds its audiences' eyes, it leaves behind its 'survivors': performance

and the digital world. In that sense, film's absence impedes performance's intricate spatial negotiations within digital environments (environments that may overhaul or even raze the potential for performance in spaces historically long-associated with performance, such as external city plazas), since film's rapport with performance is an intimate one, thereby rendering film's absence seminal, and its archival memory of performance has become so engrained that the viewing of films of performance is now widely perceived as the experience of the original performance itself. At the same time, film's opportunistic alliance with performance is temporally negligible (in the wide context of performance's near-infinite history), soon forgotten; while digital media have no memory of their own, they possess powerful instruments of oblivion. As 'survivors' from film's moribund status, performance and the digital world necessarily devise new spatial alliances that are integrally based on forgetting or obliterating previous, volatile alliances such as those entailing film.

Film, if it has vanished, holds no further significance for performance. But what binds film with digital media is their projection of moving images, and those sequences' special significance for performance. Sequences of images, carried either by celluloid or pixels, hold and revivify the human body in the performance of its gestures and acts; in that sense, they constitute contraries of photographic images, which still and petrify. Muybridge's transformative animation of photography into glass-disc-format moving images, through the technological intervention of his Zoopraxiscope projector, viewed by spectators at the San Francisco Art Association in 1880 and then at the Chicago Exposition in 1893 (just before celluloid-media cinema), forms a prescient amalgam process for that ongoing between film and digital media; each process generates a spectacular performative event, together with immediate implications for performance and its visual rendering. But whereas film left photography

intact (notably in its role as a documenting medium of performance), the fusing of film with digital media potentially annuls film in its future rapport with performance. The final part of this book explores the expiring of film's densely charged relationship with performance and the simultaneous emergence of digital media's relationship with performance, in the visibility-oriented contemporary moment of image-cultures and their city spaces, as well as within terminal, subterranean, voided and conflict-fissured spaces.

Space is now more than ever pivotal to the future status of performance cultures within the digital world: the annulling and screening off of space, alongside the expansion and transformation of space. Performance was always able to induce film to enter its space, through such elements as the projection of already-shot filmic sequences over ongoing performances' bodies, or the introduction of the figures of film-makers together with their cameras into performance spaces; that spatial and corporeal intersection of performance and film operated equally within auditoria and in the external performance spaces of central city plazas or wastelands, peripheral zones and subterranes. But digital media do not occupy space in the same way that film does in its conjunction with performance. The immanent, diffuse presence of digital media often requires its transferral into a specific avatar, such as a corporeal agent, notably through the appearance within performance spaces of image-recording figures who capture acts or gestures within that space that are *simultaneously* projected onto a surface in another part of the space. Digital media infiltrate performance's space to accentuate their distinctive capacity for simultaneity and synchronicity. But in that process of immersal into the ongoing moment, digital media also become bound into, and exacerbate, the predisposition of performance's gestures and acts instantly to expire after their accomplishment. The endurance of memory and vision are intimately at stake in that simultaneous

vanishing of performance and digital media. In the conjoining of performance and digital media (still inflected, to some degree, by film's residues), and in its transmutating implications for memory, history and vision, at least three formations of space may emerge.

Since digital media operate via their invasive extensions into corporeality, interzonal configurations of performance may now be generated through performance's welding with perpetually shifting phenomena of digital-image entities together with corporeal entities, in space. In such amalgams of digital media and corporeality, in which digital media need to take the upper hand or face their annulling, the human body itself is transformed into a spectral presence in city space in a parallel way to that in which film, across the course of time, rendered corporeality (figures seen traversing streets, bridges, plazas) into spectral emanations. Such phenomena, in which performance and digital media become allied, form unprecedented, unpredictable spatial manifestations that can only take place (and embed themselves into space) for extremely abbreviated durations: those of performance's ephemeral acts and gestures, with the simultaneous presence within them of digital media. Space is perpetually in transit, in performance's amalgam with digital media, propelled from site to site in bursts of spectacular events that pivot, even in their intensity, upon their imminent fall into obsolescence. Such spaces also signal the eventual cessation of performance as taking place within fixed auditorium sites; performance may seep or flash from hand-held digital devices to city space and back, but cannot be spatially fixed or enclosed once it is inextricably interwoven with digital media.

Such spatially located manifestations of performance and digital media, instilled via immediacy into volatile sites in flux, necessarily entail a shift in the status of memory, history and vision. If memory cannot be sustained, it can also no longer be held in archival forms which imply future-oriented endurance for memorial reactivation

(there is no tenable future in the alliance of performance with digital media). Memory then takes on such endangered or fissured forms as those experienced by dementia patients who are unable to remember all but the last few moments, and memory's performance languages become subject to a supremacy of immediacy but an embattled durational frailty, so that they may assume the scrambled form of delivery-impaired incitations of threats, as with that performed by Erich Mielke ('punks, skinheads, heavy metallers') in his oblivion-inflected evocation of the GDR's spatially infiltrating enemies of the early 1980s. Without sustained memory, or even fragments of memory, history is erased and ceases to exist, notably as an obsession of performance. By contrast, vision may be accentuated and intensified, through such spatial conflations of performance and digital media, for the split-second of performance's spatial occupation, attuned to the image-focused excesses and concentrations that enforce in vision a new mobility, and an infinite receptivity to suddenness and obsolescence. Vision is then the instrument of a self-induced syncope that takes spectatorial perception from disparate space to space for momentary performative experiences: non-linear, non-accumulating sequences of corporeal and ocular disorientation, as with those often enacted by experimental film.

In performance's spatial amalgam with digital media, history may perversely resurge from oblivion-endangered erasure, however. Predominantly, the spectating of memory-erased performance entails such syncopic traversals of space, with the characteristic exhilaration that integrally emerges from the sensory experience of releases or falls; in those blackouts, history is spatially nowhere. But the embeddedness within digital media of film's seizings of history, together with performance's own apertures for history, may aberrantly conjure new manifestations of history within digital media's image-sequences. In that sense, digital media may irresistibly project history through the conjoining and amalgamation of performance, city space and

moving-image forms. Such performative manifestations of history are no longer 'filmable' in the way that performance was filmed and transformed into history (notably, into film's history), during film's century or so of cultural pre-eminence; such manifestations lack the temporal endurance required for developmental historical perception. But, in their ocular emphasis, such momentary performances – notably, those taking place in external city space, which convulsively emits its own memories and histories even when ostensibly screened off – require the spectator's eye to look ever closer, since under the surface skin of digital media's corporate animations, the eye necessarily strikes the subterranes of history. History is then envisioned with profound immediacy, and unique configurations of memory may be conjured from that abrasive, in-transit historical eye contact. In many ways, the human eye becomes far more implicated – in envisaging its own future transmutation, as well as in tracing the detritus of memory and history – within performance's conjunctions with digital media, than in performance's former alliances with film.

Those multiple permutations of performance's future rapport with, or merging into, digital media, together with their location in spatial forms, exist simultaneously. All potential futures form utilizable futures, since digital media permit no exclusions, in the honing of space's optimal capacities, and for the binding of digital technologies with corporeal technologies; in that sense, there can exist no prefigured or preferred future, whether apocalyptic or Edenic – each possesses an equivalent capacity for the capture of time. The infinite variants of performance's conjoining with digital media, in which history and memory may survive, or not, all converge solely in their amassed simultaneity; the maximal concentration and over-layering of present time, essential to all digital media cultures, is one in which performance and digital media are also welded into the already disappearing fall into oblivion of the ongoing moment.

That simultaneity may resonate with the way in which film often deployed its spectator's eye to envision and inhabit past, present and future spaces at the same time, to flash forward or back. But in digital media's alliance with performance, no moving-image element can be delegated to future time, as occurred, for example, in film's work towards the amassed future-oriented documentation of performance; the two media forms – performance and digital media – must concur, as in the pervasive incorporation into contemporary performance's space of digital moving-image sequences both shot and projected in that space. The past is then rendered as spectral as the future; however, when performance instead amalgamates obsolete or archaic moving-image sequences into its ongoing space, rather than simultaneous digital sequences, time's expansiveness abruptly jars back into that space.

Especially when performance intersects with digital media in external city space – whether within central plazas or zonal wastelands – there can be no banal or habituated outcome from that encounter, even within the parameters of corporatized environments in which mundanity and fixity form paramount priorities; performance's volatile fissuration by its own memory strata and its histories of experimentation, together with the aberrant moving-image histories infiltrating and underpinning digital media, create the potential for insurgent events and acts in such spaces, irresistibly manifesting themselves whenever those spaces appear most sealed and mono-culturally banalized. Above all, performance's corporeal element is virulently uncontainable; it spills and fractures. As a result, contemporary city space presents sensitized, against-the-grain locations for the emergence of performance's acts, often taking place ephemerally, and instantly lost, but leaving behind traces from which the eye can meticulously sift film-inflected residues, of memory, history and corporeality. Such performances – allied to performance art's

history in many ways, but also distinctively separated from it in their distance from institutional visual culture – take the form of moving-image accentuated gestural extremes; they may emerge in delicate and barely existent acts of performative improvisation, or, at the opposite 'end' of performance's projections, they may appear fiercely structured in raw repetition, as the outcome of extensive reflections or compulsions that finally burst into space.

Performance is integrally concerned with survival: not necessarily its own survival as a medium, or that of its duplicitous moving-image media allies, but always of the body, and of the inhabitable spaces of corporeality in the digital world, notably riotous space and subterranean space. Even when the body is extinctually erased, space still holds its indelible residues, just as a cinema auditorium carries film's detritus, or a performance auditorium remains imprinted with gestural traces; lost performance, together with its corporeal gestures, may then conceivably be revivified, at a future moment, from such detrital archives. In that sense, performance forms an ecologically imbued medium, integrally poised at the instant before extinction, like an endangered species; in many ways, the medium of film – spectrally originated in the 1890s, and bound for a new extinction from its first moments – intersected with performance for a century or so primarily in order to instil performance with the future-oriented capacity to develop a dynamic of survival. Contemporary performance, taking place in spatial locations for which ecological events will certainly come to form negatively transformational ones, exists only for a split-second longer; in that sense, it is always ecologically charged and suffused, but also takes on a just-pre-extinctual form, accorded a spare interval of respite. Its conjoinings in space with digital media serve primarily to accentuate that precarious configuration of performance, rather than pointing towards a tenable future.

The first explicit alliances of performance with digital media, from the 1990s, already pivoted around obsessions with survival,

and the exploration of means to survive. In many ways, Japan formed the primary location in creating the spaces and technologies for performance's intersections with digital media. The Japanese performer Teiji Furuhashi's influential installation *Lovers* (1994) took the form of an enclosed, darkened spatial environment for spectators surrounded entirely by screens onto which digital projectors cast ghost images of animated, life-size naked figures who, perpetually in transit, criss-crossed one another, occasionally meeting and even embracing, but were compelled to keep moving. Furuhashi's figures, with their infinite permutations, resonated closely with those appearing in Muybridge's *Animal Locomotion* sequences (projected as moving images in public venues) of the 1880s, which were similarly restless, performing oblique or enigmatic acts and often abruptly turning to head in the opposite direction. Furuhashi's figures, especially the moving-image avatar of his own body, responded directly to the spectators in the performance environment, who could activate sensors in order momentarily to arrest the projected body in midmovement, so that it faced or confronted the spectator for an instant before falling backwards, as though in a tightrope-walk fall into abysmal oblivion. Spectators' traversals of the performance space's floor activated further sensors which triggered the projection of text onto that floor, with the tactile text simultaneously prohibiting further spectatorial movement through its content ('do not cross the line, or jump over'), emitted from a mysterious agent of spatial prohibition, and also in itself constituting a barrier against movement. *Lovers* proved to be the only performance-installation project undertaken by Furuhashi, who was also a prominent participant of the Kyoto-based Dumb Type performance group that had already been active for the preceding decade or so in works concerned, and conjoined, with emergent digital technologies; the following year, 1995, Furuhashi died from AIDS. *Lovers* – which evokes in part the endangered bodies of the 1990s AIDS era and the prohibitions surrounding

Teiji Furuhashi,
Lovers, 1994:
film-image.

them – was shown in many performance venues and art museums globally over the following years and activated innumerable other alliances between performance and digital media, then gradually disappeared, its own technologies surpassed; the *Lovers* performance installation was conceived simultaneously with technological innovation and an awareness of its own imminent technological obsolescence. As a last performance by Furuhashi, *Lovers*'s own survival took the form of the multiple acquisition of its material traces (projectors, moving-image sequences on laser discs) by art museum collections for potential future reactivation, together with the endurance of its promotional media, such as a short film made by the project's commissioning body, the Canon ArtLab in Tokyo (itself a digital media body which became obsolete and vanished by the early 2000s), to document it.[26]

The implications of the 'last' gestures of performance, in the digital world, together with their ecological and corporeal dimensions, have been examined conceptually in the work of the performance-theorist Alan Read, notably through his multiple evocations of a 'last human venue': that of performance, which holds and incessantly projects its integral lastness (it will survive all other media, but only by a fraction of a second).[27] That lastness of performance may be

accurately measurable by the medium of film, and through the gauge of moving-image parameters, but Read also invokes and enumerates the potential extinction of performance in the surrounding context of ecological and corporeal erasure: 'Extinction is available in (at least) three relatively accessible and well-documented contemporary modes: by nuclear accident or endeavour, by ecological disrepair and by the ratcheting up of mass exterminations common to genocides of the last century.'[28] In many ways, those three propositions of calamitous lastness are the least of it, and the last human venue is already spatially accessible, directly and immediately, via the digital world's intersection with performance, which engenders erased bodies and annulled environments. Final calamities of extinction, which necessarily engulf all performance along with the world, induce a voided form, but a spatial element may still endure in that fall into calamity: that of spectatorship's ocular space. Read evokes 'the saturated space of the witnessing of the end of all performance': a space that, irreplicable, demands a unique spectatorial attentiveness and active envisioning.[29] The spectating of the performative erasure of the world also requires its audience's eye to be able to endure for an instant longer than the process of extinction itself, so that the spectacle can be spatially viewed and registered. In Artaud's final performance manifesto of the 1930s, The New Revelations of Being (1937), which announced an imminent global calamity, a spatial (as well as textual) vantage point was imperatively needed in order to view that cataclysm's performative spectacle; Artaud chose for himself the spatial environment of the isolated island of Inishmore, off the western coast of Ireland – which he had seen depicted in Robert Flaherty's film documentary Man of Aran of 1934 – as his preferred 'last human venue' location, from which to witness extinction's projection, and travelled there from Paris for that apocalyptic experience (which duly failed to materialize).

Film, in its alliance with performance and in its own multiple preoccupation with extinctions of all kinds, served historically as

the medium which pre-emptively image-sequenced that potential 'last' act of performance for its eventual witnessing by its spectators. But in the digital world, with its spatial regimes of eradication, extinction-charged locations for the human body are incessantly generated in all manifestations of intersections between performance, digital moving-image media and city space. Such environments present the urgent necessity for future performance cultures (as well as residual film cultures) to access peripheral or subterranean spaces, in a parallel way to that in which 'extremophile' organisms (principally, microbial and bacterial organisms) intimately attach themselves to deep suboceanic or subglacial isolated spaces, even in conditions of excessive heat and cold or apparent endangerment, and as though in active preference to other sites, in order to survive. Once such 'extremophile'-inhabited spaces have been created, they may be transited from one location to another, and are rendered ineradicable zones for the performance and projection of 'last' acts. Performance and film constitute dual media of impossible corporeal survival.

The preoccupation with intimations of 'lastness' in the digital world, and with performance's extinction, along with the extinction of its intersections with film, may itself be a concept that is already obsolete in the wider context of performance's ineradicable, millennial endurance, manifested in its 'extremophile' capacities. Film, too, may present its own variant of that ineradicable capacity for survival, focused in its determination to endure by its abrupt endangering: in historical perspective, film had only just come into being as a visual medium (a century or so is nothing for a cultural form) before digital media dislodged or engulfed it. In that sense, film may have pro-visionally sidestepped into other forms, such as animation, in its anticipation of seeing how endurable digital media (subject to eradication in one data-crash or within an instant of ecological, power-annulling calamity) will be. Performance and film also hold their

potential for future alliances that draw upon those experimentally devised in the 1960s, as anti-documentational, corporeal confrontations, generating aberrant archival amalgams. In terms of lastness, space – notably in its variant as the arena for projecting and witnessing acts of performance and film – may then form by far the most vulnerable element among those three entities: film, performance and space. Space – all architectural space, all city space, all peripheral city space, together with the media by which that space transmits itself – is perpetually 'just-pre-obsolete', and subject to ecological dynamics poised on the precipice before a fall. Space itself remains precariously in transit as it attempts to hold and project its corporeal content, especially that which configures itself as performance or as film.

Space's own pre-obsolescence in the digital world follows on from the multiple histories of obsolescence that constellate performance's alliances with film, across city space. In Herzog's film *Stroszek*, Bruno S.'s infiltrations of portals that are about to vanish, traversed in order to materialize a back-courtyard performance-form itself attuned to its own imminent disappearance, with that performance in turn seized in a filmic style also marked with redundancy, demonstrates the vital concatenation of the divergent forms of obsolescence extending between space, performance and film, which film above all served to accentuate. Film's innovators of the 1890s notoriously viewed their medium – even in the face of its multiple technological and spectatorial innovations – as being already obsolete in the very moment of its emergence (some retreated to still more obsolete media, such as Max Skladanowsky, who abandoned film in 1897 in order to manufacture flick-books), thereby prefiguring contemporary conjurings of film's near-death or its already expired status. The residual presence of derelict cinemas and performance auditoria in cities worldwide, even in their multiple reusages, reinforces the ability of performance and film to transfer their obsolescence to space, especially city space, while retaining

their own resilient capacity for mutation from a pre-obsolescent condition to a resurgent condition. Space opens itself to accommodate the detritus that results from misfired conjoinings of performance and film, and city space, in that sense, forms the adhesive archive that encompasses every manifestation of performance and film, able to enumerate and resuscitate them all, and to propel them across obsolescence's boundaries and back again.

Human fury, as with that globally positioned against corporate, financial and state power (including its digital-media forms) in the early 2010s, is often directed spatially, since the power it contests works to impede and disintegrate space as well as human bodies. Space forms both the focus for that power's permeation of corporeal activity, and simultaneously the arena for that power's contestation. Digital space, as the locus for mass-surveillance and pervasive technological pacification, is intimately allied with external city space's annexations, riot policings and kettlings; resistance to such power formations responsively traverses digital and physical space across acts of hacktivism and eruptions of street protest. Since all riotous events are underpinned by performative elements, manifested and magnified from the twentieth century's origins above all by film, protest fury always takes on the forms of performance when it insurges across city space; but when performance enters digital space, it may contrarily be nullified. In the context of such riotous, deranged city-space spectacles of performance, and beyond them, Artaud still forms the seminal figure in the unleashing of unprecedented acts of resistance. Future performance will infallibly assume an Artaud-kickstarted, apocalyptic, city-located form, especially in performance's inflammatory exacerbation by film's last convulsions, prior to its final erasure by digital media. Performance itself may then be activated into spatially located protest fury by film's expiring maledictions, transmitted directly to the body in its gestural performance of furious refusal.

After an act of protest, even one of acute anger and outrage, its space is emptied out and becomes obsolete; at some point during a riot or demonstration, an intimation of redundancy often overturns the driving immediacy of the event, notably at moments in which adversaries are intractably locked together, or protestors are kettled in dislocation and stasis. The final manifestation of that obsolescence takes the form of the detritus left behind by the protest's corporeal dispersal, in the form of discarded banners, stray clothing, glass splinters, broken cameras, traces of blood; that strewn wreckage of the just-expired protest event, which also serves to corporeally archive it, resonates with the residue amassed in a performance space just after a performance has elapsed. Once corporeality begins to disintegrate in space, obsolescence immediately establishes itself in that space, along with memorial and moving-image forms. A final shot common to many films of street-protests focuses upon that scattered residue, to seize and confirm its space's fall into obsolescence, and also to gather the evidence of what has survived from the protest (at least for a momentary interval, until the wreckage is swept away). Performance may determine the gestural and iconographical forms of protest, but it is also implicated within those spaces in which a dynamic fury – determined never to yield to envisaged subjugation or eradication – abruptly collapses into the form of an enforced fixity, through its instilling into obsolete space. However, the century-long moving-image evidence of protest's expiring into obsolescence, together with the annulling of protest's performative dimensions, always leaves city space intact and ready as the arena for all future protest.

In its intersections with the digital world, performance now enters a new extinctual ecology of space, particularly of city space: a regime of space that is rendered imminently obsolete through its processes of corporate annexation, corporeal prohibition and surveillance. Performance and moving-image media, as the pre-eminent carriers

and projectors of the human body's acts, may infiltrate disruptive corporeal presences into denuded and obsolete space controlled by corporate power, but such presences, once bound into those spatial locations, then also become subject to identical dynamics of obsolescence, their movements and gestures tenable only for an instant. In their immediacy, performance and moving-image media hold bodies subject to the perpetual eroding and vertiginous vanishing of their surrounding space: corporeality in performance intimately transmits the fissuration located both around and within it. In that extinctual ecology, the body in performance attempts to sustain and reanimate space that would otherwise risk being annulled altogether.

Among performance's forms, that of performance art above all preoccupied itself with processes of corporeal and ecological disintegration, and the role of space in those processes. Performance art such as that of Ana Mendieta attempted to embody those disintegrative processes, while that of Joseph Beuys, for example, focused on myths, narratives and analysis of ecological falls that cast the body into dilemmas of imperative survival. Since celluloid film formed a material with its own disintegrative processes, prone to warping in heat or cold, to scratchings and erosions of its surface skin and to enduring unexpected transmutations, it was especially attuned to such preoccupations of performance art and their projection. Since performance art's perceptions of ecological catastrophe shifted fundamentally over the twentieth century's latter decades, responding to scientific and climatological data, as well as to individual obsessions and mythologies (as with Smithson's spiral-form preoccupations) that alternately welcomed and opposed ecological catastrophe, its conceptions of ecological 'threat' and of planetary or corporeal obsolescence remained in volatile flux. In terms of city-space ecological regimes, work such as that of the Vienna Actionists, for example Brus's *Action Vienna Walk* performance of 1964, filmed

with a Super-8 camera by another Actionist, Otto Muehl – in which Brus, his skin and clothes painted white (bisected jaggedly in black) to constitute an outlandish presence, begins to traverse city space before rapidly being stopped and arrested by police officers – configures city space as petrified, locked down and historically scarred; it cannot be inhabited in the future. The convergence, in the mid-2010s, of increasingly negative climatological and ecological data, together with the growing global pervasiveness of authoritarian city-spatial restrictions enforced by corporate or state power, reinforced by digital-media surveillance systems, points to the necessity of future performance forms that both interrogate ecological acts and negate spatial control.

Since the widespread onset in the 1990s of museological pre-occupations with the history of performance art – encompassing variants of the formative *Out of Actions: Between Performance and the Object* overview exhibition of 1998–9, together with large-scale retrospectives focusing upon the work of individual artists such as Marina Abramović as being particularly emblematic of performance art's dynamics – the status and entity of contemporary performance art has been spatially irreconcilable with that of the 1960s or subsequent decades. A museological form is almost always spatially an internal one, whereas performance art, beyond its gallery-space manifest-ations, largely took place historically in external space, either city space, as with Brus's work, or in desert and wilderness spaces (often those of ecological contamination), as in the work of Mendieta and Smithson. Similarly, the moving-image documentation of performance art, in its shift from celluloid to digital media, also presents profound spatial implications, since instead of filming performance art's spatial compulsions and locational parameters, digital media instead primarily render their own time and their own technology in disjuncture from performative acts. Contemporary performance art often positions itself directly in relation to that museological

Otto Muehl and Rudolf Schwarzkogler, *Action Vienna Walk*, 1965: film-image.

culture, either in aspiring to mesh with it, or in distancing itself from it, by relocating to subterranean or peripheral space. But in all instances, performance art is caught within the strata of an intricate history in which preoccupations with ecological and corporeal disintegration have already pre-sequenced the gestures and acts of performance art's present-moment manifestations.

In many ways, the history of performance art cannot be disassociated from film and other moving-image media, since the archival

memory of performance art is conveyed predominantly through film, beyond the detrital traces or restagings of performance-art events; many instances of performance art, as has been emphasized here, were undertaken exclusively to be filmed, and were intended solely for their traces to be rendered in the medium of film. But that conjunction of performance art with film also signals the impossibility of an autonomous history of performance art, since film's history is always an *other*, located *elsewhere*: one whose conjoining with performance art instils a duplicitous layer within filmed performances, and whose own overriding priorities impart fragility to the intentions of all performance art whose future existence depends upon its moving-image residue. In that sense, the museological archiving of performance art requires a dual, oscillating space in which the spectator's eye can move across traces of the originating performance-art event and its moving-image embodiment. But in that condition of duplicity and fragility – poised on a tightrope walk between its event and its moving-image transmutation – performance art is supremely receptive, as a medium, for the projection of the sensations of ecological and corporeal disintegrations.

History can disintegrate, too. And history's fragments may then spectrally materialize in contemporary external city space in the form of performative acts, propelled by obsession, repetition and the desire for incessant spatial traversal, and marked by unpredictable, scattered but pivotal gestures. In the spatial rapport between performance and moving-image media, two utterly disparate but intimately entangled forms – performance art in its institutional and museological contexts, and aberrant events occurring irreplicably in external city-space environments – now increasingly need to be viewed together, as a performance culture interrogative of ecological and corporeal disintegration, and of the body's spectacular insurgency against and within space, traceable and archiveable principally through moving-image residues. Those two distinctive performance

forms may come to crucially intersect as a new amalgam in the future of performance cultures, notably if wide-ranging institutional disintegration is a result of other collapses, such as that of digital cultures or of financial institutions promoting the corporate sponsoring of performance-art's museological historicization. Film forms an entity that destabilizes performance, setting its time and space into upheaval, but which can also suture performance, beyond obsolescence and the originating act's loss and extinction in time, for the eye that views it. Then, film's seizing, across decades, of performance's intensive experimentations both with ecological concerns and with corporeal projections, may be transmitted, across new configurations of space, into the contemporary moment.

Performance acts in contemporary city space, especially that undergoing intensive tension and fissuration – as with the cities of North Africa and the Middle East – often take the form of violent or disruptive incidents focused upon the nature and capacities of vision itself, that set that space into a state of upheaval; in such acts' intimate conjunction with moving-image media, the abrupt ascendancy across the early 2010s and current pervasiveness of smartphone filming in city space, in particular, serves to highlight the insurgent immediacy of such acts, together with the dilemma that they must be sustained long enough to be rendered as moving-image sequences, and then (even in the same moment) transmitted to social-media forms. The contemporary performance status of city-located gestures and rituals, especially those striated by violence, is transformed by that dynamic of immediacy. Such gestures and rituals may be evocative of those filmed by Jean Rouch at the city peripheries of Accra in the mid-1950s for his film Les Maîtres fous, in which the repetitive violence of colonial power's last moments becomes instilled into ritualistic performative acts, undertaken with at least some awareness that they were being filmed by Rouch's cinematographers; but in contemporary

smartphone-shot sequences, no temporal delay into the future – such as that required for the processing and editing of Rouch's film footage – is tenable, and specific spaces of performative acts of violence mesh instantly with digital space, in those acts' transposition into social-media forms. Notably, acts of killing comprise a primary focus of such ocularly directed, filmed performances. In many ways, the seminal moving-image sequences determining those new, fatal dynamics of performative filming are the iPhone-shot moving-image fragments of the killing of Muammar Gaddafi, on 20 October 2011, at the detrital edge of the Libyan city of Sirte, after the dictator was dislodged from his subterranean hiding place in a sewer conduit; each of those fragments carries its cacophonic soundtrack of dialogue, screams and exclamations. Gaddafi's young assailants, many of them seen holding iPhones, perform gestural rituals of exhilaration and celebration as they drag the dictator (wounded and dazed, but still vocally berating them) to a nearby road and pinion him against the bonnet of a vehicle, so that those assailants simultaneously constitute the spectators and moving-image documenters of the act to come, as well as its participants, with that interstitial status confirmed by their wielding of both iPhones and weapons. The performance of exhilarated violence destabilizes the capacity of those participants to undertake a cogent documentational record of preparations for the act of killing, so that the multiple fragment sequences (retrospectively amassed into archives by news-media organizations) pan abruptly from road tarmac to sky, veer to the ground, zoom from the crowd into the dictator's face and back again; at the same time, Gaddafi's assailants are evidently aware that they are filming one another (assailants' faces exclaim directly into the cameras) in the execution of their act, thereby accentuating the urgent desire to perform it. Even while the event remains ongoing, elements of its moving-image documentation are being transmitted to media organizations and social-media systems. At a certain point during the

furore, Gaddafi is suddenly shot in the head by an anonymous participant and killed (his body is next seen already dead, held up for display to the array of iPhone cameras, then stripped naked and beaten), but that particular element, among the multiple sequences surrounding the act of killing, is pivotally absent; smartphones always film performances of death, never death itself. The act of Gaddafi's killing appears as an unseizable improvisational gesture, undertaken irresistibly, as though it were aberrantly inserted into a pre-choreographed performance, thereby derailing and annulling the entire performance. From that instant, the durational momentum and performative focus of the moving-image sequences that had held the *imminence* of the act of killing are abruptly lost and rendered obsolete; the living body is gone and all that now remains for its redundant assailants is to abuse it, and then transport it for further display.

Muammar Gaddafi death scene, 2011: iPhone image.

The moving-image medium of the smartphone may multiply surround and even precipitate the act of death, as with the lethal gesture of Gaddafi's over-eager assassin, but the wielder of that medium, in city space, can also become the targeted focus of the act of killing. The Lebanese performance artist Rabih Mroué's work *The Pixelated Revolution* (2012) anatomizes what he calls the 'war on the camera'; his work takes the form both of a 'lecture-performance' commentary on its moving-image sequences, and the exhibition and projection of those sequences. From YouTube, social-media sites and other sources, Mroué collected and analysed moving-image sequences in which solitary rebels in part-destroyed Syrian cities had operated smartphones to scan and record the movements and gestures of the Assad regime's snipers, potentially to use their moving-image sequences in the future as punitive judicial evidence against the snipers. After a short or extended interval in which the sniper (operating in the same solitary mode as the smartphone-wielding documenter) is filmed in a state of unawareness, performing covert gestures, or remaining still, he abruptly becomes conscious that he is being filmed, and immediately shoots at the smartphone and the figure wielding it. Even though that immediacy contains a split-second respite in which the documenter could potentially retreat out of sight and elude being shot, he is perversely compelled to keep recording. A performative reversal takes place in the instant of eye contact, in which the solitary, furtive filmer who has been the spectator of the sniper is now transformed into the performance's locus, for an act of death or wounding. In its intentional exposure to extreme danger, the eye becomes a 'self-killing' entity, for Mroué. The moving-image device is perceived by the sniper as supremely threatening, far more so than if its operator were also wielding a gun; the instrument of vision itself must be obliterated. The moving-image camera is itself a form of weapon, but one which always reconfigures corporeal performances into another entity, as with

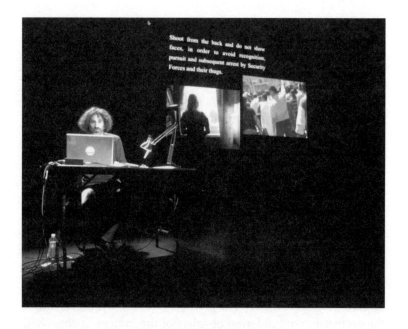

Rabih Mroué, *The Pixelated Revolution*, 2012: film-image.

the 'chronophotographic gun' camera which the French moving-image innovator Etienne-Jules Marey designed in the early 1880s, to be carried by an operator walking on foot, in order to gesturally 'shoot' (exactly as though he were aiming a gun) and record, for potential future projection, sequences such as the flight of birds. Once shot by the sniper, the iPhone-filming figure then falls, often with a recorded cry of fear or terror, so that the smartphone camera's lens veers from its focus on filming the sniper's body to filming the ground, in stasis; the smartphone itself may be penetrated by the shot and rendered inoperable, so that its pixelated footage expires at the same moment as its operator's corporeal expiration, but remains recuperable for its transmission online. The sniper's bullet may pierce and traverse the smartphone's lens to enter its operator's

eye; in the deadly conjunction and interpenetration of the eye with the lens, via the medium of the sniper's bullet, that act resonates with the 1920s Soviet film-maker Dziga Vertov's envisaging of a vital simultaneity of ocular and moving-image lenses, in his concept of the 'kino-eye'. As with the killing of Gaddafi, the representation of corporeal death itself is always absent in the sequences of the Syrian cities, and what appears instead is a technological fall, accentuated by cries or exclamations; the fallen figure's body is never seen, and his status remains unknown (he may be killed or wounded, or else the sequence may even be an elaborately conjured act of moving-image duplicity, of the kind intimately familiar to film's innovators of the 1890s). In that sense, such digital sequences form the inverse of the celluloid sequences shot with a hand-held camera by Stan Brakhage, for The Act of Seeing with One's Own Eyes, in which nothing but the figure of corporeal death – autopsied in a mortuary, ocularly revealed – is present. The smartphone-operator's fall, together with the destruction or rendering obsolete of the camera, is conceived by Mroué as manifesting the 'assassination of images': a multiple assassination, extending far beyond each instance of a solitary sniper shooting a solitary filmer. As Mroué emphasizes in The Pixelated Revolution, such sequences exist (or once existed) on such sites as YouTube in their tens or even hundreds, each of them curtailed with the same repeated choreography of the invisible fall of the filmer and his smartphone to the ground; the performative process of collecting and archiving such sequences, in their gestural variants and permutations, forms an accumulatory act subject to the image-compulsions propelling Muybridge's amassing of sequences for his Animal Locomotion project of 1884–7, also manifested in a public 'lecture-performance' form.[30]

The dynamics of digital eye-imagery which Mroué performatively explores, from their traces in sequences shot in contemporary Syrian city space, contrast with those of the footage recorded in many

mid-riot situations by late-1960s Tokyo protestors simultaneously deploying Super-8 cameras. The smartphone-wielder in contested city space can continue to film his sniper almost indefinitely, in an interrogation of that figure's corporeal form, so that the sniper's infinitesimal gestures or periods of stillness are recorded alongside his abrupt acts of gunfire; in that sense, the smartphone-wielder is lured into a temporal duration which has no in-built terminal point, and the resulting continuum is one in which, sooner or later, his act of filming will become a lethally provocative one, finally perceived by the sniper, who then erases both the moving-image instrument and its human manipulator. In the Tokyo riot environment, no temporal continuum is tenable; the ongoing riot is being pursued with the same intensity of exhilaration and immediacy displayed by Gaddafi's assailants in 2011, and its Super-8 film documenter has only 3 to 4 minutes – the span of the film cartridge – to render the event in evocative fragments, together with the cacophony and cries that accompany the performative act of rioting. The Assad-regime sniper and his filmer never spatially coincide – even in the act of filming and the respondent act of killing, distance is maintained, and the two figures are interconnected only by their ocular capacity to maintain one another in sight; but when the Tokyo rioter is clubbed down, thereby abbreviating the film-making process, no distance exists at all between the riot-police assailant and the protestor's body. All that crucially adheres the processes of digital moving-image making, in civil-war-torn Syrian cities in 2012, and those of film-making in the riotous Tokyo of 1969, with their respective per-formative dimensions, is their execution within extreme spatial environments, together with the fall – a fall of the body in which the moving-image camera must also simultaneously fall – that curtails them, into stillness.

Beyond lethal environments such as those of Syrian and Libyan cities, city space performances take place in which the act of

moving-image documentation serves to accentuate the desperation and repetition of such ocularly configured spectacles. Moving-image media possess the capacity to transform the most mundane gestures and vocal elements of performance so that they constitute future archives for reactivation in unprecedented forms. Such performances may take on spatially mobile manifestations, as with those framing the narratives enacted by the homeless on city transit systems, moving from subway carriage to carriage between station stops, but presenting the same vocal narrative in a near-identical repetition that must be perpetually revivified for its (often-oblivious) spectators: in such narratives, something in the past has always gone irreparably wrong, thereby precipitating a chain of misadventures rendering that recitant homeless and in need of passengers' donations, and the calamity's narrative – an intimate, corporeal one in which secrets are publicly divulged – must be concentrated, in its fragmentary form, into the urgent seconds still available before the next station stop, so that it can then begin again from scratch in an adjacent space. Such performances, infinitely recorded as moving-image sequences by digital surveillance cameras positioned within the ceilings of each subway carriage, as well as accidentally and tangentially, for example by smartphone-owners concurrently filming the faces of friends or the city landscape beyond the carriage's windows, constitute corporeal performance archives (always deletable or discardable) of raw, open repetition.

In the intersection of digital moving-image cultures with performance cultures, repetition constitutes the pivotal dynamic in which bodies, gestures and acts are caught. Across situations of extreme danger, such as that of the moving-image assassinations undertaken by Assad-regime snipers in Mroué's performance-art work, and situations of anonymous mundanity, such as that of surveillance camera footage recording the narratives of the homeless on city subway trains, that dynamic remains invariable. Whenever

a performative event spatially insurges which demands memorial documentation, as with the instant of Gaddafi's killing, the act of death eludes digital media, in its multiplicities of deflected, lost sequences that cannot finally seize the body; the body then vanishes. Film's distinctive ability to incise and to preserve for reanimation the otherwise ephemeral traces of performance constitutes a surpassed, obsolete capacity within digital media's intersections with performance.

In such manifestations of performative acts in city space as those incorporated by Mroué, via iPhone moving-image documents, into the domain of performance-art in *The Pixelated Revolution*, along with manifestations of performance that directly enter archives, such as those of news-media organizations archiving the performative fragments surrounding Gaddafi's death or those of city-transit companies archiving surveillance-camera footage of the homeless's concertinaed performance narratives, what is always pivotally at stake is the visibility or invisibility of such acts. Whenever the eye seizes a performance, a process of documentation immediately begins; the eye may call upon a device that substantiates or hones its own vision, as for example with a film camera that can zoom more adeptly than the eye, or else the eye may not require or have at hand such a device, in which case what is visible as a performance will enter an ocular and memorial archive. In many digitized environments, such as subway train carriages, no triggering eye needs to be present, and only the archiving surveillance camera will render the performance – such as that of multiply reiterated narratives of incanted calamity – without intention, in an endless repetition that concurs with that performance's own temporality. By encompassing intersections of performance and digital media, city space environments become the privileged, always mutating site for the aberrant visibility of exiled, displaced, deranged and peripheralized presences. An

exceptional intention of film was always needed to materialize (and reinvent) such presences, as in Aristakisyan's film *Palms*; but digital media will undifferentiatedly transfer into moving-image forms such otherwise invisible presences, in their performative acts, either through the sheer pervasiveness of the moving-image surveillance scanning of external space, or via the focused isolation of such acts with a view potentially to suppressing them and expelling their perpetrators from visibility. In either instance, the acts of peripheral bodies in city space are moving-image archived in the moment of their execution, and made visible.

In performance's first experiments with digital technologies and their implications for dynamics of visibility and invisibility, especially in Japanese digital-media performance art of the mid-1990s, a primary concern was to invoke and materialize such presences, notably in the context of bodies that appeared unable to reach the surface skin of visibility in city or social environments. In that historically vanished moment of performance art's experimentation – before digital technologies became overwhelmingly co-opted by corporate and governmental entities for their own promotion, and to further their visibility with such expansiveness that it created a 'digital world' – emergent technologies were often perceived as possessing the potential to render visible what would otherwise remain occluded. In such performance experiments, digital media were deployed ambivalently, with a prescient awareness that they could imminently slip from the domain of creative exploration focused on activating peripheralized presences, but with the awareness, too, that digital media (notably in the face of film's relative petrifaction in this regard) offered the unprecedented performative capacity to reconfigure bodies, to precipitate and coordinate riots, to excavate subterranean space, to uncover secrets; contemporary activist and hacktivist groups may aim to restore that originating potential perceived in digital media.

Notably, the performance-art group Dumb Type (of which Teiji Furuhashi, instigator of the digital installation *Lovers*, was a prominent member until his death in 1995) experimented with the technological, corporeal and spatially focused implications of digital media, especially in such performance projects as *S/N* (1994), underpinned by choreographic elements, which aimed especially to materialize gay, HIV-infected, transvestite and transsexual presences in Japan that were otherwise consigned to low or zero visibility. Simultaneous digital projections alongside corporeal acts in performance space both accentuated the liminal areas between bodies and their technological mediation, and deployed digital media's capacity to transmutate hidden bodies into visibly pervasive bodies in the act of performance. During the same era, the Tokyo-based performance-art group Kaitaisha, directed by Shinjin Shimizu, in works such as *Tokyo Ghetto* (1996) and *Zero Category* (1997), also experimented in the interzonal space between corporeality and digital technology, notably to render into visibility occluded presences such as that of Japan's *burakumin* outcast community, consigned to inhabit peripheral city space and to work in slaughterhouses and sewage processing; incorporating choreographic elements, resonating with ankoku-butoh dance and with conceptual inflections from Artaud's work, Kaitaisha's projects within that formative (already fast disappearing) moment in performance's volatile alliance with digital media also explored issues of sexual violence through performative elements of incessantly repeated beatings of performers' bodies, and, as with the work of Dumb Type, interrogated the implications of performance space projections via digital media of acts occurring simultaneously in that space.

To mesh emergent, innovative technologies with performance acts, as in the mid-1990s corporeally focused work of performance art groups such as Dumb Type and Kaitaisha – in a context in which those identical technologies would imminently become surpassed

Dumb Type, S/N,
1994: film-images.

and redundant, or else be transformed for antithetical ends to sharpen corporate power – creates a contrary performance status of 'cutting edge obsolescence' in which peripheralized bodies are spectacularly highlighted for an instant before being shuttered out of visibility with an ocularly focused violence accentuated by the driving momentum of that obsolescence. Such bodies' traces may then barely subsist, even in archival forms, subject in terms of visibility to their profound redundancy; only exhaustive excavations, via moving-image residues, can revivify that status of obsolescence into one of renewed resurgence. Performance's negotiations with new moving-image technologies, such as choreography's first intersections with film (the 'serpentine dance' of Annabelle Moore, filmed in Edison's studio in 1894, for

example) or performance-art's first alliances with film (such as the Japanese Gutai group's experiments with Super-8 film documentation of performance art in 1955) always form unstable amalgams in which the dynamics of visibility and obsolescence are intimately implicated; when performance becomes conjoined with digital media, those precarious dynamics are highlighted still further by digital media's capacity to erase or annul corporeal presences and to transmutate them beyond recognition.

In the eruption of performance in city space, notably in the form of in-transit acts and incidents that abruptly insurge, then disappear (or else shift to a new location to infinitely repeat themselves), those dynamics of visibility and obsolescence appear to operate compulsively, as though emerging of their own accord. City space – as an essentially autonomous, irreducible entity – materializes performative bodies across its central, peripheral and subterranean zones, but whenever those bodies are exposed to regimes of expulsive corporate space, delineated and surveyed via digital media, they risk unforeseen overturnings into invisibility. In that sense, city space forms the sensitized domain for the ephemeral performative manifestation of lost or vanishing presences – especially those of refugee, silenced, outlawed and stigmatized bodies – whose rendering into digital-media moving images is itself also subject to evanescence and dispersal, as well as to generating potential visual evidence for bodies' prohibitive erasures from space. Corporeal disappearance forms performance's pre-eminent mode in digital culture.

Contemporary city space, as the arena for in-flux performative explorations and as the primary locus for digital culture, is comprehensively instilled with the dynamics of corporeal loss and vanishing. Space's active work forms that of embodying those dynamics of loss, together with comprising exposed surfaces for the work of the eye in attempting residually to locate and collect traces of the body. As such, city space

Thomas Edison and W.K.L. Dickson, *Serpentine Dance*, 1894: film-image.

itself constitutes a performative space – space as a performative entity in its own right – through its in-transit mutations and perpetual seisms; its reformulations are both inflected by the loss of the body's integral presence, and also by the need to compensate for that loss, in terms of incurring collapses and overloads, and generating excessive manifestations and projections. Whatever traces the body has left behind, in the form of archivings – such as those of graffiti strata once performatively inscribed on city space's external surfaces or of corporeal residues imprinted in deteriorating auditoria, in addition to institutional archives – comprise elements of that loss-inflicted compensatory burden. Even as the performative body appears to hold a precarious role in digital environments, subject to expulsion or erasure, city space remains always saturated with potential spectators and witnesses (evidenced by the near-infinity of moving-image devices that must record an act, event or incident of some kind, at all costs), so that city space's own spectacular convulsions generate multiple points of focus for ocular concentration. City space can

only be rendered 'performative' as a direct counterweight to corporeal evanescence, and requires its spectators' eyes to prise and conjure that performativity from out of the material of its surfaces and sub-terranes; its habitual status is that of constituting the parameters, background and sustaining medium for corporeal performative acts, so that for city space to take on its own performative role implies an aberrational source for future spectacles and their documentation in moving images.

In many ways, this book's three focal points – performance, moving images and space – themselves amount to an impossible amalgam that can never be totalized or fixed, and whose many inter-sections, often resistant or contrary ones, form far more illuminating and open means to approach and anatomize those subjects (in particular, their future forms, in the digital world and its spaces) than any attempt to seize each in isolation. Whenever a medium is set into dynamic contact with another medium, it will be transformed into something unprecedented and compelling, and that process is maximally at stake in the context of the media of performance and moving images, with their direct, tangible contact with spectatorship, with the corporeal amassings of audiences in city space and with the seminal work of the eye in exploring and incising new conjoinings of media. Once the dynamic entities of performance cultures and moving-image cultures are exposed through their intersection, their components' own intersections – those located within the proliferating forms of performance, and within the proliferating forms of film – are also more openly revealed, subject to such imperatives as techno-logical innovations, transmissions of knowledge, conceptions of auditoria and projection, and preoccupations with the forms and gestures of the human body.

In considering performance cultures and moving-image cultures in their conjunction, an ongoing theoretical re-envisioning of each form is essential in determining their relationship to the viewing

eye, together with their rapport with space, including digital or future space. Performance is an integrally vision-instilled entity, just as film is, each medium always viewed in a multiplicity of ways, and involved in a volatile process of oscillation in which the eye is both receptive to and also generates manifestations of each medium. The eye takes distinctly variable approaches to performance and to film, since performance historically encompasses the body itself and its projections, while film, by contrast, holds the body's *images* and their projections. If the digital world subtracts or diminishes performance's integral corporeality (for example, through simultaneous moving-image projections of its acts, or in the prohibitive excising of bodies in performance from city-space zones), it also curtails the distance between performance and film, alters the intersections between them and reconfigures the human eye's divergent responses to performance and film. If the digital world nullifies film or renders it obsolete, it also initiates fundamental shifts in the ways in which performance sustains itself into the future, and virally infuses the aura of obsolescence not only into film, but more pervasively into its own forms, as well as into performance and the spaces in which performance potentially takes place. Above all, it transforms the human eye so that it, too, is split between impaired obsolescence and the compulsion to create and embody new, autonomous visions.

In order for performance and film to survive, and to intersect, the world surrounding them – whether digital or not, and whether composed of city space or of other spaces – must also endure, so that any re-envisioning of performance cultures and moving-image cultures is subject to its incorporation into an exploratory ecology of endangered space that interrogatively accentuates those spaces in which performative acts are at their most vital. Such spaces may be those of fragmentation and disintegration: spaces of extremes. Film's capacity to position itself as the detrital receptacle for the traces of performance's acts – often contesting or resisting them,

even as it documents them – may form film's seminal spatial gesture for performance's future endurance. The process of re-envisioning performance and film, via ecologies of space, requires the dissolution and expansion of the spatial parameters in which performance is conceived, just as it entails a refocusing and overhaul of the ocular and moving-image forms by which performance is propelled into the future.

Under conditions of ecological or digital-culture endangerment – of temporal 'lastness' and imminent obsolescence, and of spatial tautening and evanescence – contemporary manifestations of performance and film increasingly pivot around the work of the human eye in determining future forms. In many ways, the ocular manoeuvres required for such manifestations extend *beyond* film; they may collect and absorb the detrital, spectral remnants left behind by film, and investigate, too, the strategies by which film perversely infiltrated itself into digital moving-image cultures in spite of the technological surpassing which digital media had imposed over film; but such manifestations also entail exploratory manoeuvres extending deeply into the capacities of vision itself. All fixed histories of performance and film impede such explorations, since they are imbued with the assumption that film primarily documents performance, and that once a performance has been filmed, and projected to spectators, that document's audience is watching the originating performance itself; as film-makers such as Kren demonstrated, film may also (or instead) create dynamic, oppositional intersections with performance, in which the status and entity of performance are in flux whenever a performance encounters the space and time of moving-image cultures. The eye may also need to explore beyond the digital world itself, in the context of the potential redundancy, expiring and death (technological expirations which are now also ecologically precipitated) of digital devices that, instead of endlessly shooting the body

or its expulsive voiding from city space, can mutate into a precarious condition of being shot, beyond their user's intentions and autonomy, or of even being shot at, as in Mroué's The Pixelated Revolution performance-art work and in other cracked-lens media of volatile contemporary space.

Film and conceptions of film from the first decades of its existence, such as those of Vertov's 'kino-eye' of the 1920s, already envisaged film's obsolescence in direct rapport with the future work of the human eye, emphasizing the eye's exceptional status and its capacity to extend further than the body's parameters, and to detach itself performatively from corporeality in order, through that distancing, to incise and re-visualize the body, along with city space, notably in Vertov's momentous sequences in the film Man with a Movie Camera (1929) of the omniscient eye that vertiginously soars above city space in order to fragment and overlayer it, rather than to subject it to surveillance. To enable that spatial propulsion above city surfaces, the eye is integrally meshed with film's technologies and supporting devices, such as lenses and tripods, but those fragile media are distinctly ephemeral and appear to signal their incipient obsolescence while inversely prioritizing the eye as it extends out from the body. Film's zoomings exemplify that irrepressible extruding at speed of the eye, along with hallucinatory sequences such as those in Japanese horror films in which the eye outlandishly snakes its way out from the head (itself elongated away from the remainder of the body) on a stalk in order to penetrate and illuminate hidden space. The prevalence in film-inflected, contemporary, digitized city environments of hoardings or screens depicting nothing but an immense eye (ostensibly one which will be allied in subservience with corporate media, but instead appearing irresistibly to assert its own autonomy from all such media), without a face or body, signals the spectacular capacity of the eye to exploratively materialize itself in space.

The exposed eye in city space, stripped of the delineating histories of film and of digital media, forms an actively performative presence, potentially attuned more intimately to performance's temporal expansiveness than to the split-second disintegrations of moving images. In that sense, the eye's explorations, in locating and interrogating corporeal traces, work in conjunction with city space's own performative role as a seismic medium for the spectacular activation of its own subterranean, wastelanded and peripheral zones, and in perpetual tension with its annexings and surveillance by agents of corporate power. Even in the face of cultures of corporeal vanishing, the exploratory eye and the spaces it transits and occupies must performatively generate acts for those spaces' audiences of spectators. The eye then aberrantly takes the place of digital media with their dynamics of surveillance and pervasiveness; it operates as an instrument of vision that infuses performativity into the perception of movement, for its spectators. What emerges from that process, then, are not moving images drawn from events for replication or projection, but movements of the eye itself, caught in mid-perception, transmitted directly into memory and into ocular archives.

As well as performatively supplanting digital moving-image media in contemporary city environments, the work of the eye now also fully assumes the cinematic project Vertov envisaged at the end of the 1920s, in which film itself was seen as simultaneously a seminal and also a provisional, eye-prefiguring medium. But in its performative explorations (which may extend, in their corporeal tracing, notably through the auditoria of performance and film), the eye takes on film's own welding of obsolescence and endurance; its components – the iris, the retina – are as fragile and primed for disintegration as the film camera's elements, but it compulsively generates formative sequences from its anatomizing of space and time and of the body's presence, in performance and in protest or subjugation, within them. The eye may then operate as though the medium of film had

never been invented and its century or more of audience-captivating conjurations were consequently nullified, or else as though the eye's status had emerged, after a momentary syncope, directly from the obsessive ocular experimentation of such figures of the 1880s as Muybridge and Marey, with their combative projects – performative projects, in many ways – to extend and accelerate the movements of the eye in space, with multiple cameras firing simultaneously, and with chronophotographic weaponry such as the body-'seizing' camera gun.

Whether seized with many eyes or by one isolated eye, by film or by digital moving-image media, or in their transposition into other forms such as that of text, performance's gestures in contemporary city space form presences that activate vision, even in a condition of lastness or obsolescence. The process of seizing such presences may itself constitute a performative one, and the spaces in which that seizure occurs may themselves appear to be undergoing transformative acts with such conflictual intensity as to appear to possess performative dimensions. What is vitally perceived of performance – as always moving-image registered, or else rendered with the eye, and simultaneously propelled into the distinctive archival forms assigned to experiments extending across performance and its visually animated representations – may be drawn from in-transit, experiential and momentary contact with the evanescing, surveillance-imprinted, corporeally determined dynamics of space. Whether or not a body maximally occupies space, as in the performance of an act of riotous protest, or whether that body has already irrevocably vanished from space, via a just-finished performance's abrupt expiry or through the violent expulsion – even before the first gesture is made – of a potential performer from that space, performance leaves its detrital, infinite traces for the eye and its lenses.

In mapping emblematic instances of performance's intricate amalgams and intersections with film, along with the theoretical dynamics surrounding that process, this book has itself operated as an archival eye, isolating filmic or digital-media sequences' images from their overall movement, and arresting gestures and acts of performance within their spatial transits. Film and digital-media forms work temporally in assembling their sequences of images, oscillating in erratic flux between future, past and present, and also deploy themselves spatially, propelling those sequences across city space's central plazas and its peripheries, such as back-courtyard zones, while their projections transport moving images through multiple locations of spectatorial engagement. Performance, too, is a medium whose anticipated temporal sequences and successions of acts may be abruptly reversed or fragmented in mid-performance, notably within the wayward durations of performance art; the congruence or disintegration of performance's time pivots (as film's does) around its reception in the engagement and attention of its spectator, which may veer from entranced focus to oblivion within the span of an instant. The enduring spatiality of performance is evidenced in its millennially sustained locations, as in the ancient Greek empire's still-resonant sites of performance and mediumistic conjuration, such as Cumae, in a parallel way to that in which cinematic spaces of projection extend almost all the way back to film's origins, as with the continuous operation of such cinemas as the Kino Pionier in Szczecin, since 1909; but performance's spaces may also be subject to extreme disruption, as in the spatial razings and riot-police expulsions of spectators in Castellucci's production *Hyperion: Letters of a Terrorist*. All of those inhabitations of time and space, for film and performance, are subject to acute transformation whenever performance is placed into intimacy with film; in isolating and exploratively 'stilling' instances of filmed performance, this book has attempted to render the multiple

conjoinings of performance and film across all of their spatial and temporal dimensions.

Whenever a spectator exits the space in which a performance or film has just been experienced, that experience immediately mutates in memory into a new entity in which preoccupations and intentions conceived as significant by the director of the performance or film are utterly erased; the work of memory may sieve, distort and reconfigure that experience until only fragments or highlighted images survive. The work of film in embodying performance is subject to those same processes of memorial mutation; in many ways, film constitutes memory's projection: it performatively deploys memory into filmic space. Even when a film appears to have integrally preserved the exact duration and spatial form of a performance to the optimal extent – as, for example, with a performance shot frontally, with one camera, in external space or in an auditorium, as though replicating its spectator's perception – what appears in film is intractably another opposed or inverse entity, which may draw a surface skin of corporeality and its gestures from that performance, but filmically misremembers and overhauls the performance, which has now entered another domain. And when performance and film, in their conjunction, are transformed again into the medium of writing, they enter yet another domain. Film is always a striated, scrambled memory of performance, subject to a determining malfunction that crucially resuscitates performance into a new form. In that sense, memories and films of performances both constitute the recollections of lost performances; all performances become lost instantaneously, in their ephemerality and lapsing, and are then subject to that second loss, in their reconfiguring into memory and moving-image media. In many instances, notably in the recording of performances during film's early decades, in countries such as India and Japan in which a substantial percentage of those celluloid artefacts were lost, through climatic damage and warfare, or in contemporary digital culture in

which a smartphone-recorded performance can be capriciously deleted at any moment, the moving-image residues of performance appear irreparably lost; they may then only be actively re-created as stilled images through the invocation of memory, or else subsist, for arbitrary revivification at unforeseen moments, as spectral after-images of memory, lost to both performance and film.

If memory returns performance to a sequence of isolated, stilled images that serve to recapitulate, in a transfigured and duplicitous form, the pre-eminent instants from the ocular and sensorial experiences of witnessing a performance, those fragments of performance constitute a documentation close to that of the photographic representation of performance; a photograph can be taken at any moment of a performance's duration, and need not form any element of a sequence. But, since the initiation of moving-image forms in the 1880s and '90s, and notably with those forms' abrupt exacerbation and expansion in contemporary digital cultures, performance's corporeality actively generates *sequences* of images in order for that corporeality's gestural projection to be perceived, even if those sequences misfire, in anti-linear proliferations, across time and space. As such, all stilled memory-images resonate inescapably with Muybridge's raw materials of the 1880s, in the form of endless thousands of images of figures in movement, captured by his arrays of cameras; such images, in Muybridge's work, originated in performative obsession explicitly to animate gesture-enacting bodies in performance. Without the capacity for projection, images remain stilled or petrified media, and never exit photography's own distinctive domain of death. Along with amassing visual materials, moving-image innovators – Muybridge above all – simultaneously conceived of projection as a performative medium to dynamically embed those materials, as image-sequences, within the human eye, to infiltrate memory; even the most contemporary digital-media projections are located only a hair's breadth (the breadth of obsolescence) from

Muybridge's own conceptions of performance's projections. Contemporary performance forms the unique event of performance *together with* its moving-image capturing, rendering, processing and spectatorial perception – and the imminent surpassing, slippage, malfunction and loss all integral to that process.

Moving-image fragments that seize performance in the contemporary moment, in the digital world, are instilled with the spatial vanishing of the bodies that inhabit both performance and film; that pervasive vanishing – compacted from corporate power's annexings of space and its expulsions of bodies, along with the obsolescences and lastnesses now integral to the entities of performance and film – serves contrarily to highlight resilient acts of performance, charged with compulsions, derangement or riotous unrest, enacted within or against city space, extending from or into its subterranes and wastelands, attuned and perhaps even intended for loss and oblivion, but also exposed to their capture through moving-image forms into a perverse condition of survival – as performances – together with their projection into the coda form of text (as with this book's own coda). Such final traces of performance constitute an essential detritus of the processes of exploring the conjoinings of performance and moving-image forms, alongside those forms' multiple histories, and they generate, too, a simultaneous blackout and illumination of the surveillance regimes of contemporary city space, which reveal the vital intensities of intersections between performance, moving-image media and space.

The Lost Films of Performance

Films of performances are not documents. Films of performances are not performances. Films of performance form projections, predominantly of performance's corporeality and its acts. Films of performance form transformations of performance, by film. Films of performance can constitute art works, or discarded detritus, or both together. Films of performance can activate and extend ocular capacities and propel the eye into a new domain. And films of performance can also form the lost films, of performance.

In performance's lost films – subject to film's obsolescence, to its deterioration and disintegration, to its incapacity to infiltrate a performance space, and to its engulfing within digital-media forms and consequent liquidation as an autonomous visual entity – the body in performance remains intact, and may even be accentuated in its presence by the absence of film and of film's transmutational impact upon performance's time and space; in film's loss, the body is rendered in memory's fragments, or else instils itself into the moment before its own gestures' loss. In the lost projections of performance, an all-consuming malfunction occurs either in the capacity of film to replicate and document performance, or in the failing of the sites of digital media, through data overloads or crashes, to transmit the evidence of performance; such misfirings of projection may be essential to performance's survival. In the lost spaces of performance, the acts and gestures of the performer's body embed themselves into the surfaces of imminently voided space, and the

fragile duration of a corporeal act also permeates that space in its elapsing and disappearance; film then forms a spatial excavator, infiltrating space's surfaces, layers, strata, and its subterranean dimensions, to locate corporeal traces in lost spaces. In the lost archives of performance – notably encompassing all totalizing digital archives, annulled from the first moment of their collection – performance's corporeal acts adeptly slip through film's grip, leaving behind amassings of spectral residues and fragments: performance's films, film's performances. And as a final instance of those processes of loss – loss also constituting the from-scratch origination of performance's futures – this book's own exploratory archive, of seminal intersections between performance and film, also disintegrates at its last moment, into scattered ocular blurs of potentially filmed performative gestures, enacted across city space.

Riding the near-deserted escalator ascending to the platform of the Zoologischer Garten station in Berlin – a space under the lenses of automated surveillance cameras, and potentially moving-image-captured, too, by the capricious lenses of smartphones – a near-naked man turns, as the escalator gives out under his feet, performs a meticulous military salute to a hallucinated audience, then moves to the adjacent downwards escalator and descends back to the station's subterranean level; immediately, he ascends again to the platform level, pauses momentarily, and salutes again in an exact replication of the previous salute. Then, that performance of obsessional repetition continues, impeded and inflected only by the occasional interruptions of passengers attempting simultaneously to use the performance space of the escalator. The duration of each escalator ride is nine seconds, and every salute takes two seconds to perform, so that the entire duration of each performance is an inflexible twenty seconds; the escalator's metallic spool regulates the performance as though it were a projectable strip of celluloid.

The accumulated length of the performance, rendered into surveillance-camera moving-image time as well as corporeal time, is two hours and twenty minutes, until the man salutes a final time, without added emphasis, the performance accomplished, and vanishes.

On the pavement of the Friedrichstrasse's eastern side – directly across the street from the site of the first-ever projection of films on celluloid format, as films of performances, by Max and Emil Skladanowsky, on 1 November 1895, in the ballroom of the Central Hotel, that venue then destroyed by RAF bombing raids in June 1944, its ruins razed post-war by the GDR authorities and now, in the contemporary city, its space occupied by a block of mirror-facaded corporate offices reflectively projecting the ongoing events on the street's opposite side – a man dressed entirely in black, with a large rucksack strapped to his back, strides backwards and forwards over the same span of pavement, adjacent to a Starbucks coffee shop and a Lush cosmetics shop, narrating in English, in sardonic condemnation and at extreme vocal volume, the acts of the Turkish army and its commanders in their interventions against dissident groups. Again, that performance is potentially filmed by oblivious surveillance cameras and, momentarily, in fragments, by bemused passers-by with iPhones, or accidentally, as a background element, by other passers-by filming their friends; no witnesses gather, the incessant movement of the performative incantation making static spectatorship near-impossible. Although the man's transits and the space they occupy are invariable, with each outward and return journey, from arbitrary starting to finishing points, lasting for twelve seconds, his vocal performance is cut and intermittent, sometimes self-interrupted, into reflective silence, for three or four transits, as though he had become aware of his outlandish marooning in obsession-locked oscillations across city space, until the outrage accumulates again

to such a degree, in that man's body and throat, that it erupts, from coherence to incoherence and back, from cold fury to maddened delirium, blood-reddening his face.

Across the Alexanderplatz, past the site of Franz Biberkopf's 1931 filmed performance, three figures, each dressed entirely in body-covering latex and rubber from neck to toe, apart from their sexual organs, with tightly fitted masks and snorkels inhaling and exhaling city air, walk impassively on flippers after emerging upwards from the mouth of one subway exit, until they vanish down into the mouth of another orifice at the plaza's far side; simultaneously, that performance holds zero, void content, and also forms the insurgent manifestation of subterranean-city aquanauts momentarily detached from their 'extremophile' environment and aberrantly exposed, in that spatial transit, to their potential moving-image rendering by sur-veillance film cameras whose antecedents prohibitively filmed the uproarious transits of Alexanderplatz punk-rock gangs, and by any smartphone filmers fast or adroit enough to seize that performance.

In a rundown zone of the Friedrichshain eastern district of the city, the activists who had occupied a crumbling, five-storey building since 1990, in successive generations, the traces of each imprinted in graffiti strata on its cracked facades, are evicted, kicking and screaming, by specialist paramilitary squads, while a riot takes place in the surrounding streets, hosed and eventually kettled, by riot police who appear aware, in the violent finality of their gestures, that they are performing the last acts of subjugation required of them in the near fully sealed, digitized, corporatized, expulsively overseen city, against rioters whose own furious performance of resistance remains raw and open. That event is moving image rendered both by the evictees and rioters, their cameras' lenses vulnerable to shattering, and also by the riot police wielding high-definition digital devices, in order that those

sequences – once all evidential traces of prosecutable bodies are sieved from them and catalogued – may be added to the near-infinite city archives of riot sequences shot by previous generations of police cinematographers, back through the death-inflected sequences of the demonstrations against the 1967 visit to West Berlin of the Shah of Iran, and far beyond, deep into film's spatial past, then abruptly back to the contemporary moment, in which the masked street rioters perform their corporeal rituals of negation in locked-down city space, until night falls and it is now too dark to film.

REFERENCES

1 Erika Fischer-Lichte, *The Transformative Power of Performance* (London and New York, 2008), p. 107.
2 Jean Genet – in *Le Funambule* [1957], *Oeuvres Complètes*, vol. V (Paris, 1979), pp. 26 and 9 – proposed that tightrope walking constitutes a 'terrain of desperation' whose traversal finally makes the tightrope itself 'live and speak'.
3 Discussions with Eikoh Hosoe, Tokyo, 1998.
4 Robert Smithson, 'The Spiral Jetty' (1972) in *Robert Smithson: The Collected Writings*, ed. Jack Flam (Berkeley, CA, 1996), p. 150: 'Back in New York, the urban desert . . .'. Smithson commented on the construction of *Spiral Jetty* and on his filmed performance: 'A cameraman was sent by the Ace Gallery in Los Angeles to film the process . . . For my film (a film is a spiral made of frames) I would have myself filmed from a helicopter (from the Greek *helix, helikos* meaning spiral) directly overhead in order to get the scale in terms of erratic steps' (ibid, pp. 147–8). Smithson's position in 1970 as a filmed performer – an exposed figure on the ground, running the course of *Spiral Jetty* while being filmed from above by the helicopter-borne cinematographer – contrasts with his death, three years later, in which his position was inversed to that of the in-flight recorder or viewer, in the light airplane that plummeted to the ground while visually documenting the site of his planned *Amarillo Ramp* artwork.
5 An example of that response is the newspaper review of the projections in the *Staatsburger Zeitung* on 5 November 1895: Albert Narath, *Max Skladanowsky* (West Berlin, 1970), p. 23.
6 Michael Kimmelman, 'From Berlin's Hole of Forgottenness, a Spell of Songs', *New York Times*, 24 December 2008, p. C1.

7 A sound recording of one of Mielke's dementia-inflected
 speeches, as well as film documents of the East Berlin punk-rock
 performance culture (encompassing both Super-8mm films shot
 by the participants themselves, and state-security surveillance
 film footage), are archived in two documentary films: *Störung-Ost:
 Punks in Ostberlin 1981–1983*, dir. Cornelia Schneider/Mechthild
 Katzorke, Germany, 1996, and *Ostpunk!: Too Much Future*, dir.
 Carsten Fiebeler, Germany, 2007.

8 Fyodor Dostoyevsky, *Notes from the Underground* [1864] (New York,
 1992), p. 25.

9 Robert Smithson, 'A Cinematic Atopia' [1971], in *Robert Smithson:
 The Collected Writings*, p. 142.

10 Around 50 years later, that excessive darkness of the film was
 corrected digitally, by a laboratory working for Keio University's
 performance archive of the work of Hijikata, in Tokyo; this
 passage is informed by discussions with Donald Richie, Tokyo,
 2004, and with Hayato Kosuge, Tokyo, 2011.

11 Natasha Pradhan, presentation and screenings at the
 'Performance in/and the Public Sphere' conference, as part of
 the Festival de Tanger des Arts de la Scène, Tangier, June 2013;
 Pradhan's lila-films can be viewed on her website:
 natashapradhan.com.

12 Artaud's performative announcements of his own imminent
 assassination extend from his Ville-Evrard letters and magic spells
 to the letters he wrote from his subsequent asylum, Rodez, where
 he was interned from 1943 to 1946, and finally to his notebook
 entries (unpublished, but conserved in the manuscript collections
 of the Bibliothèque de France in Paris), of 3–4 March 1948, from
 the Ivry-sur-Seine sanatorium at the peripheries of Paris, where he
 died.

13 Antonin Artaud, letter to René Guilly, 7 February 1948, *Oeuvres
 complètes* (Paris, 1974), vol. XIII, pp. 136–7.

14 Kuniichi Uno, *The Genesis of an Unknown Body* (Helsinki and São
 Paulo, 2012), p. 15.

15 Mel Gordon's *Voluptuous Panic* (Port Townsend, 2006), researched
 for a performance project with the musician Nina Hagen, forms
 an individually amassed visual archive of materials from a

corporeal performative culture that, in the intervening decades, had appeared anachronistic and obsolete, or had been intentionally occluded.

16 Antonin Artaud, Le visage humain [1947], in Antonin Artaud, Dessins (Paris, 1987), p. 48.

17 Antonin Artaud, unsent letter to André Breton [1947], in L'Ephémère, 8 (Winter 1968), pp. 20–21. This paragraph is informed by discussions with Rustom Bharucha, Berlin, 2013.

18 Werner Herzog, Conquest of the Useless: Reflections from the Making of 'Fitzcarraldo' (New York, 2004), pp. 294–5. That journal followed Of Walking in Ice, the journal Herzog made in 1974 of his performative walk from Munich to Paris, whose ostensible 'uselessness' resided in its aim of keeping alive the ailing film historian Lotte Eisner. Shortly after Herzog's 2012 performance, the Volksbühne venue presented a spectacle, Fucking Liberty!, by the film-maker Uli Lommel, a close collaborator of Rainer Werner Fassbinder, in which Lommel, on stage, also performatively embodied his own fragmented self-history, adopting a post-death perspective of memorial hallucination in which (in contrast to Herzog's film-voided performance) moments re-enacted from his memory were projected as 3-D digital moving-image interventions into the performance space.

19 Interview with Genet's archivist, Albert Dichy (who had himself interviewed Genet's 1969 Tokyo companions, such as Jackie Maglia), Paris, 2002.

20 Marker and Wakamatsu both died in 2012, several months apart. Marker's death led to discussions of his brief wartime role in France as the young editor of a cultural journal – La Revue française – for the Vichy government, affiliated to the occupying German National Socialist regime, and of how his screening away of the public memory of that never admitted 'collaboration' had led him performatively to devise an always shifting persona for himself, propelled by the medium of film, together with an aura of invisibility, embodied in successive experiments with moving-image and digital technologies. Wakamatsu's death resulted from his being struck by a taxi while traversing a nocturnal avenue in the Shinjuku district, still irreversibly associated with

the late-1960s cultures of protest and performance, as though
the violent immediacy of that moment had abruptly resurged.

21 Takahiko Iimura, *Media and Performance* (Tokyo, 2007), pp. 1–2,
and discussions with Iimura, Tokyo, 1998.

22 Bertolt Brecht, *The Threepenny Opera* (London, 2007), p. 65.

23 Robert Peckham, interview with Lu Yang, 'Tortuous Visions of
Lu Yang: The Bioart in China', *Digimag*, 52 (March 2010), online.

24 Hollis Frampton, 'Eadweard Muybridge: Fragments of a
Tesseract', in *Circles of Confusion* (Rochester, NY, 1983), p. 79.

25 Robert Smithson, 'A Cinematic Atopia' [1971], in *Robert Smithson:
The Collected Writings*, p. 139.

26 *Lovers* was first shown in Tokyo at the Hillside Plaza arts space
for experiments in performance and digital media, September–
October 1994, then at major venues such as the Museum of
Modern Art, New York. Along with *Lovers'* survival, in the form
of its moving-image sequences and now-obsolete technological
components acquired by art museums' collections, the
installation's traces are also archived in the collection of
Dumb Type-related materials at Seika University in Kyoto.

27 Alan Read, *The Last Human Venue: Theatre, Intimacy and Engagement*
(Basingstoke, 2008), p. 272, and discussions with Alan Read,
Berlin, 2011.

28 Read, *The Last Human Venue*, p. 273.

29 Ibid.

30 Discussions with Rabih Mroué, Berlin, 2013.

ACKNOWLEDGEMENTS

I am very grateful to all of the directors and staff of the Freie Universität Berlin's International Research Center 'Interweaving Performance Cultures', for their great generosity and support in granting me a fellowship to write this book. I'd also particularly like to thank Rustom Bharucha for first inviting me to the Center.